HISTORIC PHOTOS OF
OKLAHOMA CITY

TEXT AND CAPTIONS BY LARRY JOHNSON

TURNER
PUBLISHING COMPANY
NASHVILLE, TENNESSEE PADUCAH, KENTUCKY

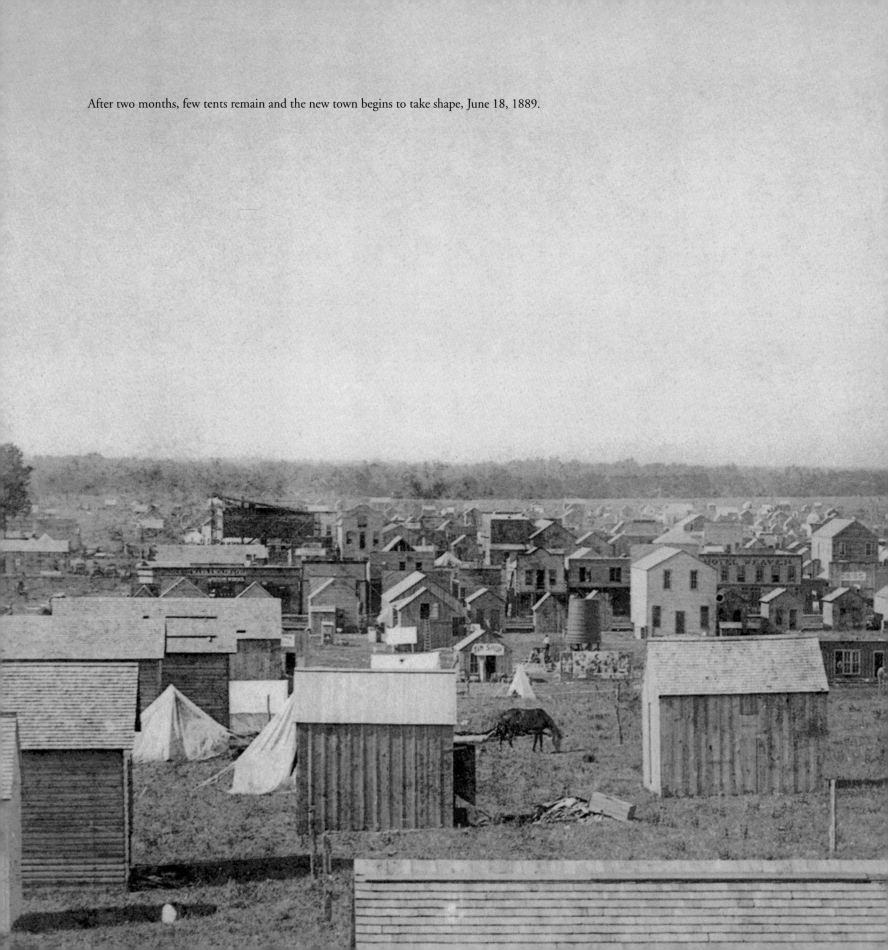

After two months, few tents remain and the new town begins to take shape, June 18, 1889.

HISTORIC PHOTOS OF
OKLAHOMA CITY

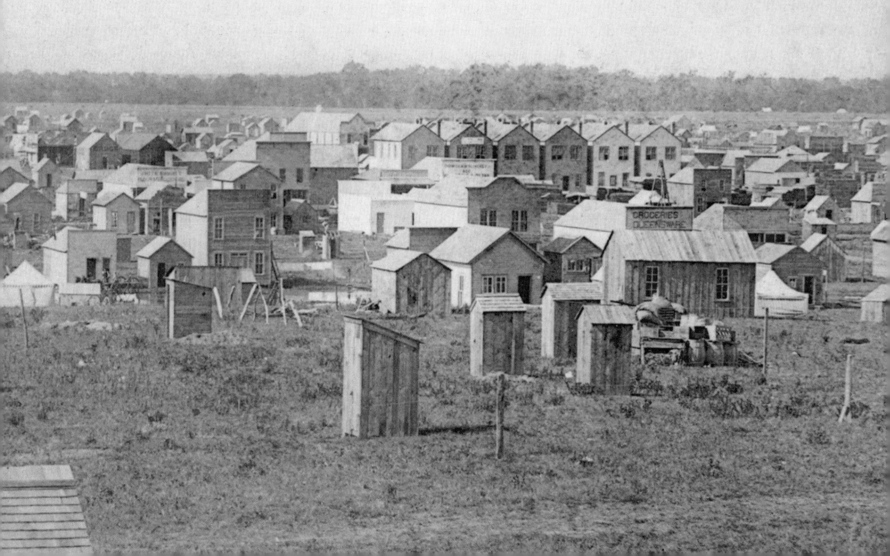

Turner Publishing Company
200 4th Avenue North • Suite 950 412 Broadway • P.O. Box 3101
Nashville, Tennessee 37219 Paducah, Kentucky 42002-3101
(615) 255-2665 (270) 443-0121

www.turnerpublishing.com

Historic Photos of Oklahoma City

Library of Congress Control Number: 2007923670

ISBN-13: 978-1-59652-364-7
ISBN: 1-59652-364-6

Printed in the United States of America

07 08 09 10 11 12 13 14—0 9 8 7 6 5 4 3 2 1

CONTENTS

From left to right, Chester Pierce, actor Charlton Heston, and L. J. West prepare to march in support of civil rights, to integrate downtown stores (May 27, 1961).

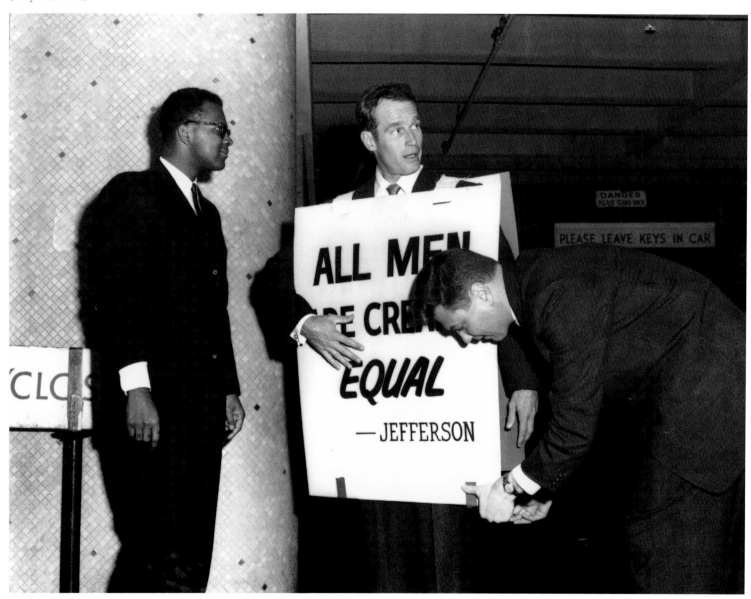

Acknowledgments

This volume, *Historic Photos of Oklahoma City,* is the result of the cooperation and efforts of many individuals and organizations. It is with great thanks that we acknowledge the valuable contribution of the following for their generous support:

The Library of Congress
Oklahoma Historical Society

The author would like to thank Margaret Nell and Madeleine Claire for their valuable assistance in selecting photographs for this work. Pamela Bracken and Victoria Dixon provided inestimable assistance in proofreading and editing the text.

PREFACE

Oklahoma City has thousands of historic photographs that reside in archives, both locally and nationally. This book began with the observation that, while those photographs are of great interest to many, they are not easily accessible. During a time when the city's people are looking ahead and evaluating its future course, many are asking, How do we treat the past? These decisions affect every aspect of the city—architecture, public spaces, commerce, infrastructure—and these, in turn, affect the way that people live their lives. This book seeks to provide easy access to a valuable, objective look into the history of Oklahoma City.

The power of photographs is that they are less subjective than words in their treatment of history. Although the photographer can make decisions regarding subject matter and how to capture and present it, photographs do not provide the breadth of interpretation that text does. For this reason, they offer an original, untainted perspective that allows the viewer to interpret and observe.

This project represents countless hours of review and research. The researchers and writer have reviewed thousands of photographs in numerous archives. We greatly appreciate the generous assistance of the individuals and organizations listed in the acknowledgments of this work, without whom this project could not have been completed.

The goal in publishing this work is to provide broader access to this set of extraordinary photographs that seek to inspire, provide perspective, and evoke insight that might assist people who are responsible for determining Oklahoma City's future. In addition, the book seeks to preserve the past with adequate respect and reverence.

With the exception of touching up imperfections caused by the damage of time and cropping where necessary, no other changes have been made. The focus and clarity of many images is limited to the technology and the ability of the photographer at the time they were taken.

The work is divided into eras. Beginning with some of the earliest known photographs of Oklahoma City, the first section records photographs through the end of the nineteenth century. The second section spans the beginning of the

twentieth century up to World War I. Section 3 moves into the 1920s era, section 4 covers the Great Depression and World War II eras, and the last section covers the postwar era to recent times.

In each of these sections we have made an effort to capture various aspects of life through our selection of photographs. People, commerce, transportation, infrastructure, religious institutions, and educational institutions have been included to provide a broad perspective.

We encourage readers to reflect as they go walking in Oklahoma City, strolling through the city, its parks, and its neighborhoods. It is the publisher's hope that in utilizing this work, longtime residents will learn something new and that new residents will gain a perspective on where Oklahoma City has been, so that each can contribute to its future.

Todd Bottorff, Publisher

New postmaster George A. Beidler arrived at Oklahoma Station a few days
before the land run. With five dollars in material, he and a group of soldiers
constructed this lean-to across from the Santa Fe depot. In this photograph,
Beidler is on the right; his son, Chase, is in the center.

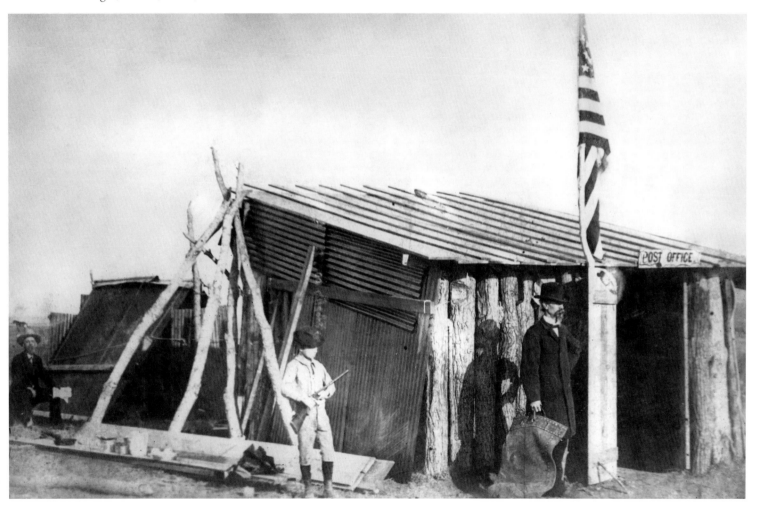

Out Where the West Begins

(1889–1899)

Oklahoma City was not opened to settlement by a rifle's report—unleashing land-hungry waves of homesteaders in a mad dash to stake a claim—but rather by the toot of the locomotive whistle as trains teeming with people began arriving on the afternoon of April 22, 1889. By day's end, a tent city of 10,000 settlers had emerged. Two companies produced two different surveys of the town, and confusion reigned as claimants tried to determine just where their lots were. In the absence of any sort of government, a citizen's committee rose up and created a compromise townsite and a provisional municipal government.

The first dozen years in Oklahoma City were marked by a succession of crises, which threatened the civic dreams of its founders. The land run took place too late in the season for planting, so there were no crops that first year. An influenza outbreak spread misery that first winter as well. There were bank panics and recessions. Commerce was slow to develop because of a lack of suitable trading partners—it seemed the same dollar was being passed around.

But this was the Gilded Age and fierce competition was the order of the day. Early city leaders were determined to succeed in their quest to build a metropolis worthy of the East Coast. Under the aegis of the Commercial Club, Oklahoma City set its sights on its more developed northern neighbor and territorial capital, Guthrie. The none too subtly stated purpose was to build Oklahoma City into an economic powerhouse so that it could challenge Guthrie for the title of state capital when statehood finally arrived.

Throughout the 1890s investment was heavy in the processing of agricultural products, luring in cargo-thirsty railroads and thereby opening the city to world markets. As the new century dawned, there were eight rail lines running through the city, and businesses controlled 65 percent of the distribution in the Oklahoma and Indian (the Twin) Territories.

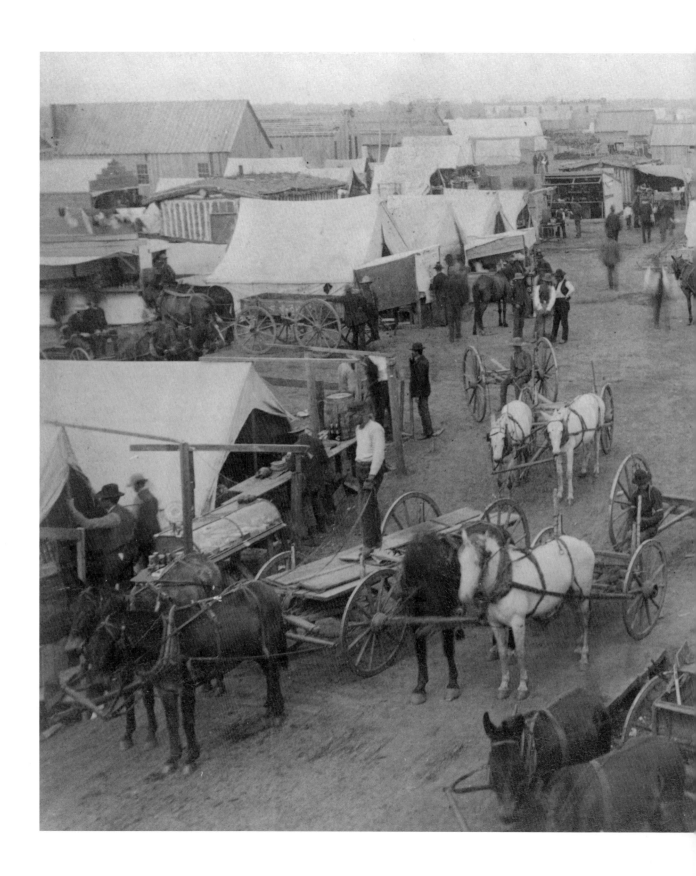

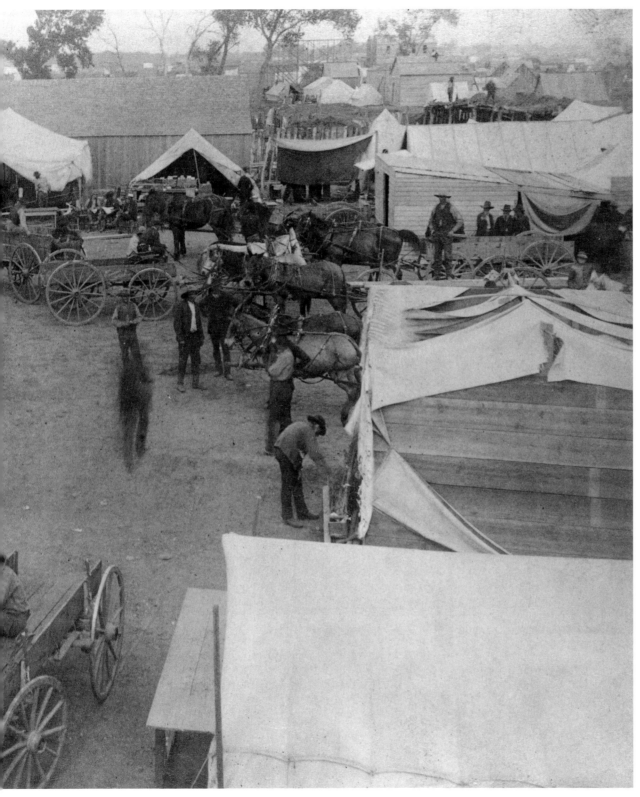

Confusion reigned while the two townsite companies feuded over which was the accurate survey. Shown here are the makings of the notorious jogs in the streets that would plague the city for decades (April 24, 1889).

Until a townsite survey could be agreed upon, Oklahoma Station remained a tent city. Meanwhile, hundreds of people arrived daily on the Santa Fe Railroad. This view northwest from the depot was recorded on April 27, 1889.

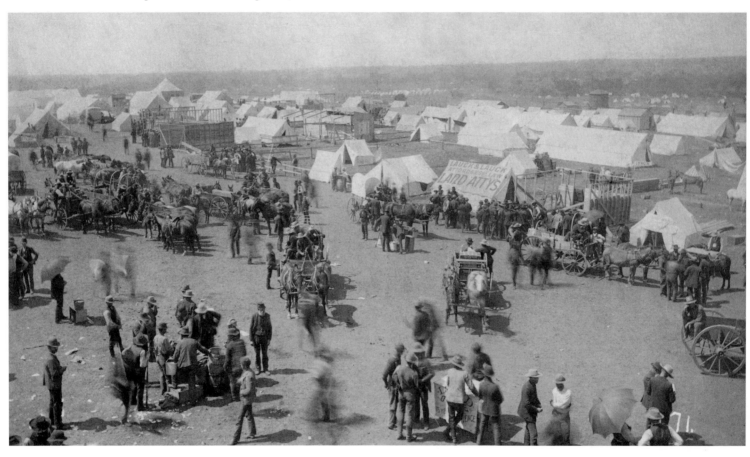

John A. Hebble established the first brickyard in Oklahoma City, shown here on April 29, 1889. An acute shortage of building materials plagued the city from the outset.

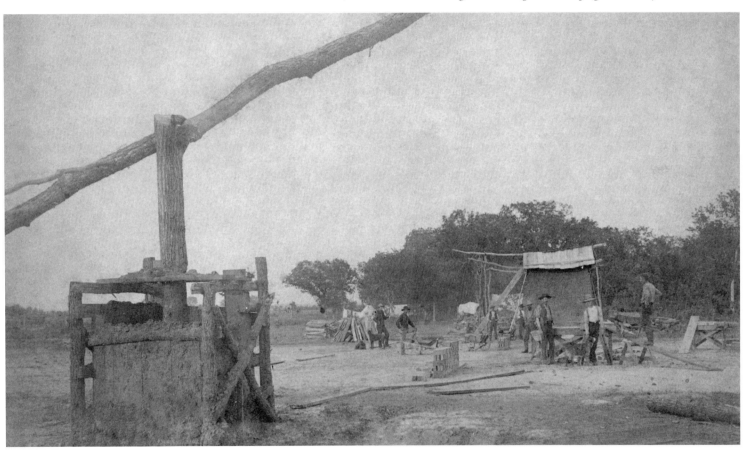

Bolstered by the compromise townsite survey and a provisional government,
settlers began to replace their tents with wood frame structures by May 1889.

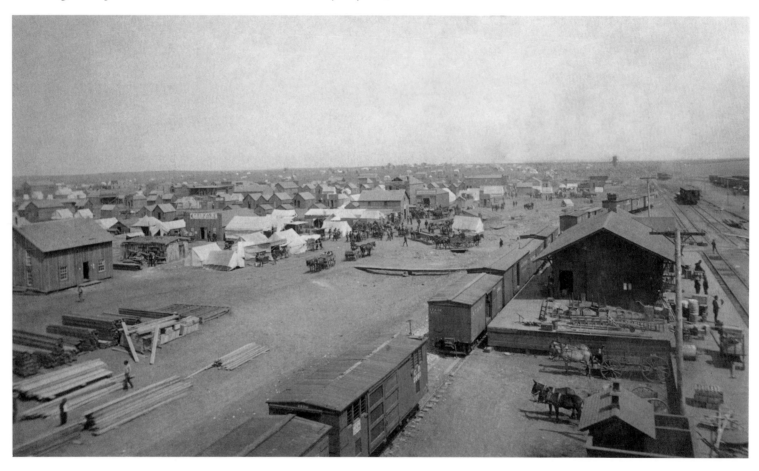

Indians on California Avenue, May 5, 1889. Several Cheyenne and Arapaho leaders met in the city in May, and these people may be part of that group. Oklahoma Station was also the depot for several Indian agencies in the region.

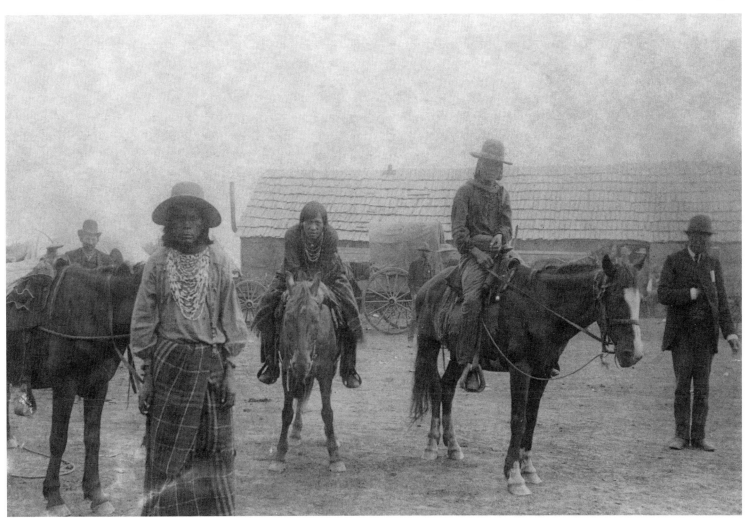

This new post office at 8 West Main was built two weeks after the opening.
It often served as a public meeting space, including Indian councils. At this
meeting in May 1889, the Cheyenne and Arapaho tribes met here with
federal officials to sell some of their land.

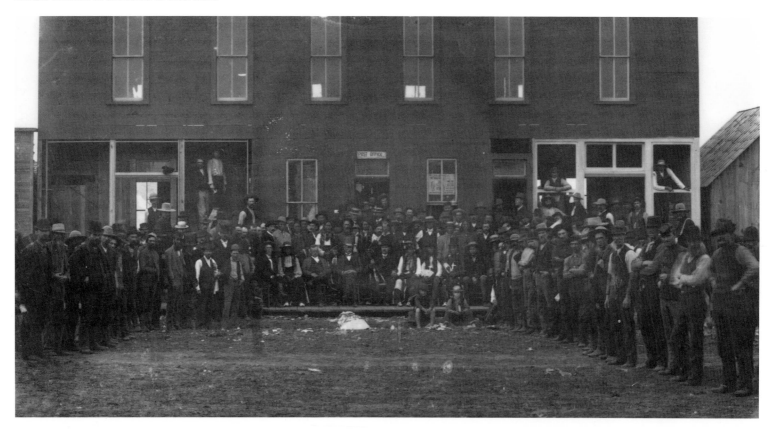

The Arbitration Board in front of City Court tent, May 31, 1889. Following the first election on May 1, an arbitration board was established to settle disputed claims. Nevertheless, claim disputes were sometimes settled with a shotgun.

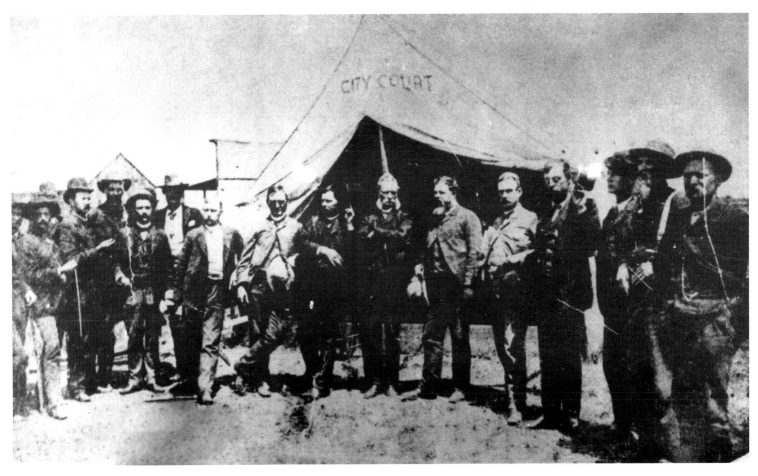

C. A. McNabb is believed to be the first merchant to erect a permanent building. McNabb was head of the Oklahoma delegation to the World's Fair in St. Louis and would later serve as state Secretary of Agriculture.

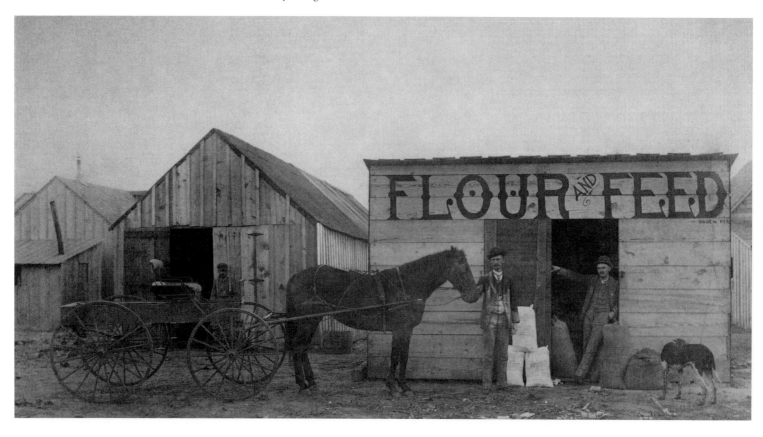

A busy Main Street as seen on June 1, 1889.

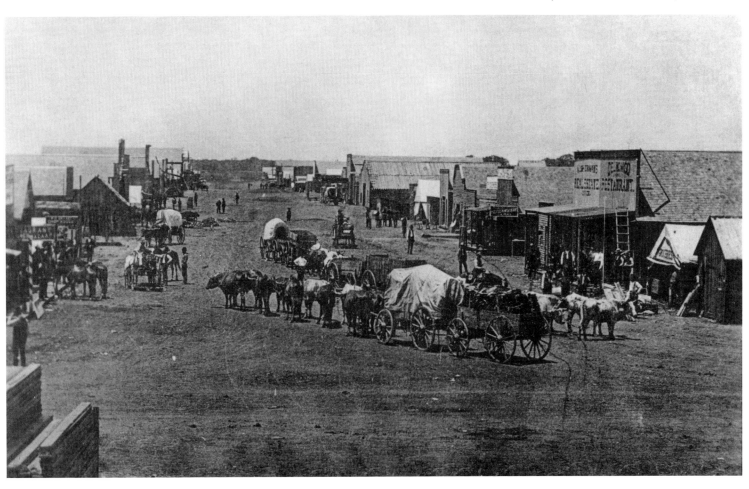

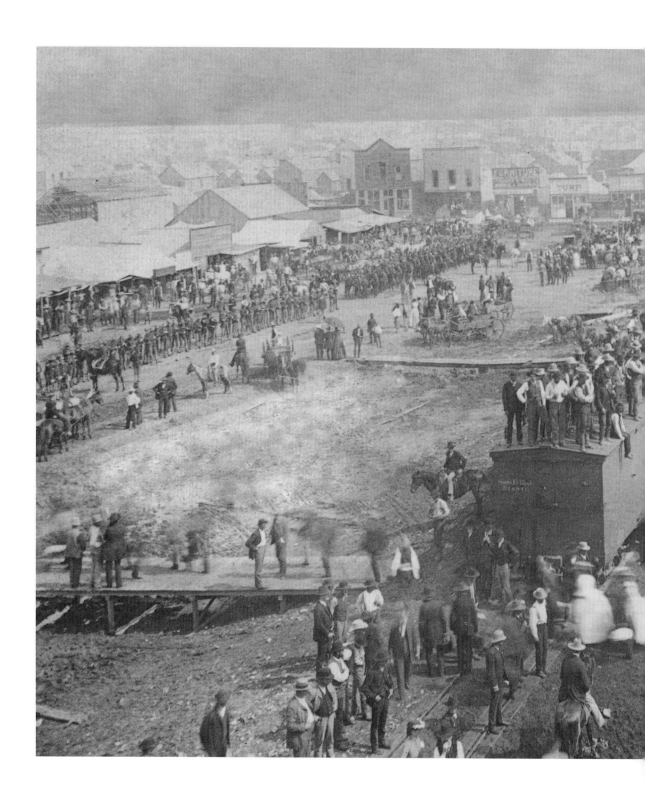

Independence Day, 1889. Crowds gather around the Santa Fe depot for the city's first big celebration. Impromptu picnics, games, and sporting events would take place on the hillside east of the depot.

The city's first disaster struck during the Fourth of July revelry in 1889. A hastily constructed grandstand buckled under the strain of hundreds of people watching a horserace. Three people were killed and at least one hundred were injured.

C. A. McNabb's feed store was located on Broadway between Main and Grand across from an early city jail. An outlaw named Scarface Joe was killed by sheriff John Fightmaster as he fled the jail and ran into McNabb's store.

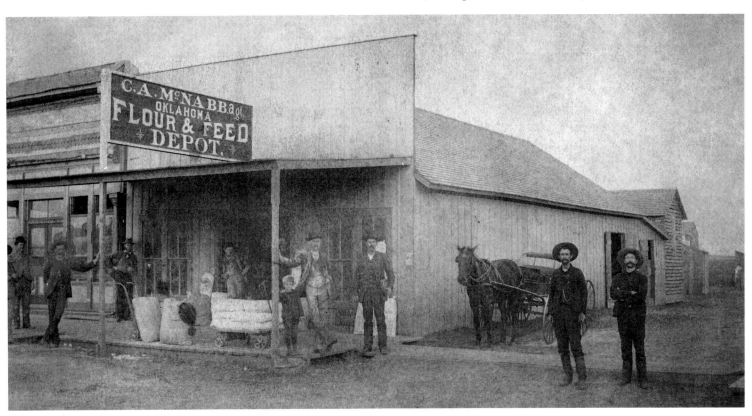

Soon after the lots were made official, an enterprising Henry Overholser
shipped in these six prefabricated storefronts and erected them along
Grand Avenue between Robinson and Harvey.

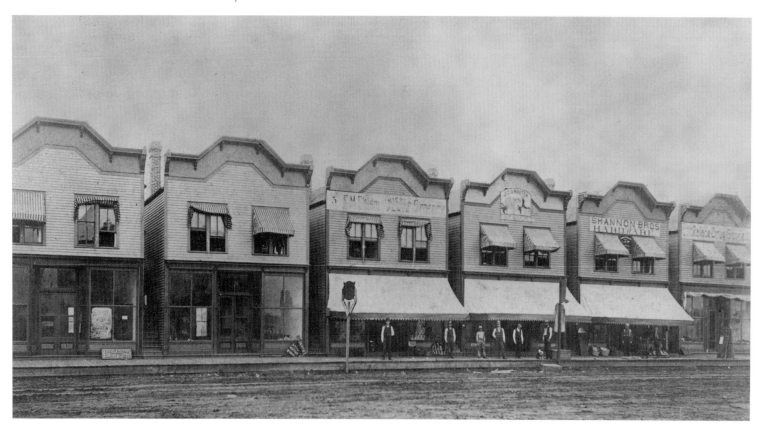

Ox-drawn wagons near Santa Fe depot, 1889. Teamsters delivered freight to Indian agencies and Fort Reno in addition to customers in the new city.

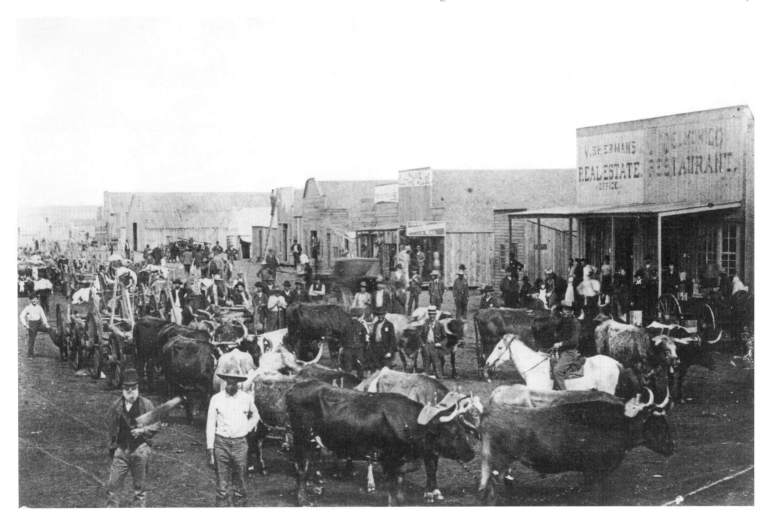

Until the railroad could deliver enough supplies, industrious citizens made do with what they could scavenge. This shop owner built his place with a variety of building materials.

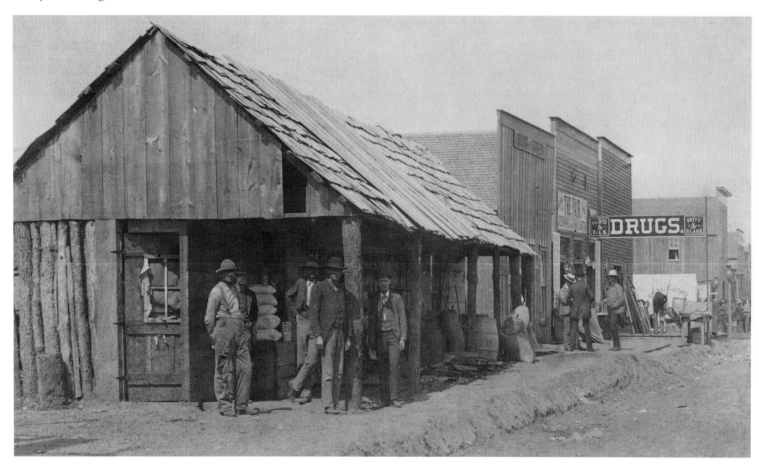

Baseball was popular in the city from the earliest days. Here a crowd is assembled to watch a game in the summer of 1889.

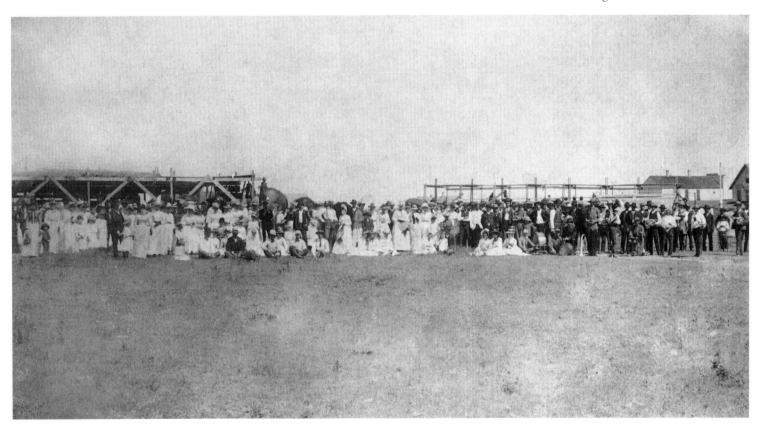

A deal is struck not far from the Santa Fe depot as teams of oxen wait nearby, 1889.

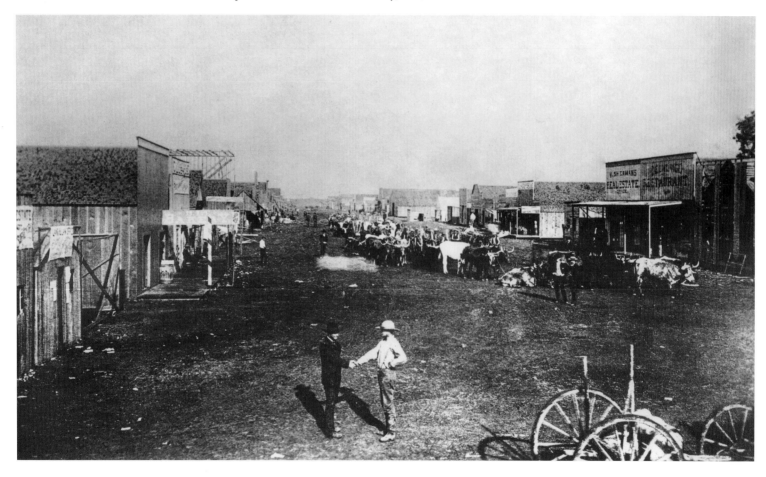

The Weaver, often referred to as the city's first hotel, was located on the south side of Main between Broadway and Robinson. It was named for presidential candidate James B. Weaver, Congressman from Iowa, who was present at the opening.

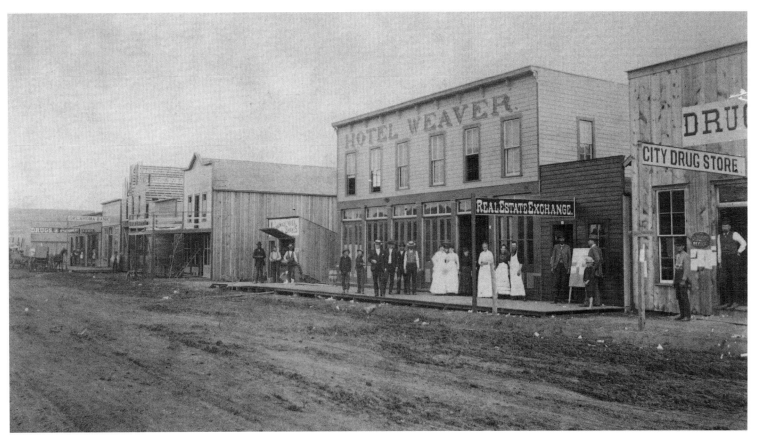

The Bassett Block on the northeast corner of Broadway and Main Street, seen here in 1890, was one of the first substantial brick buildings in the city.

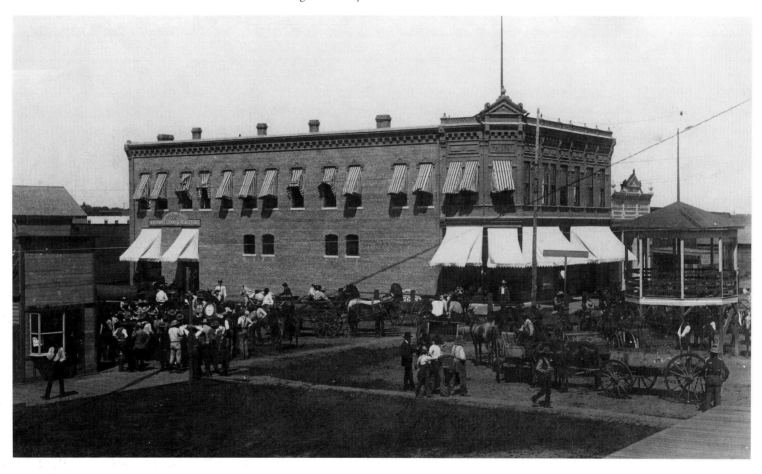

This is the view west along the north side of Main Street between
Robinson and Harvey in the 1890s.

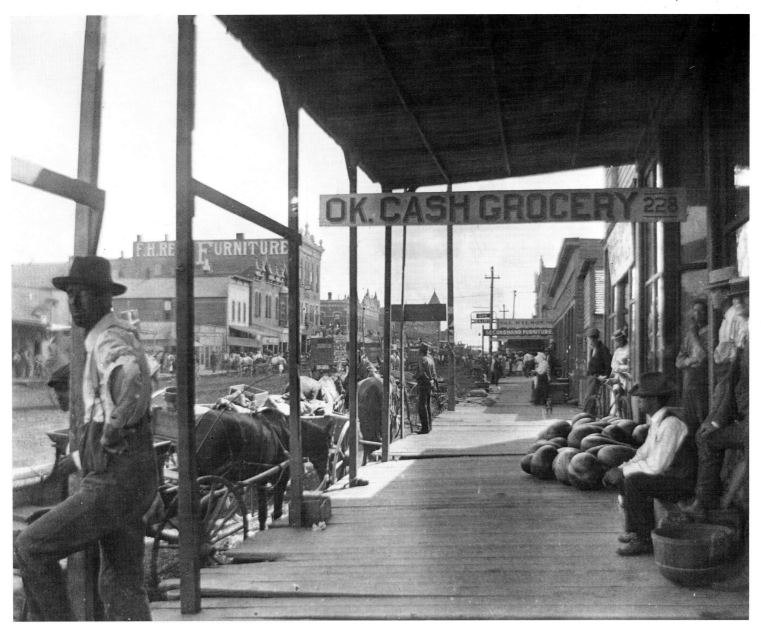

T. M. Richardson built his ornate First National Bank building on the
southeast corner of Broadway and Main after emerging victoriously from
the bank panic of 1893.

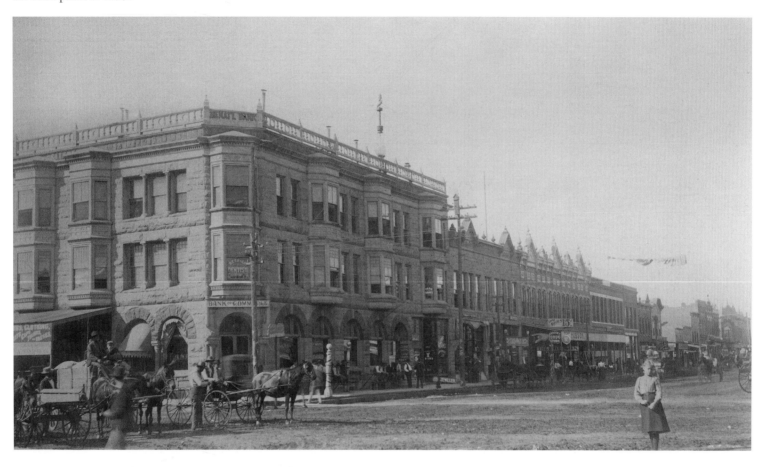

This is the view west on Main from Broadway in 1894. A number of fine multi-story buildings, including the new Masonic Temple (right), illustrate the growing importance of Oklahoma City as a commercial center.

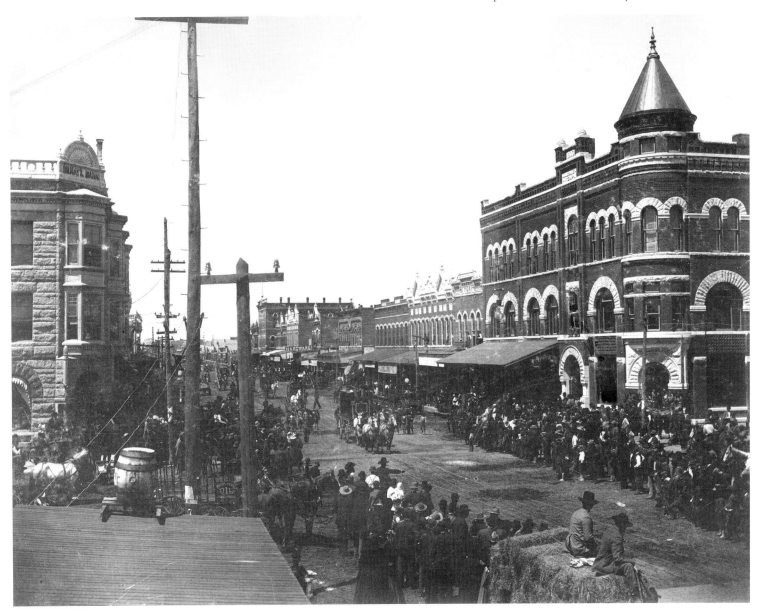

The Aurora Bargain Store, shown here in the 1890s, was operated by the
Herskowitz family at the corner of Broadway and Grand. Max Herskowitz would
eventually build a twelve-story tower on the site of this one-room store.

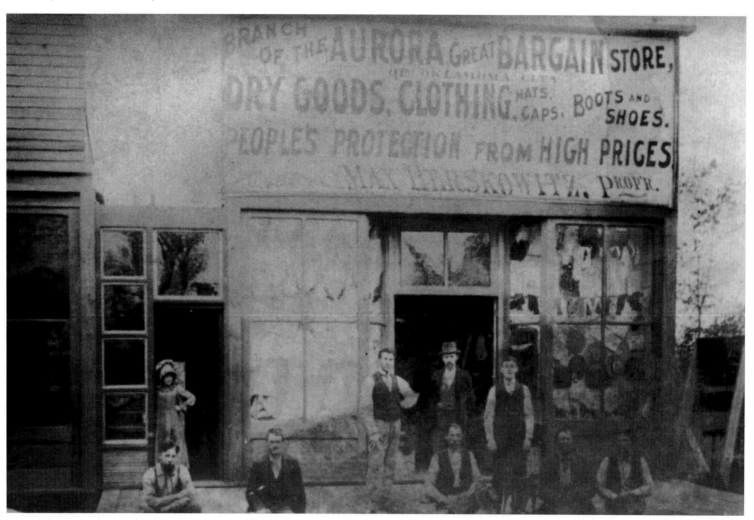

The J. W. Hill Stage Line (ca. 1890s). Despite the advent of the automobile, stage lines would still play an important part in transportation into the early twentieth century.

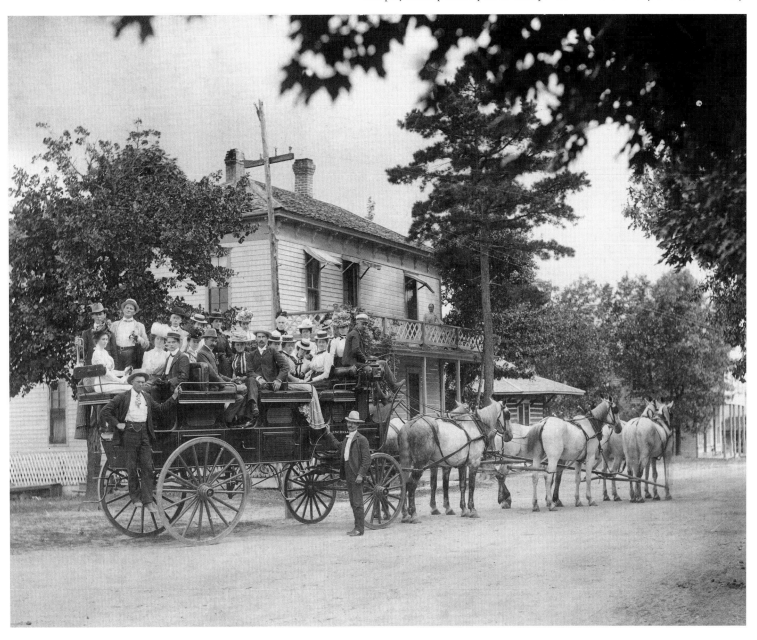

Settlers gather in front of B. J. Dreesen's Real Estate office on Grand Avenue (ca. 1890s).

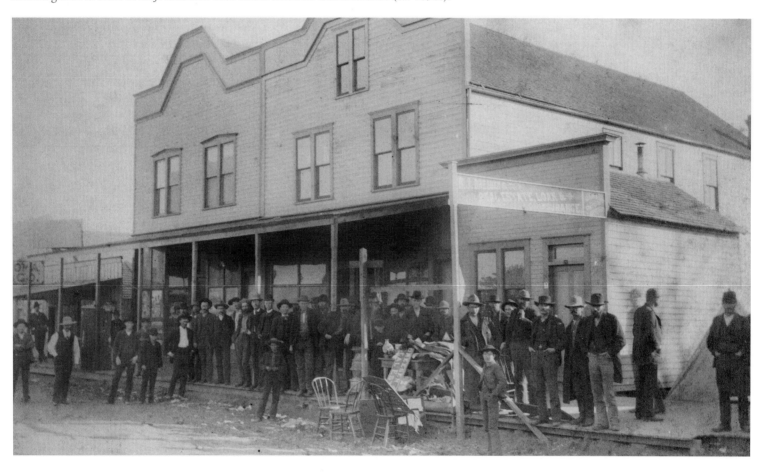

This tornado struck the Oklahoma City area in May 1896. Described by the Weather Bureau as a "twisting serpent-like cloud," it did little damage, but another tornado struck nearby Britton half an hour later damaging a house and a barn.

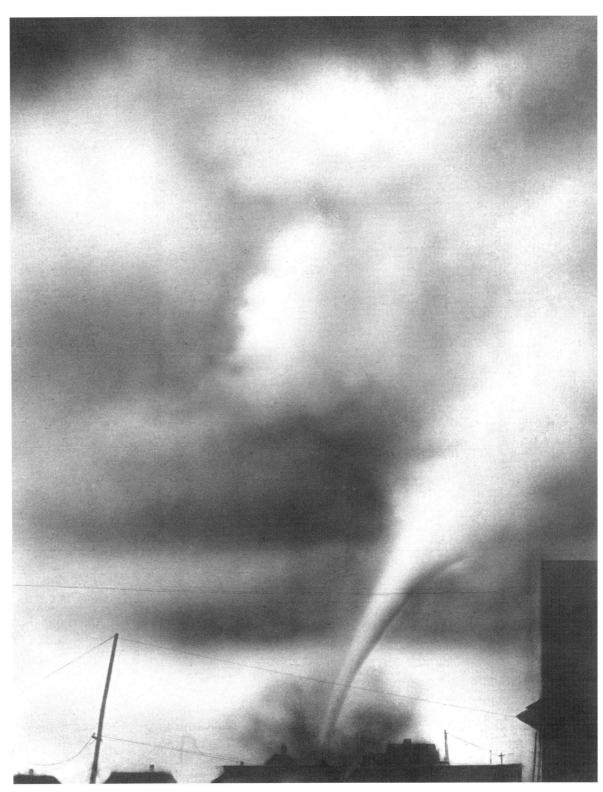

Oklahoma City Free Street Fair, October 10-15, 1898. Street fairs were very popular in the early days of the city. This view is to the east on Grand Avenue from Harvey.

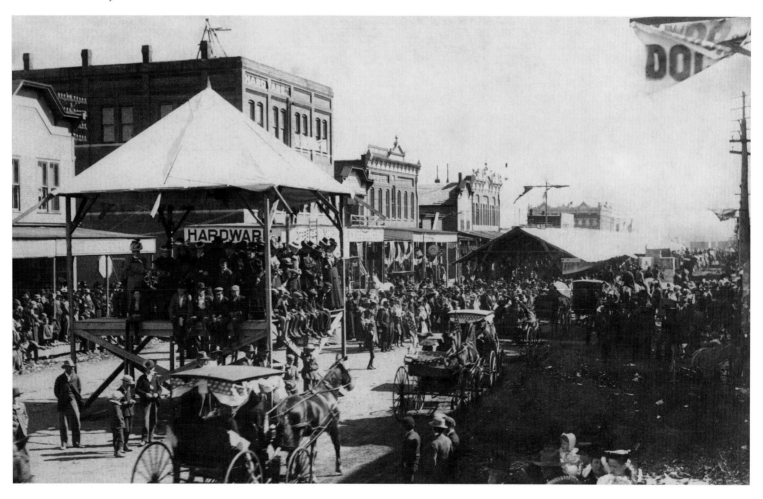

These ladies, who carry advertising placards in front of First Methodist
Church, may have been assembling for a parade (ca. 1890s).

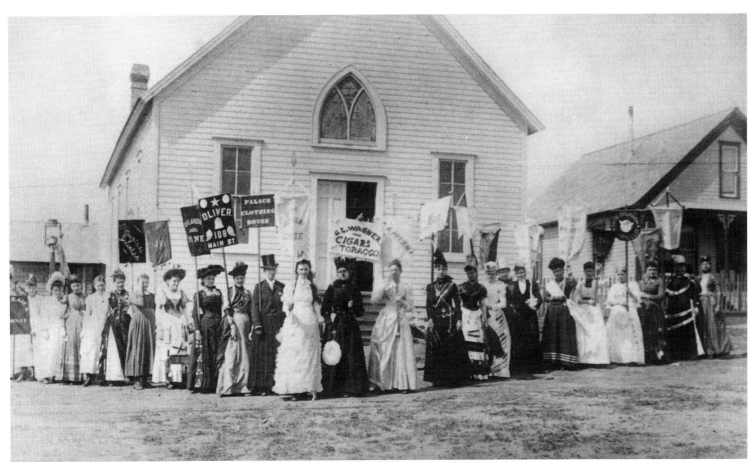

The Ragon and Atwood Lumber Company float advertises its products in the Oklahoma City Free Street Fair, September 18-23, 1899. Hitching a ride on the float is an ad for the "famous Studebaker Wagons" of Gilpin and Frick.

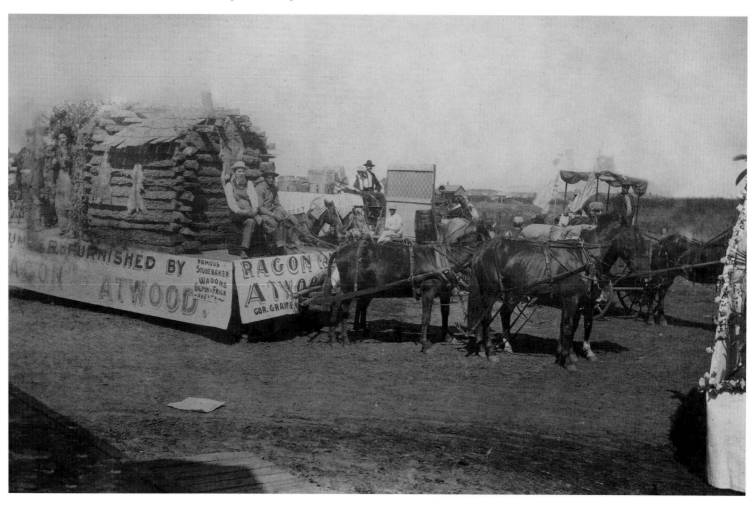

Crowds throng the vendors on Main Street at the Oklahoma City Free Street Fair, September 18-23, 1899.

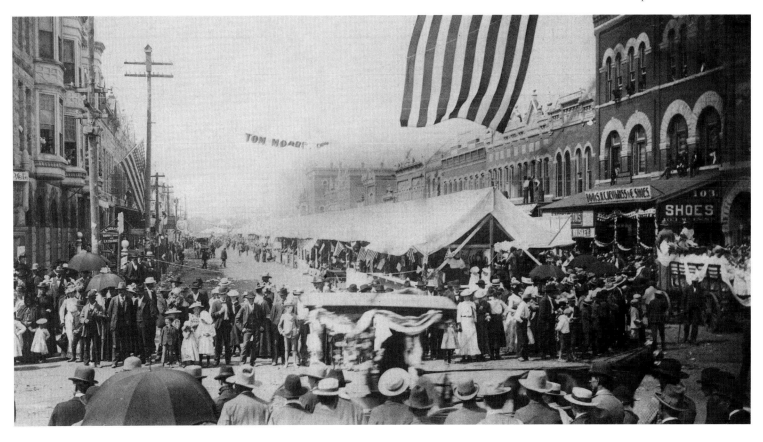

The parade route passes Western National Bank (formerly the Masonic Temple) heading west on Main Street from Broadway, at the Oklahoma City Free Street Fair, September 18-23, 1899.

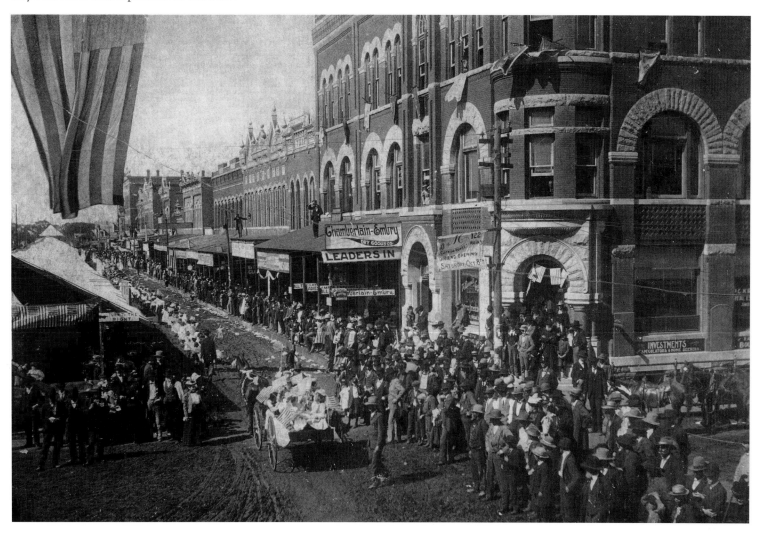

THE INDUSTRIAL PRODIGY OF THE SOUTHWEST

(1900–1917)

By the turn of the century, Oklahoma City brimmed with prosperity. The population had remained at about 4,000 for nearly ten years, but jumped to 10,000 around 1900 because of economic expansion. This was mainly fueled by large national companies establishing regional offices in the city and the rise of wholesaling as the most lucrative economic activity.

Developers began to expand the city around the perimeter of the original limits. Anton Classen, both as a developer and as a leader of the Chamber of Commerce, was the driving force during much of this era. Beginning in 1903, he pierced the open prairie with his streetcar lines and then platted developments along the routes, enabling builders and other developers to fill in the gaps. In 1902 he persuaded the Methodists to build Epworth University, then later developed a park and boulevard system, and planted thousands of trees—all done with his own money.

The city still strove to put itself into position to win the state capital. Classen and the chamber, secure in their commercial base, began to promote Oklahoma City as an "industrial prodigy" and were successful in wooing some industry, including the stockyards and two large meatpacking plants; other industries followed. This had the immediate benefit of doubling the population from a 1907 total of 32,000 to 64,000 in 1910—arch rival Guthrie was stalled at 10,000. The twenty-year struggle for the state capital ended that year in an overwhelming victory for Oklahoma City.

For the rest of this era the city continued to mature. Great strides were made culturally with the establishment of the Carnegie Library in 1901, the construction of magnificent churches on Church Row (North Robinson), and the building of palatial homes in neighborhoods such as Heritage Hills and Mesta Park. Outdoor recreational facilities developed during this period were the state fairgrounds, Delmar Garden, Belle Isle, and Wheeler Park (which also housed the zoo). In the civic arena, the city gained a new county courthouse, annexed Capitol Hill, created the Lake Overholser reservoir, and built the State Capitol.

Vice-presidential candidate Theodore Roosevelt parades down Main Street, July 3, 1900. Roosevelt's Rough Riders recruited heavily from Oklahoma during the Spanish-American War.

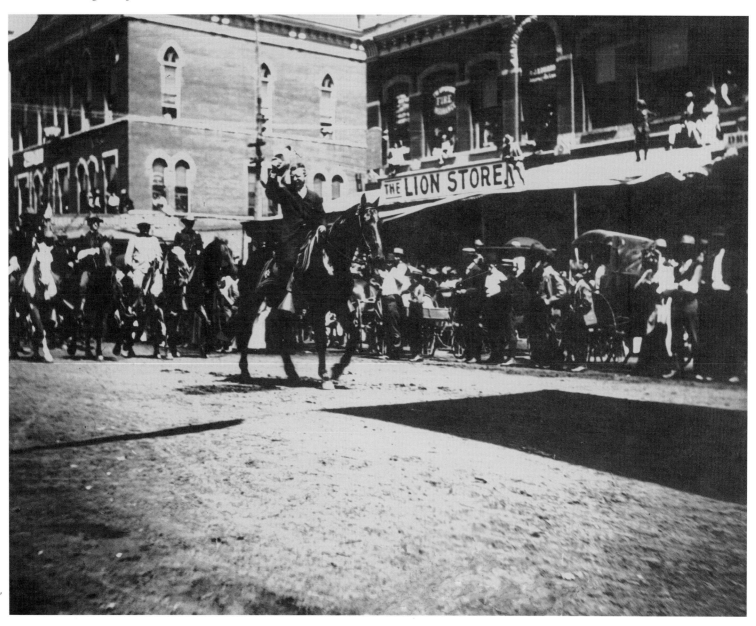

The Rough Riders parade down Main Street, July 3, 1900. Anton Classen arranged this second reunion of the regiment during the Independence Day holiday that year. Youngsters Lucille Mulhall and Will Rogers both performed rope tricks for Roosevelt.

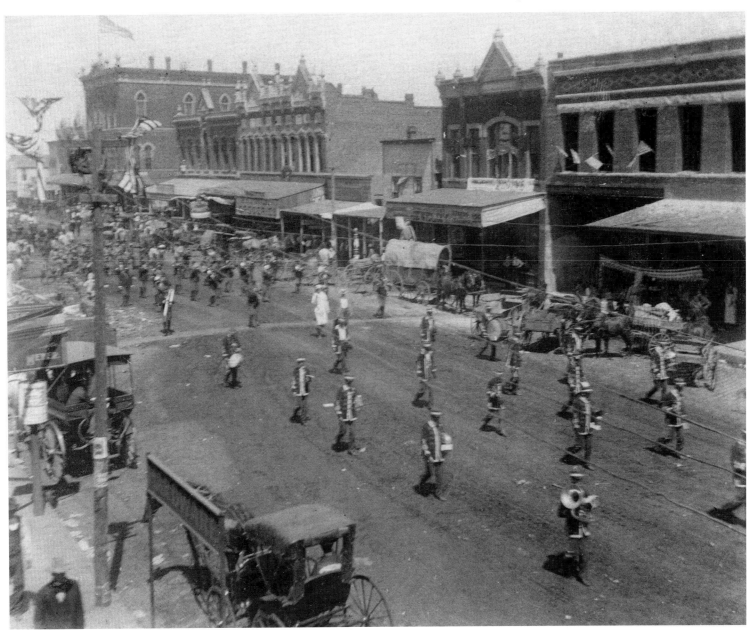

Native Americans parade down Grand Avenue during the Rough Riders
reunion, July 4, 1900.

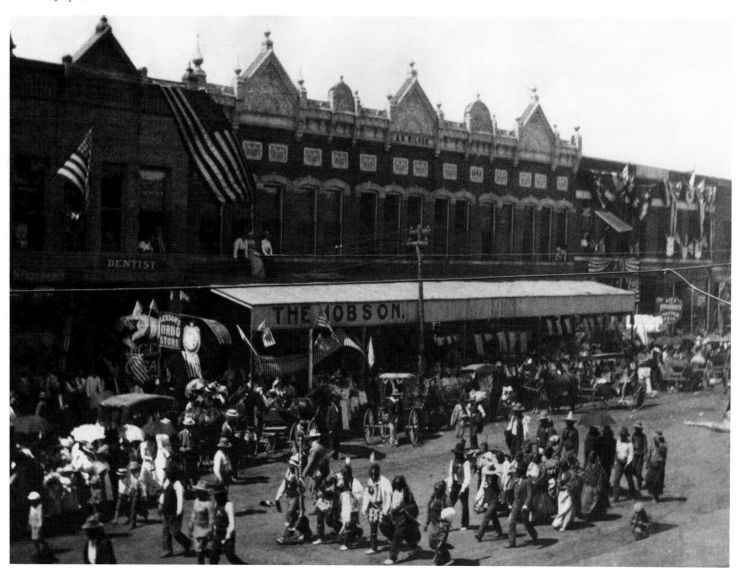

Curious onlookers marvel at a new "horseless carriage" in the intersection of Main and Broadway (ca. 1901).

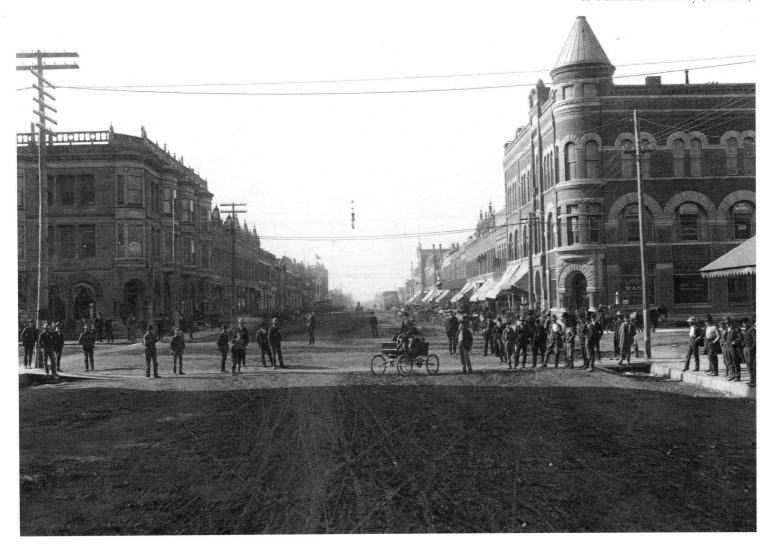

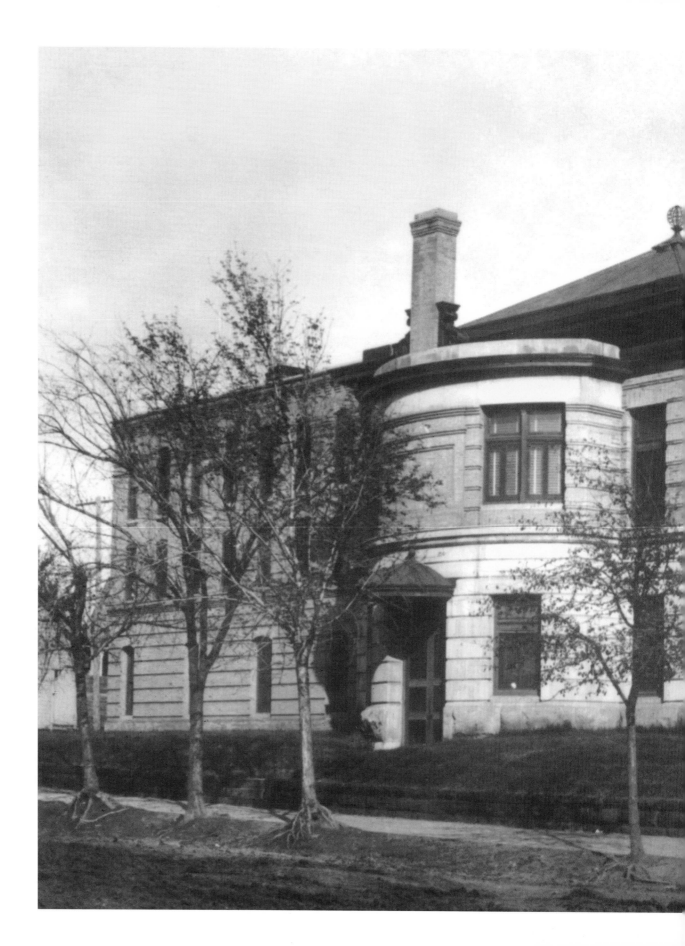

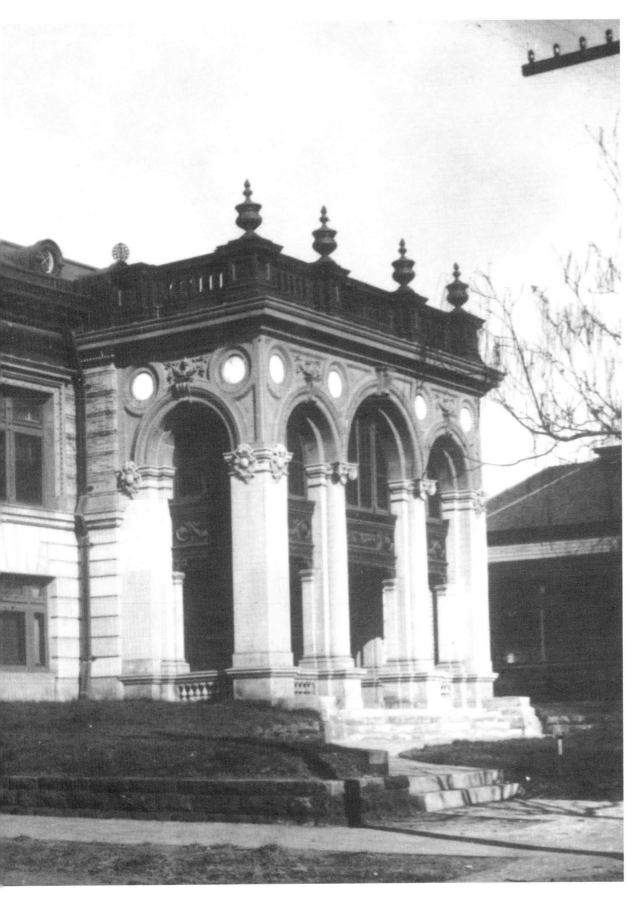

The Carnegie Library at Third
and North Robinson was
considered among the most
elaborate of Andrew Carnegie's
public gifts. Built in 1901,
the library was an important
factor in the city's cultural
development.

A scenic drive in Wheeler Park (ca. 1903). J. B. Wheeler donated a wooded forty-acre plot of land north of the North Canadian River for the city park in 1902. The city improved the area and established the first zoo there, but chronic flooding limited its development.

Uncle Earl's team, Doc and Bob, pass the west side of the Carnegie Library on Robinson at Third Street (ca. 1902).

Anton Classen put up his own money to finance Epworth University, thus persuading the Methodists to build here. This 1903 view of the nearly completed school a mile from downtown illustrates the stark prairie just beyond the city limits. Within a few years, streetcars and houses would fill the area.

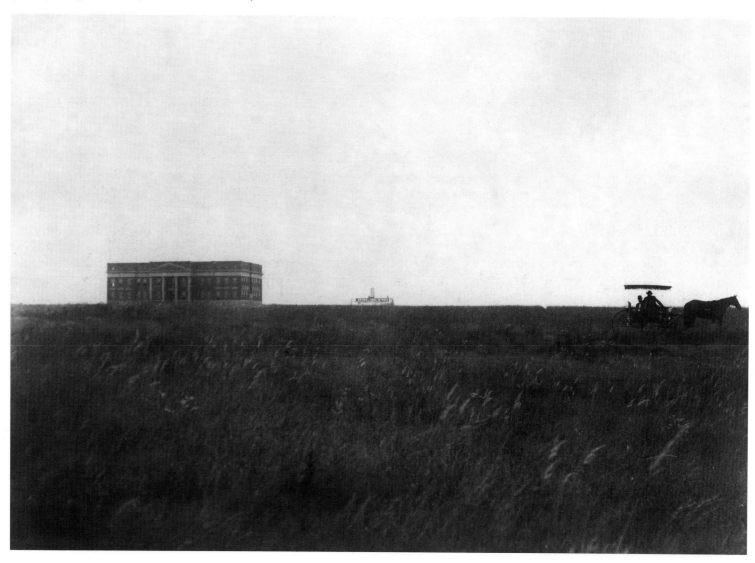

Built before the Huckins and Skirvin hotels, the Threadgill, seen here ca. 1904, once reigned as the most luxurious in the city. Renamed the Hotel Bristol in 1913, this building stood at 300 North Broadway until 1957.

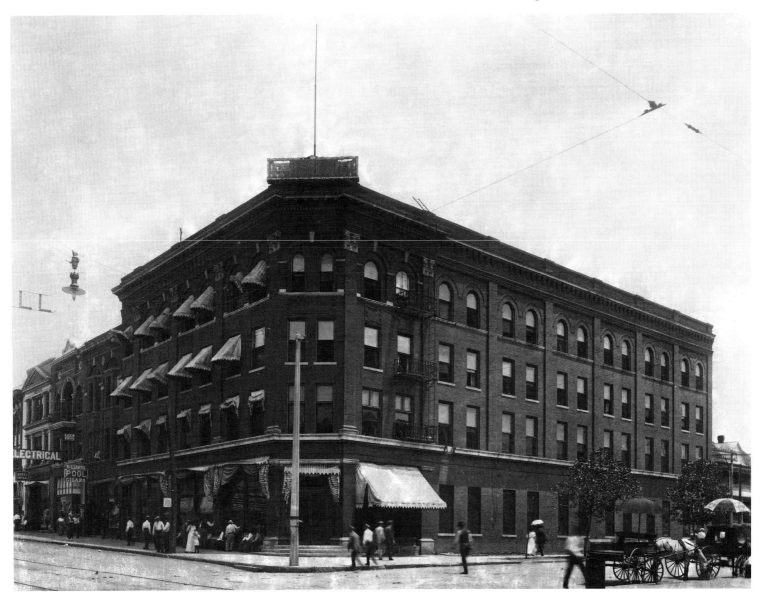

The Herskowitz Store, 2-4 North Broadway, was another of the Herskowitz family stores, seen here in the early 1900s. Brothers Mose and Max operated two dry goods stores and Max's son Abe carried on the family tradition.

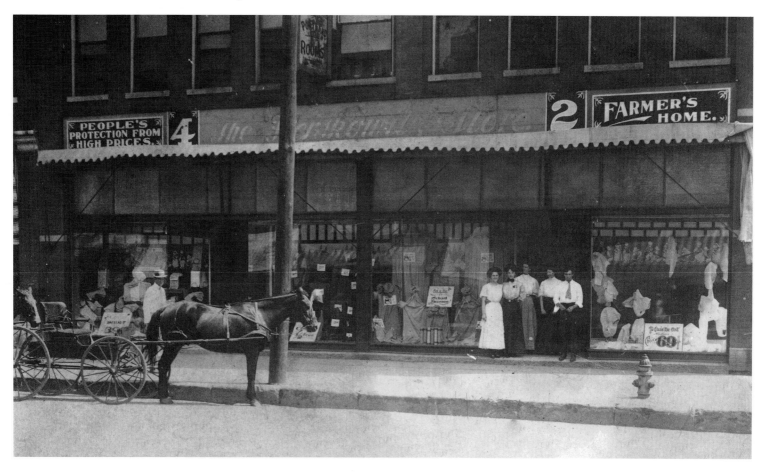

A delivery wagon pauses in the 500 block of West Main (ca. 1905).

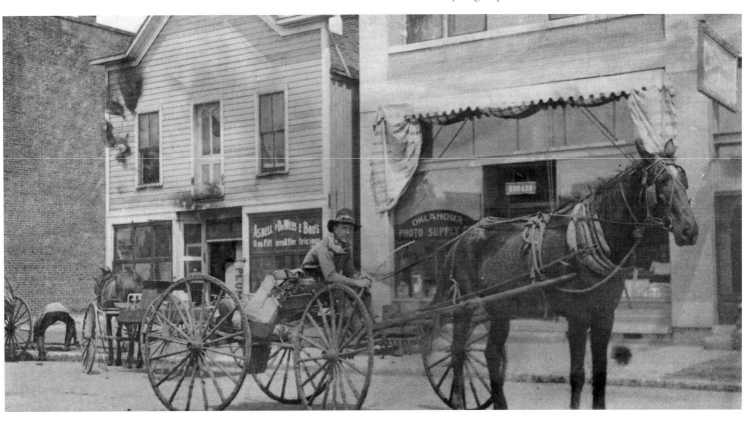

This is the view north on Broadway from the Rock Island tracks, ca. 1905, showing the Threadgill Hotel (center) and the Missouri House (right). The Missouri, located across from the Rock Island depot, was a frequent target of police raids for liquor and gambling.

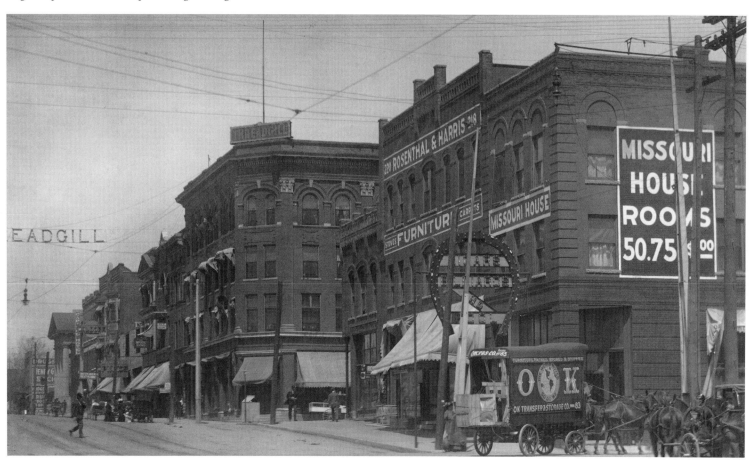

Thousands crowd into the grandstand at the fairgrounds (ca. 1905).

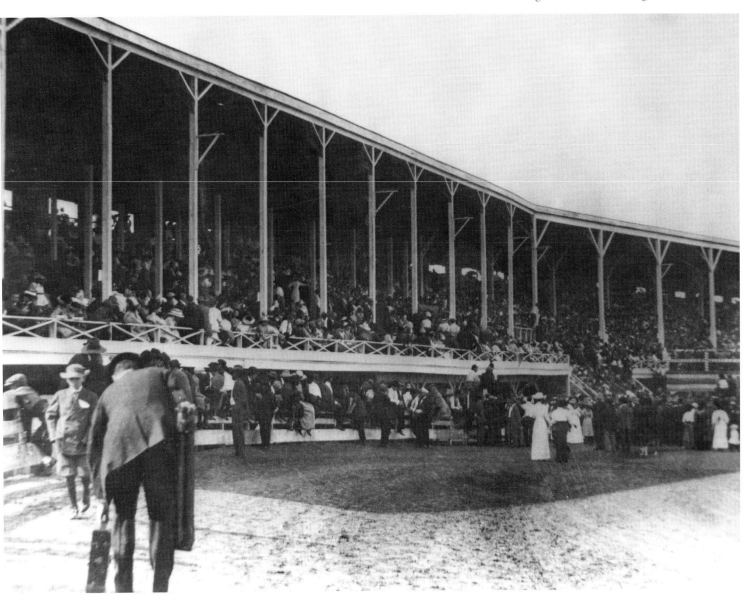

Shown here on California Avenue in May 1906, teams prepare to deliver produce from J. C. Gilmore's Home Fruit Company to customers around the city.

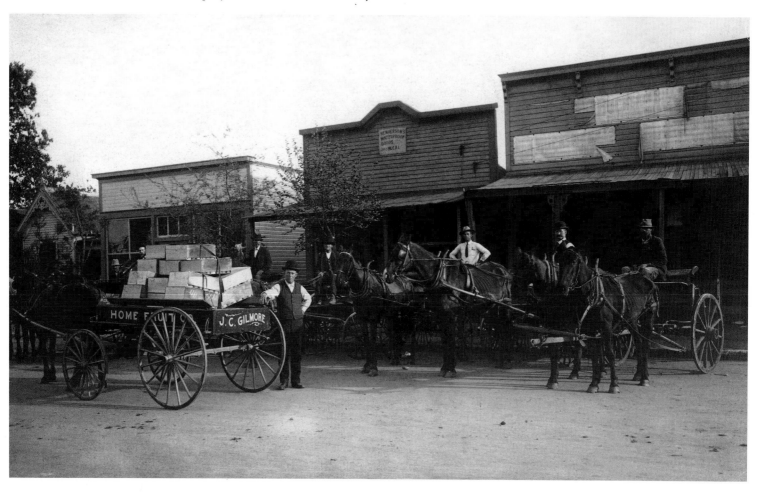

The Jenkins Music Store is under construction at 223 West Main (ca. 1906). J. W. Jenkins opened a branch of his Kansas City store here just in time for the Christmas shopping season of 1906, selling everything musical from sheet music to pianos.

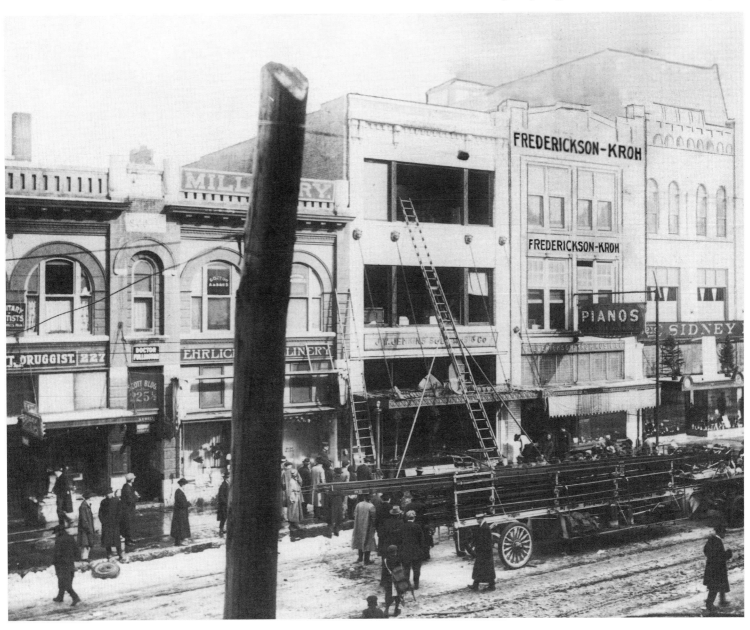

The *Daily Pointer,* at 216 West Grand, was a free newspaper that began publishing around the time of statehood. Its popularity and sensational stories became a nuisance to the *Daily Oklahoman* for a few years before the *Pointer* folded in 1911.

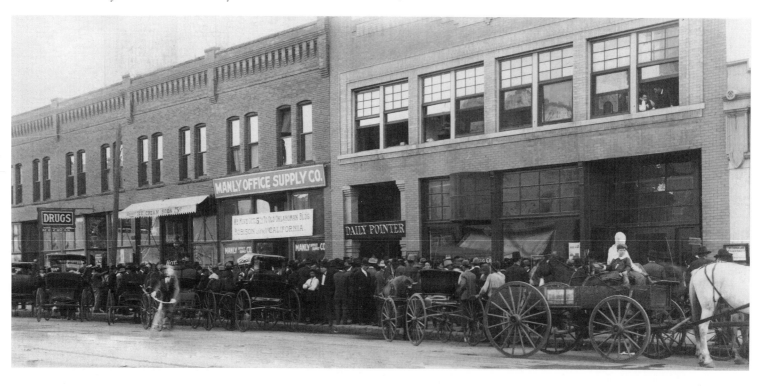

Aftermath of the Lee-Huckins Hotel fire, August 16, 1908. The fire was so intense people in El Reno thought all of Oklahoma City was ablaze. The five-story building at 22 North Broadway was destroyed in two hours.

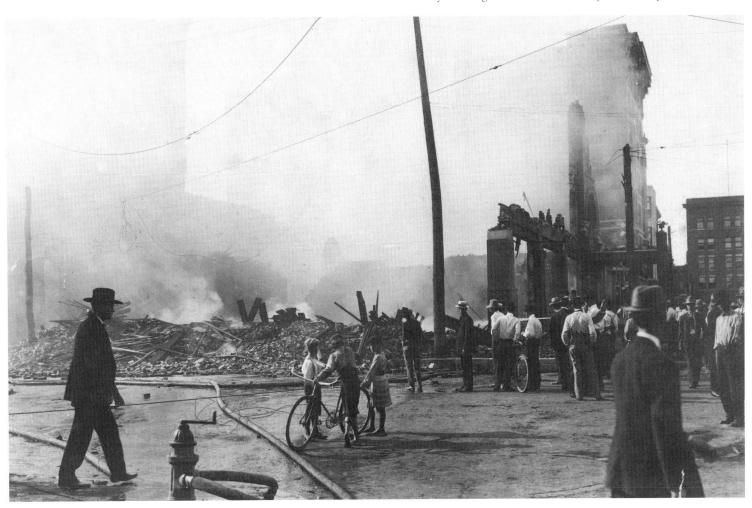

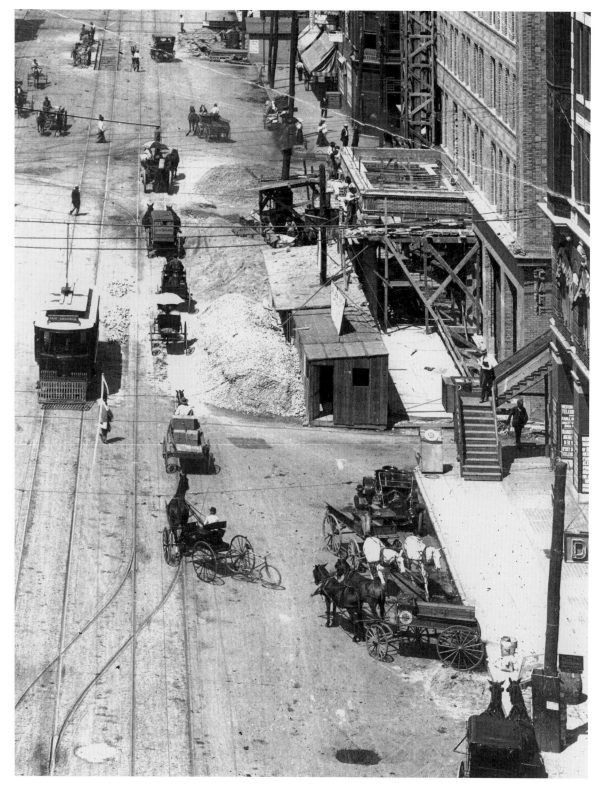

The new Huckins Hotel under construction, 1909. Rebuilt after the devastating fire in 1908, the Huckins, at 22 North Broadway, would become one of the most luxurious in the city.

The view east on Main from Robinson, ca. 1909. This image reveals a city preparing to embrace the modern as the new ten-story Huckins Hotel dominates its neighbors, and carriages begin to share the streets with automobiles.

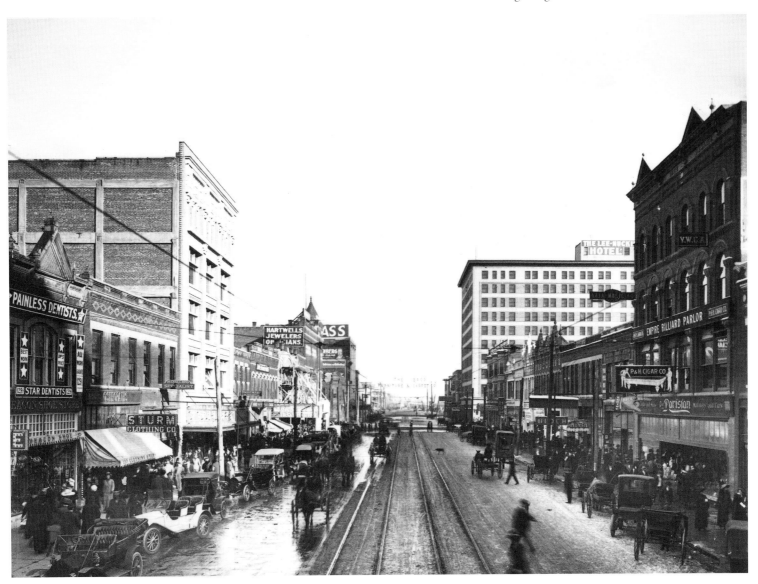

Anton Classen (second from right) is pictured here with the staff of the
Classen Company at 120 West Grand (ca. 1909). It was from this office
that Classen benevolently ruled a real estate empire.

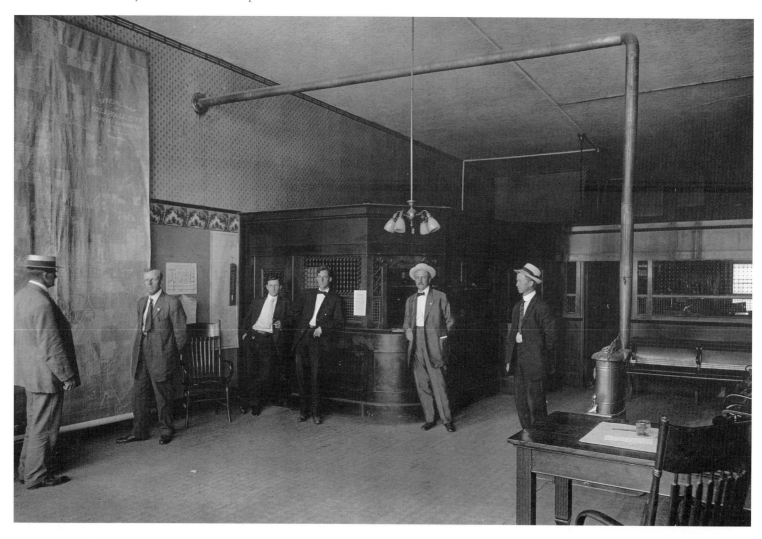

Cars from the Oklahoma Motor Car Co., 515 West Main, prepare for the Labor Day parade, September 6, 1909.

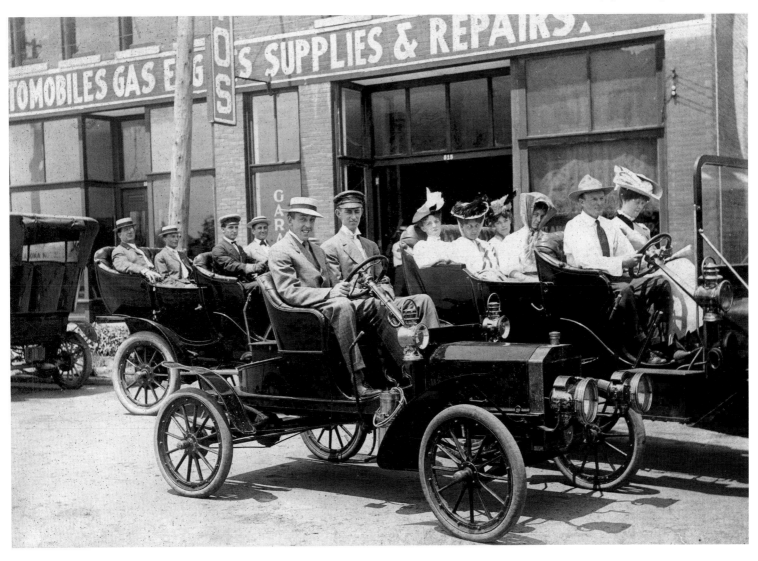

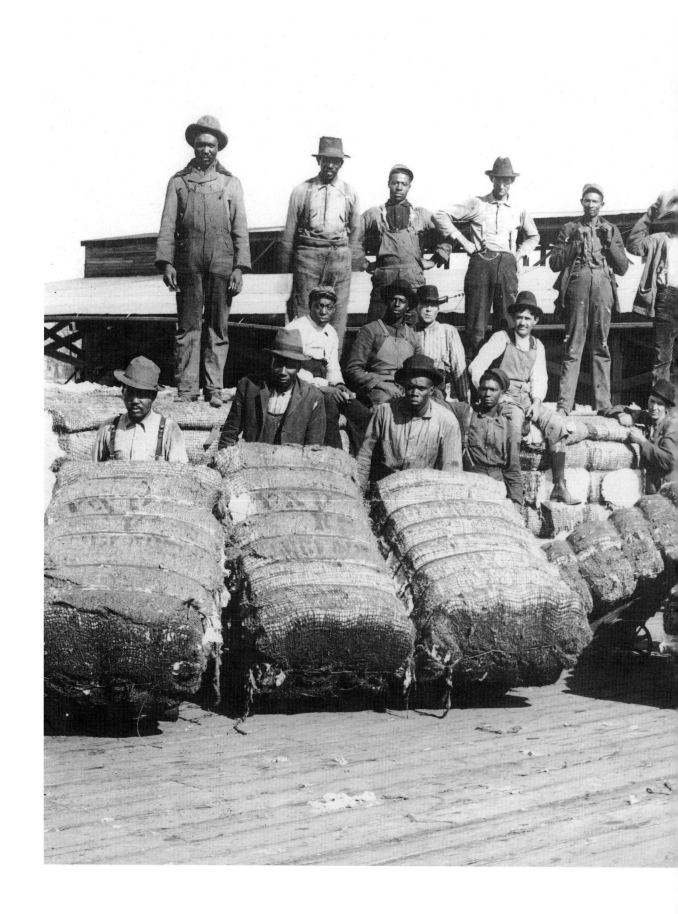

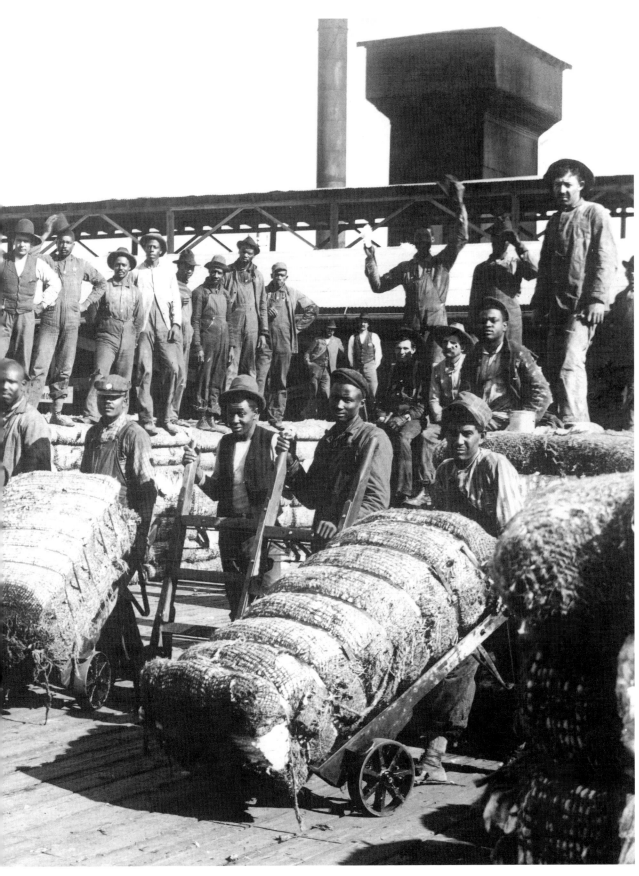

Cotton was an important crop in the first decades of the city's history. Here workers pause from their backbreaking labor at the Oklahoma Cotton Compress on the city's southeast side (ca. 1910s).

Smith & Meyer Real Estate and J. I. Gray Roofing & Manufacturing
Company shared this double storefront at 10 South Robinson ca. 1910.

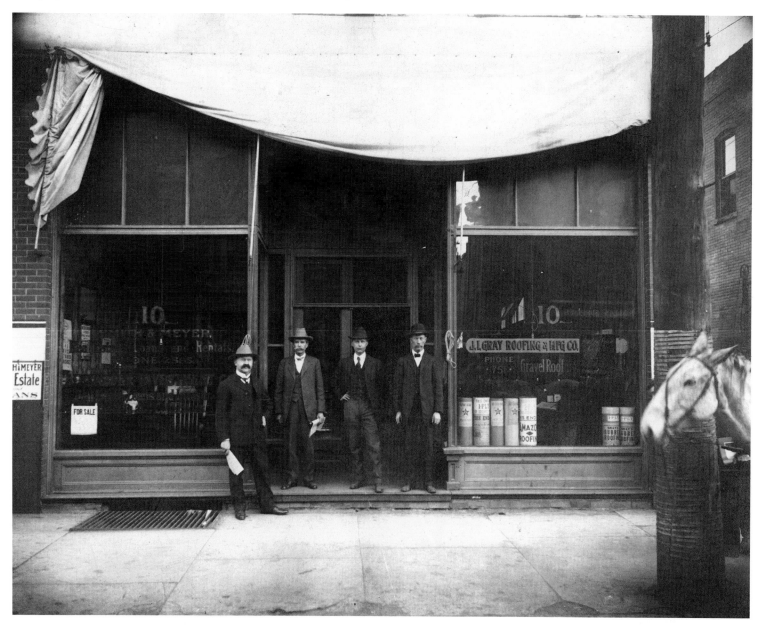

This Craftsman-style house was typical of those built on the northeast side of the city after statehood.

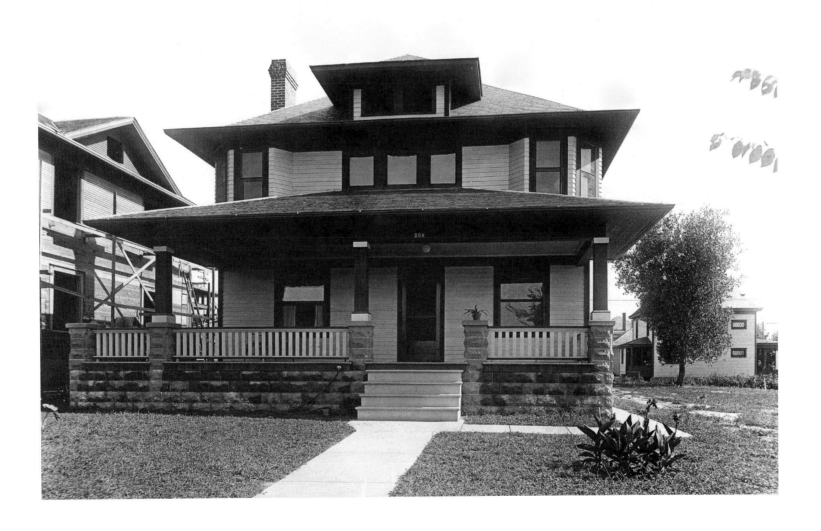

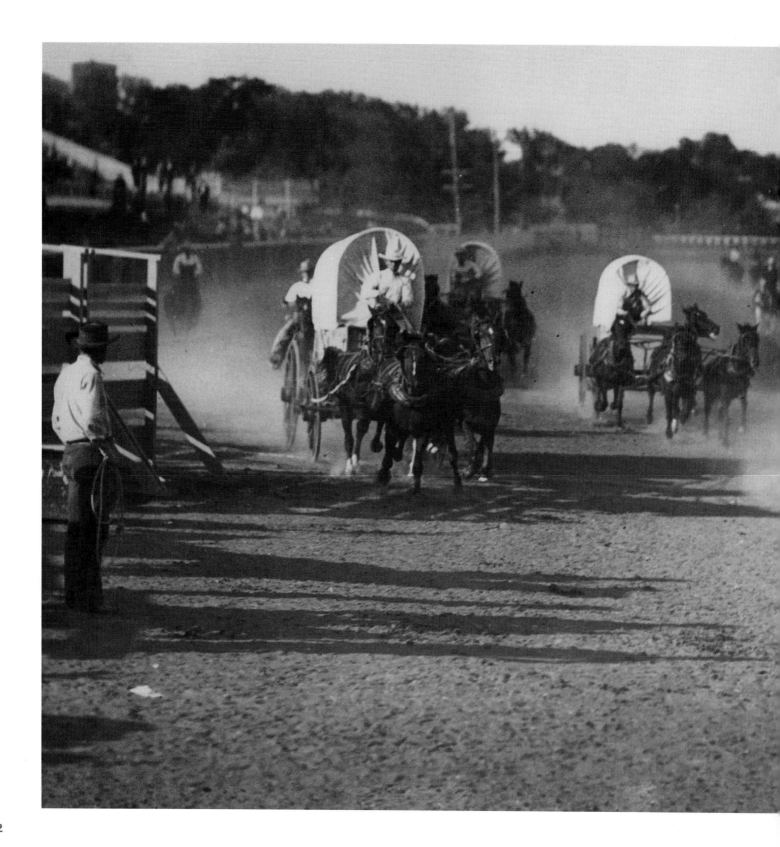

Horse racing was an immensely popular pastime in Oklahoma City from the beginning. Here is an entertaining chuck wagon race at the first state fair in 1907.

This pay-as-you-enter streetcar may be delivering riders to a Mets baseball game at Colcord Park. Street railway workers were upset with the arrival of these new cars in 1910, which eliminated the need for conductors.

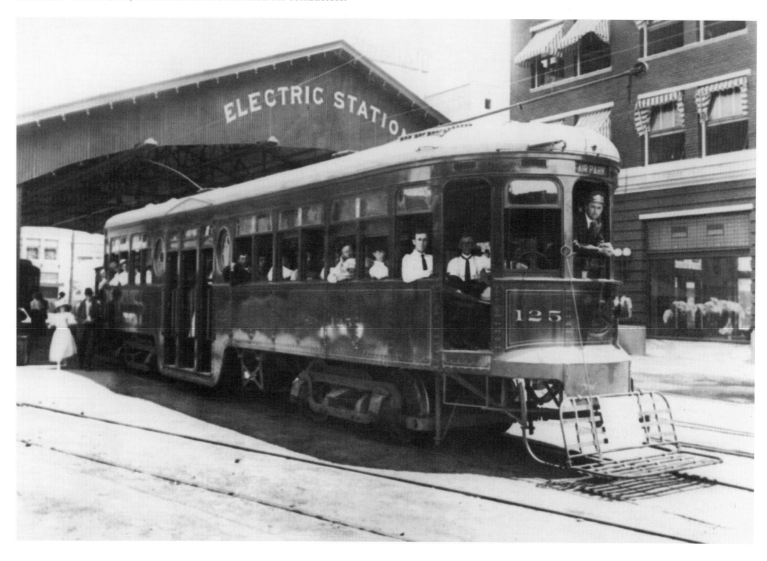

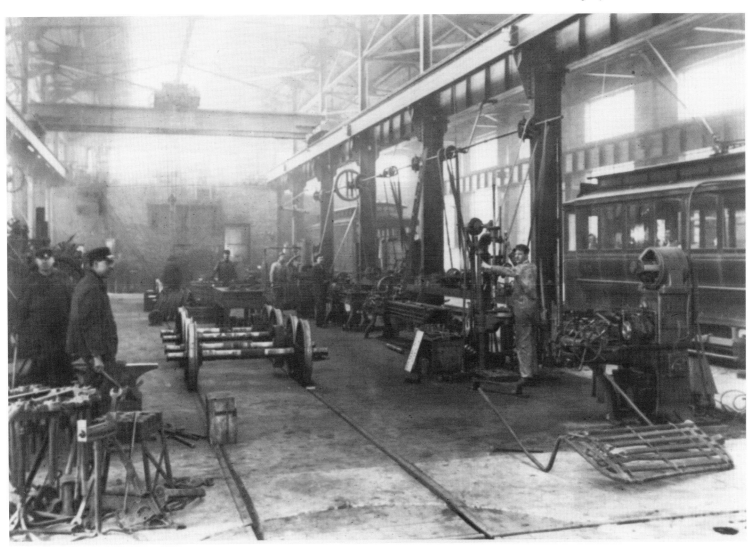

Scene inside the shops of the Oklahoma Railway Company (ca. 1911). The shops, at Third and North Olie, provided maintenance for all of the company's streetcars and interurbans.

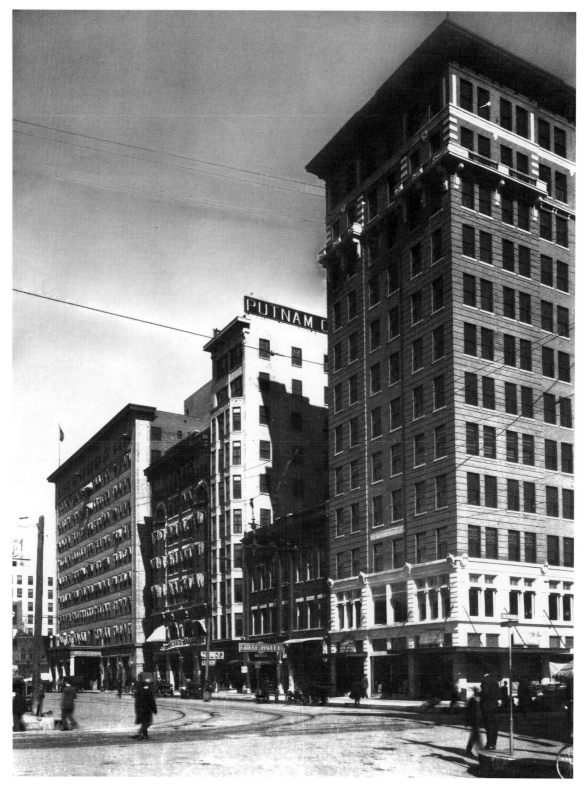

The Broadway building boom is on as (left to right) the Huckins Hotel, Huckins Annex, Oil Exchange Building, and Herskowitz Building all rise between 1908 and 1910.

This peaceful scene was captured looking north on Broadway from atop the Culbertson Building at Grand Avenue (ca. 1907). The jogs (doglegs) in the streets along Grand Avenue gave rooftop photographers excellent, unobstructed vantages down the center of the main streets.

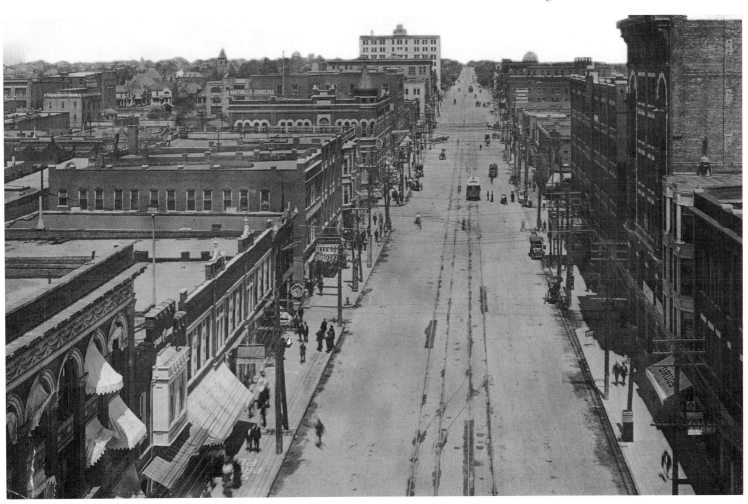

First Christian Church nears completion (ca. 1911). An estimated 3,000 people attended the dedication of this magnificent building at Tenth and North Robinson on December 3, 1911. The building continues to serve as a church today.

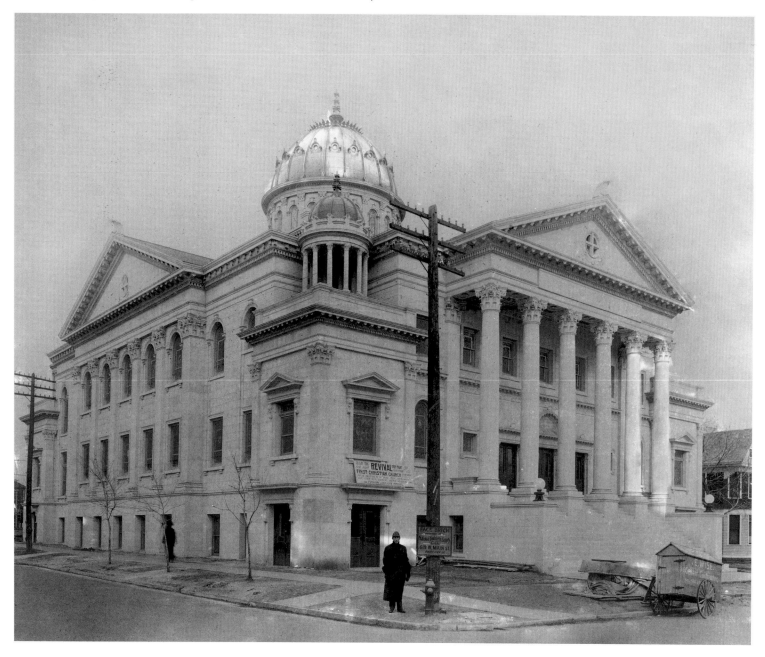

Designed by legendary city architect Solomon Layton, the Daily Oklahoman Building was completed in 1909. Edward K. Gaylord ran his publishing empire from this stately building at 500 North Broadway, where it still stands as elegant today.

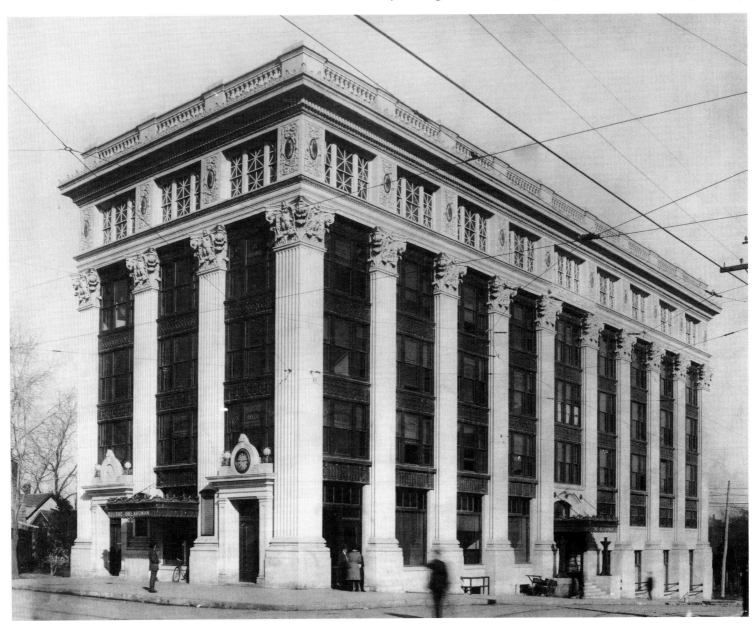

An Oklahoma City Fire Department parade float moves along the 200 block
of West Main Street (ca. 1910).

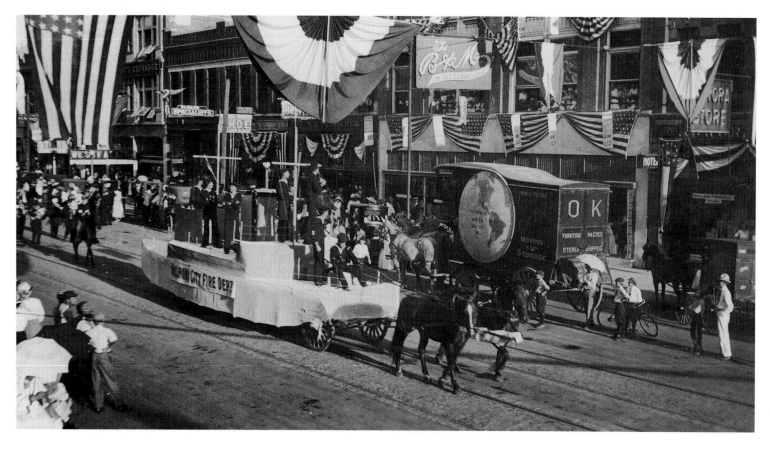

Delmar Garden was a popular entertainment venue for early city residents. Located some distance from the city center, most funseekers traveled there via streetcar. Here trolleys load and unload passengers at the entrance to the park (ca. 1906).

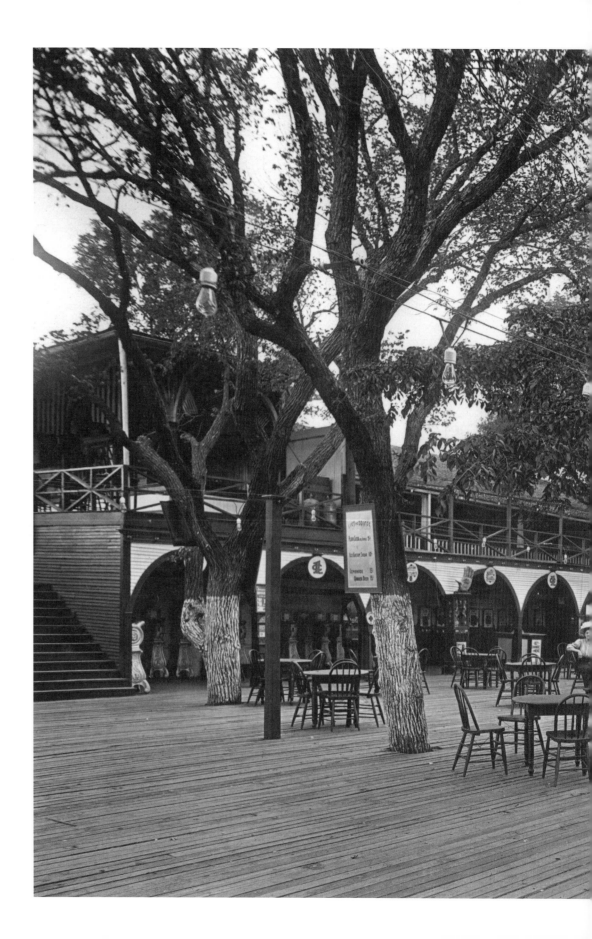

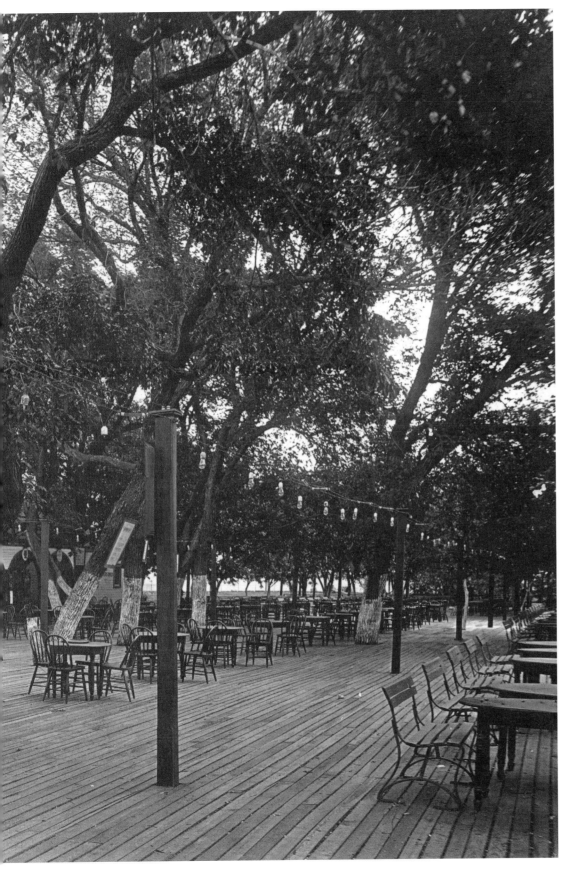

The beauty of Delmar Garden is evident in this view of the boardwalk. Owner John Sinopoulo made good use of the copse of cottonwoods at the site along the North Canadian River to add shade and natural beauty to his park.

Statewide prohibition was a contentious issue in September 1907, and both parties tried to avoid taking a position on the topic. It was assumed that whoever got saddled with the drys would alienate what today is known as the swing vote and lose the election. The Republicans shrewdly hung this banner from the Democratic Party headquarters in the Hotel Lee, 20 North Broadway, in an attempt to associate the Democrats with the prohibitionist cause.

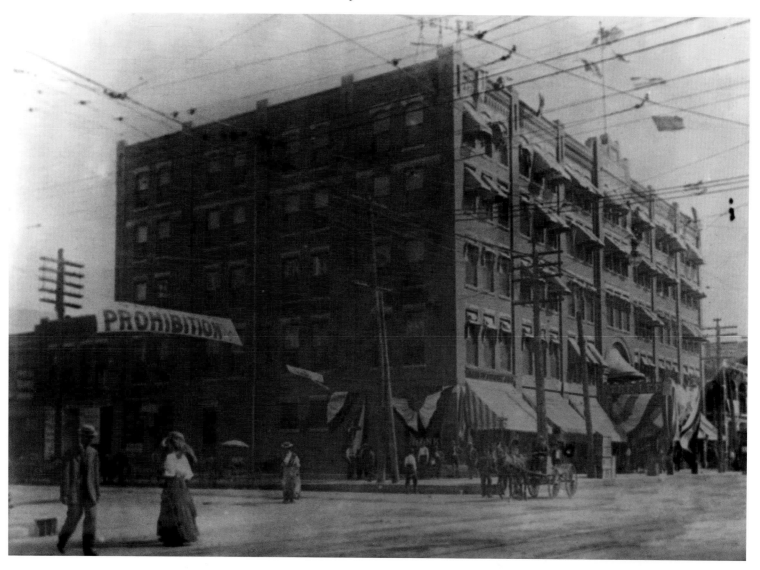

Noted state architect William Wells designed the Oklahoma County Court House at 20 North Dewey in the Romanesque style. It was begun in 1904, but the city was growing so fast that by the time it was completed in 1906, the space was already inadequate.

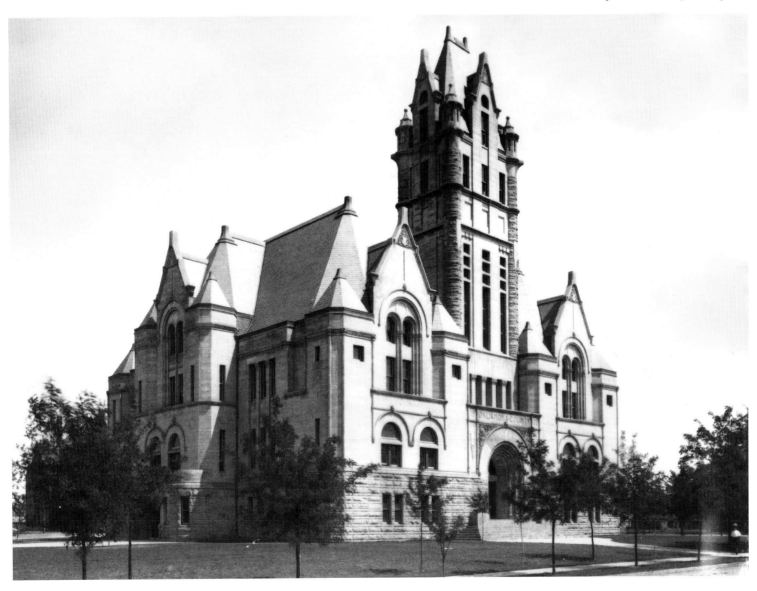

Because the front entrance of the County Court House (shown here ca. 1906) faced away from downtown on Dewey Street, the side and rear entrances were used more often. The county occupied the building until 1938.

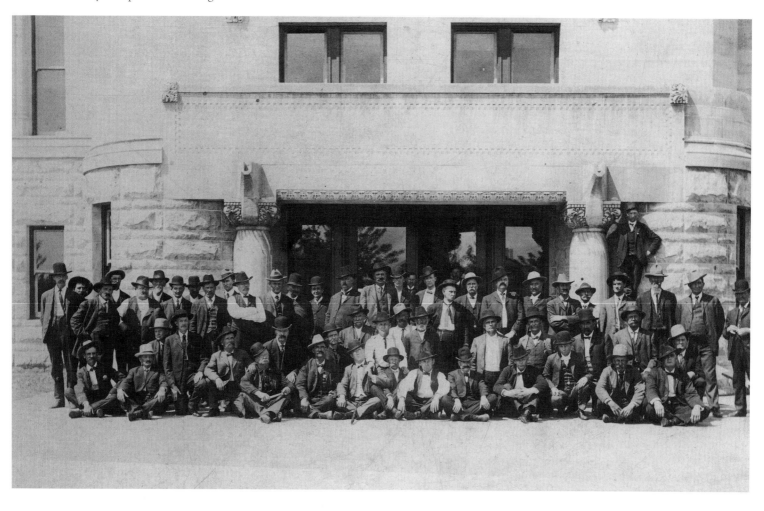

The handsome entrance to the State Fair Grounds was constructed in 1907 at the terminus of East Eighth Street. A circular drive allowed both automobiles and streetcars to drop off and pick up fairgoers.

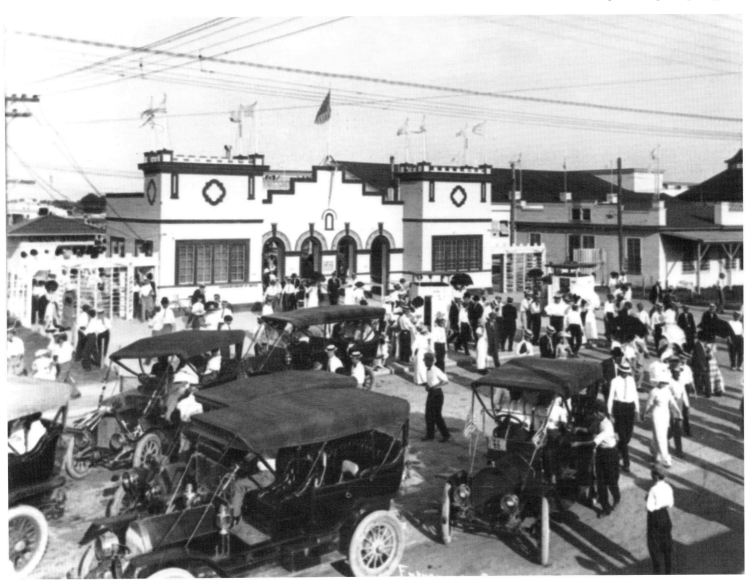

Myron E. Friss operated the Reno Wood Yard on the northeast corner of Reno and Harvey in 1906. As evidence of the quality of his product, he claimed to be the yard of choice for visiting circuses. The Reno Wood Yard sold coal and feed as well as lumber.

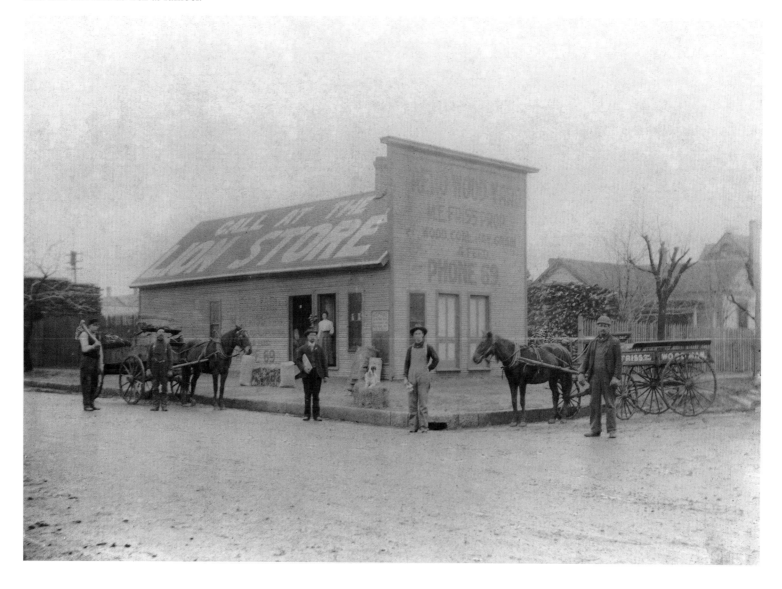

Before 1910 at least three streetcar lines competed to carry traffic between Oklahoma City and its nearest neighbor, Capitol Hill. The year 1911 brought the annexation of Capitol Hill and integration of the Capitol Hill Line into the Oklahoma Street Railway Co.'s service.

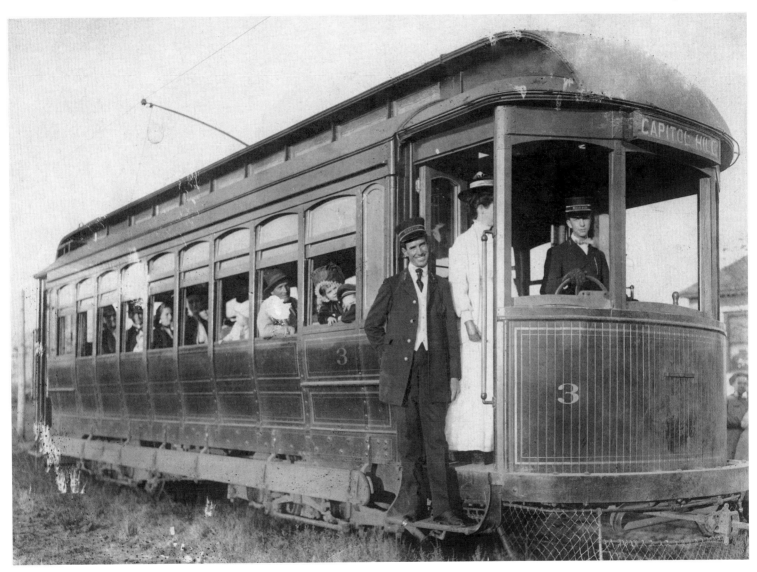

The National Firemen's Association convention was held in the city in September 1907 and featured a parade and exhibit of firemen's equipment. The coming of prohibition, just weeks away, would damage Oklahoma City's prestige as a convention destination.

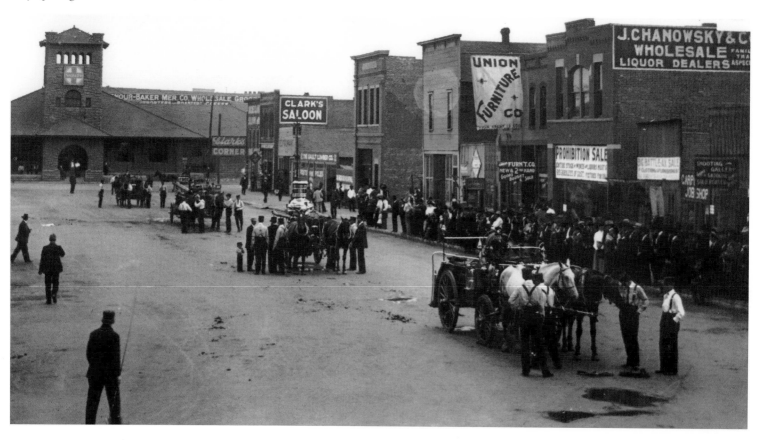

Belle Isle Park was a very popular entertainment venue after 1908, witnessed to by the smiles on these swimmers' faces (ca. 1910). The park provided lots of water activities as well as dancing and music in the pavilion (seen in the background on the left).

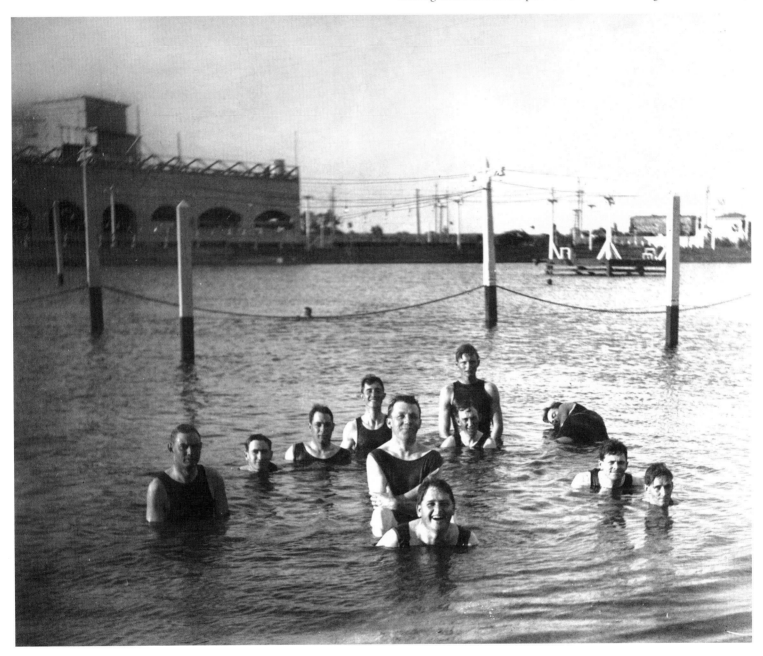

Canoeing was one of the many activities offered at Belle Isle Park. Besides cooling the power plant, the lake provided many inlets and small islands to explore.

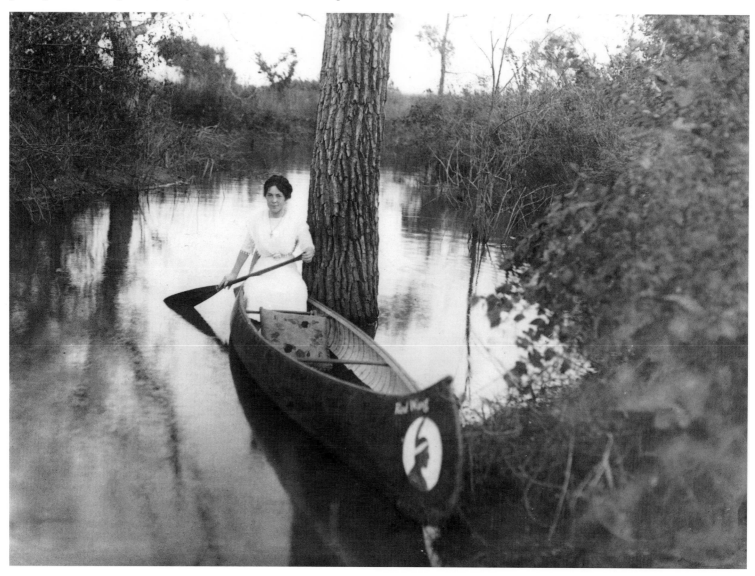

These workmen are laying streetcar tracks near Olie and West Sixth. Because of the recessed grade and the many curves, laying streetcar tracks was often painstaking work.

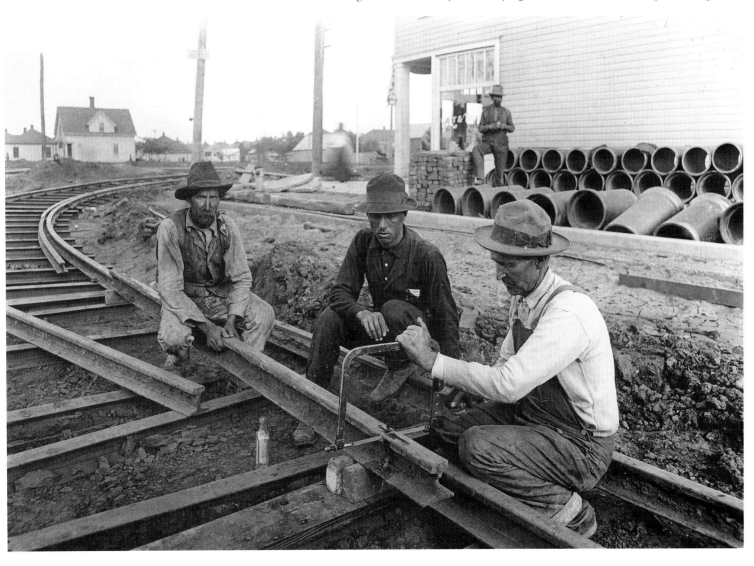

An automobile passes the State National Bank, which was built at the northwest corner of Main and Robinson in 1910. The twelve-story office tower would later be purchased by W. T. Hales and renamed the Hales Building, standing until 1979.

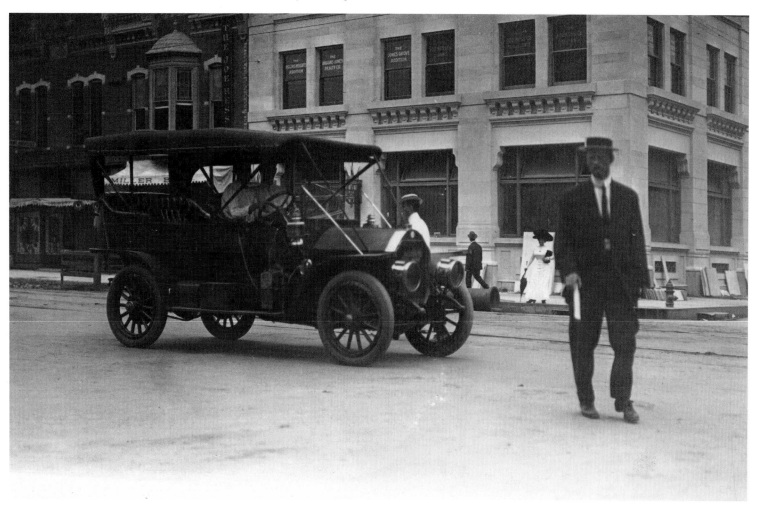

St. Luke's Methodist Church, at 201 Northwest Eighth, was one of the more elaborate edifices along Church Row. Despite its imposing look, it was built in 1908 for a congregation of just 500.

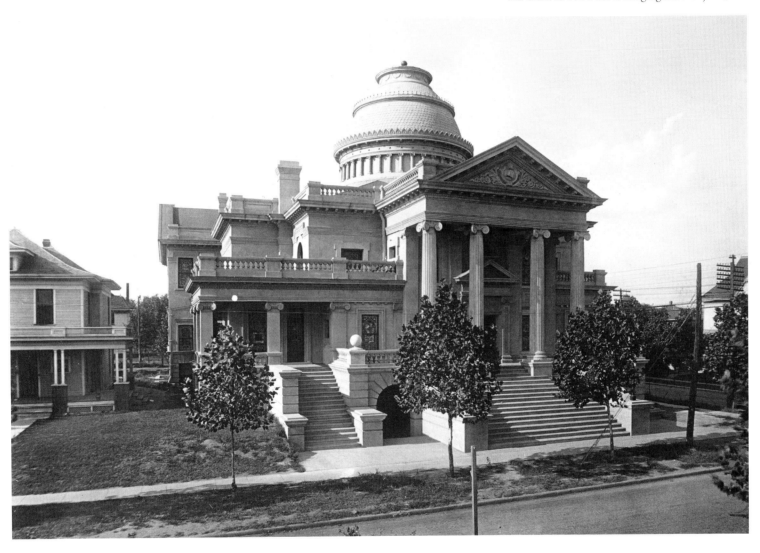

Oklahoma City's love affair with aviation began on March 18, 1910, when "bird-man" Charles Willard flew his Curtiss biplane off a hillside south of Capitol Hill. Seen here is the result of his second attempt the next day, into a stiff Oklahoma wind.

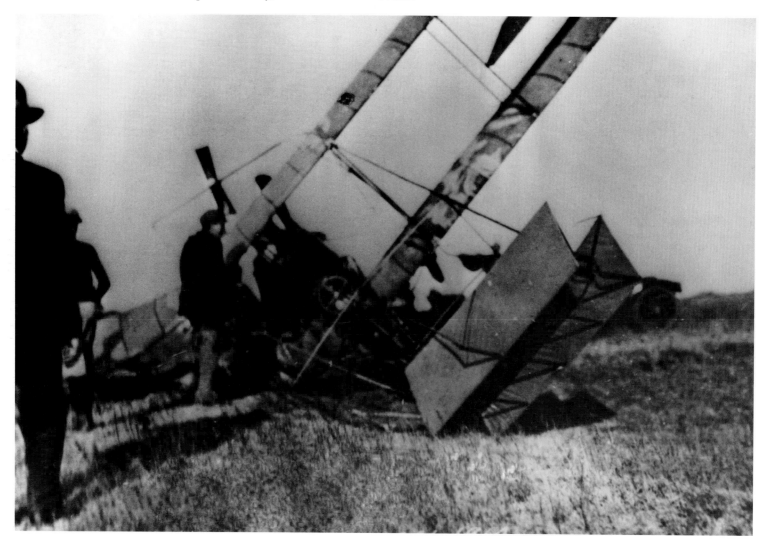

The Livestock Exchange Building was built in 1910 just inside the gateway to the Oklahoma National Stockyards. The Exchange was the vital link between ranchers and the giant meatpacking plants just to the south.

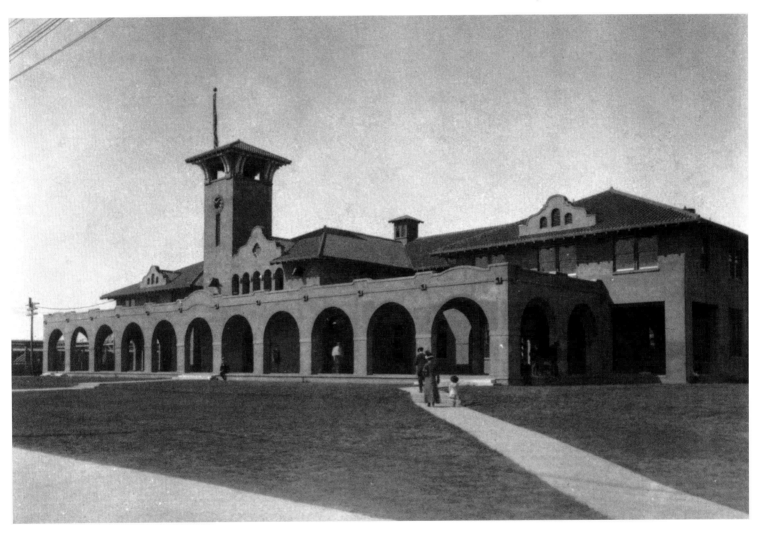

Service to Yukon on the Oklahoma Railway's interurban line began in the summer of 1910. Shown here in 1912 is one of the comfortable observation cars at the terminal. The cars left on the hour, featured a smoking lounge in the rear, and charged a fare of 30 cents each way.

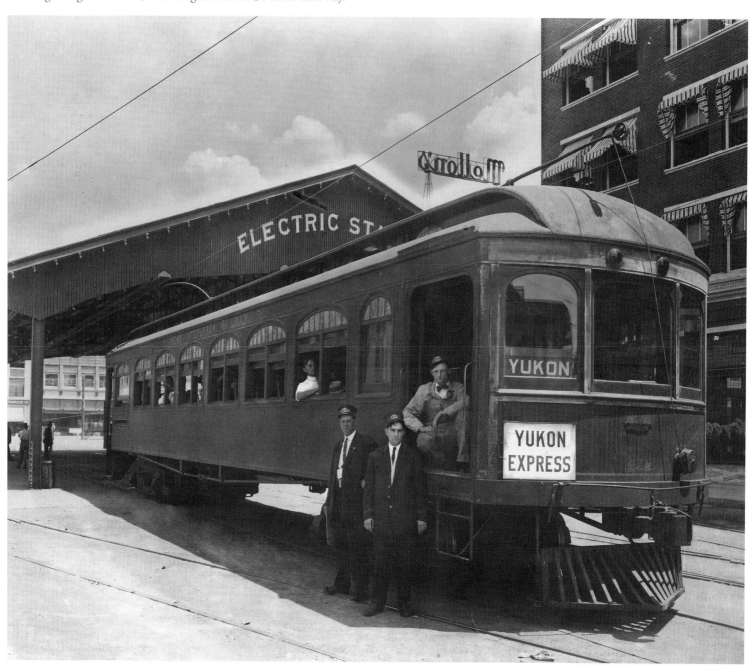

The Oklahoma City Golf and Country Club employed architect William A. Wells to design this new clubhouse on the club's land near Western and 39th. Years later, they swapped this site for their current home in Nichols Hills, and this site became Crown Heights.

Following Spread: Governor Charles N. Haskell, seated at the table, poses with his staff at his new temporary office in the Huckins Hotel in 1910.

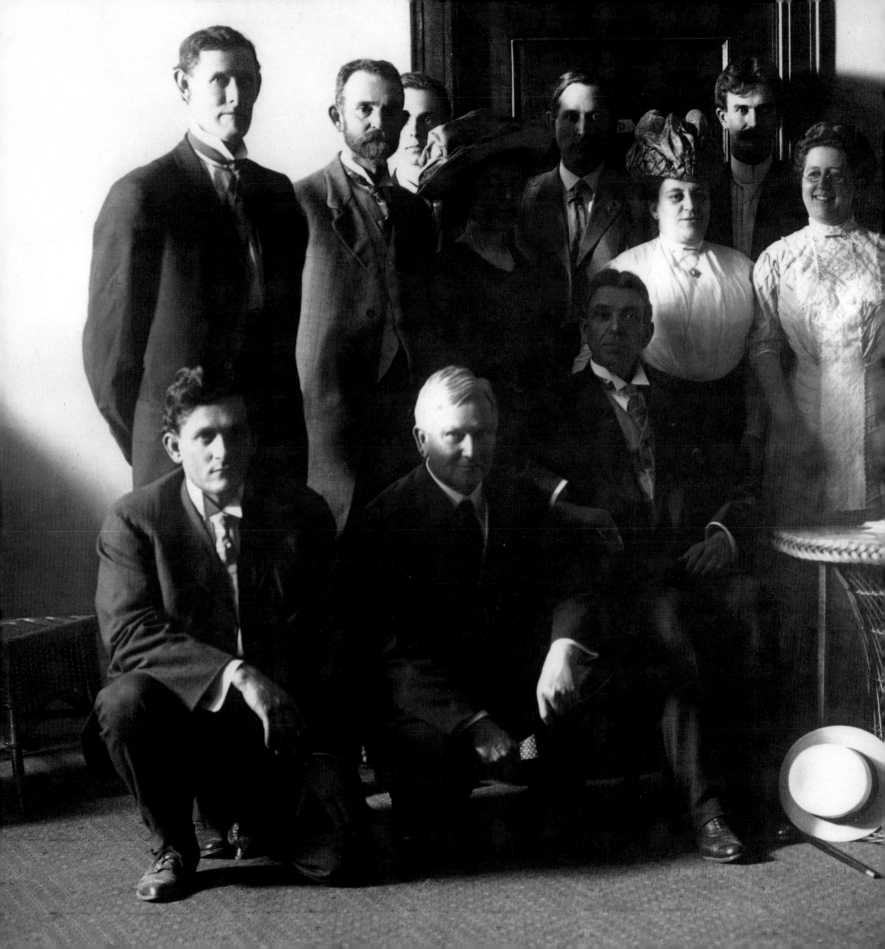

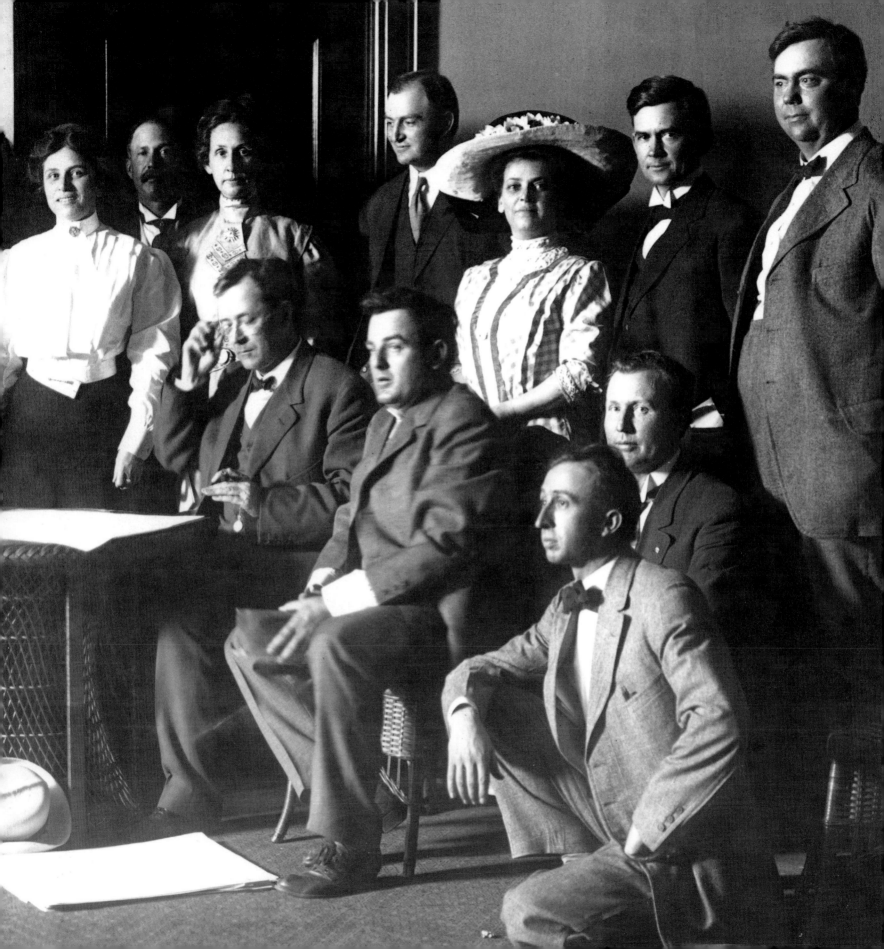

The twelve-story State National Bank (background, left) rises above all
others in this 1912 view east on the busy 300 block of Main Street.

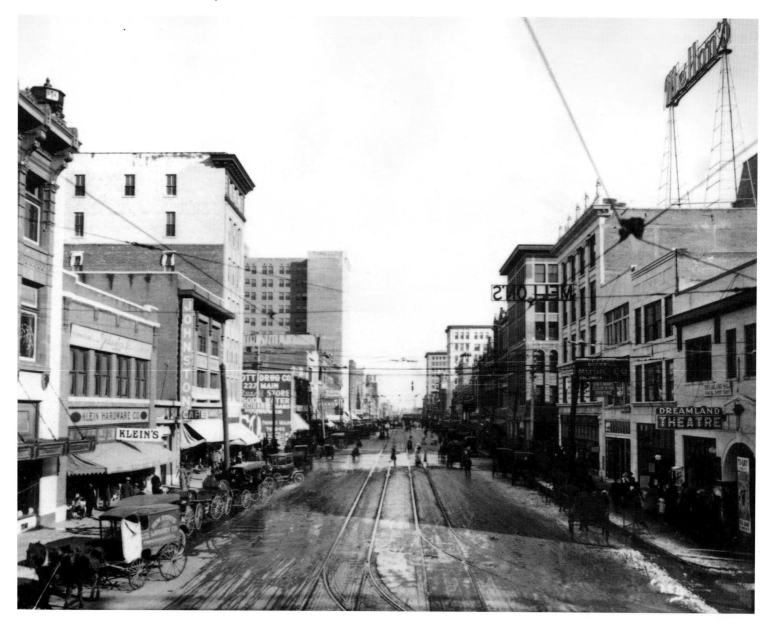

The Dreamland Theatre opened at 308 West Main on September 2, 1912. The Dreamland was a top venue for vaudeville and musical comedy shows until 1920, when it was sold and renamed the Capitol Theatre.

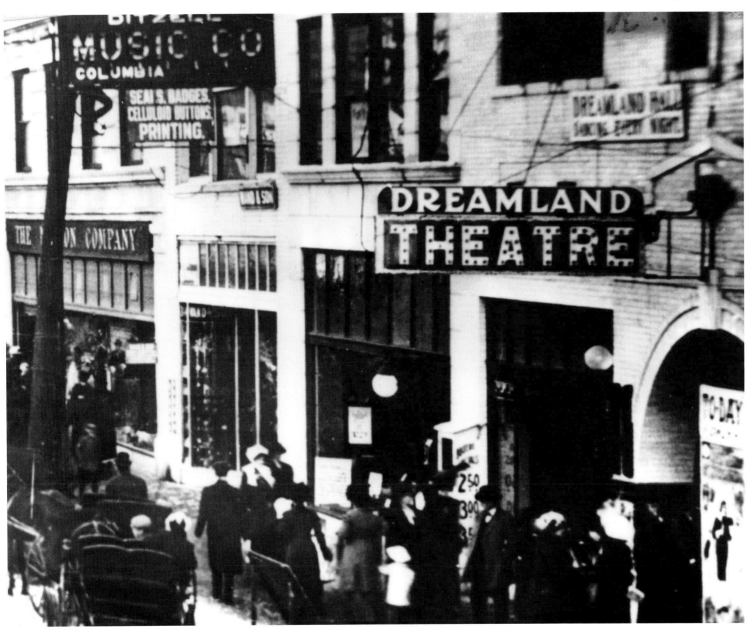

Maywood Pharmacy, at 120 East Sixth, was built on one of the triangles created by the Harrison Avenue diagonal, which led to Maywood, one of the city's earliest additions.

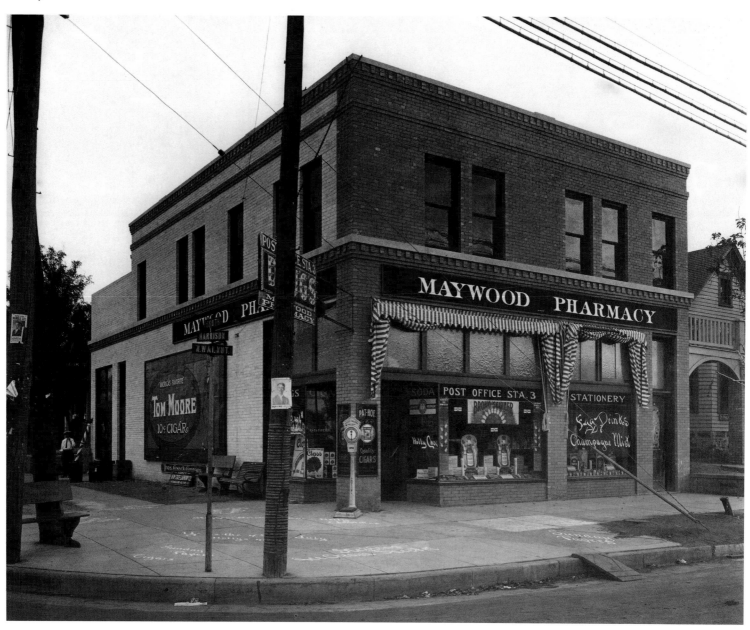

"Doc" Monroney and Bill Schweinle opened their furniture store at 8-10 West Grand in 1895 and offered moderately priced furniture there until 1954. Doc's son, Mike, became one of the most powerful senators in state history.

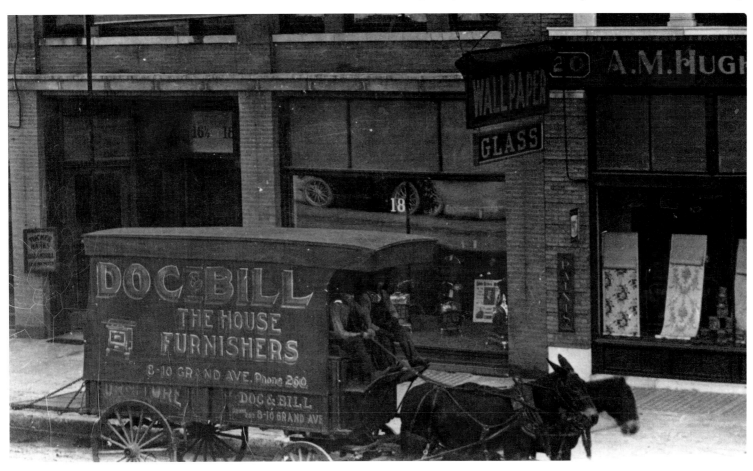

In July 1913, eighty-eight city firemen staged a walkout to protest low wages, poor equipment, and the removal of their chief, Mark Kesler.

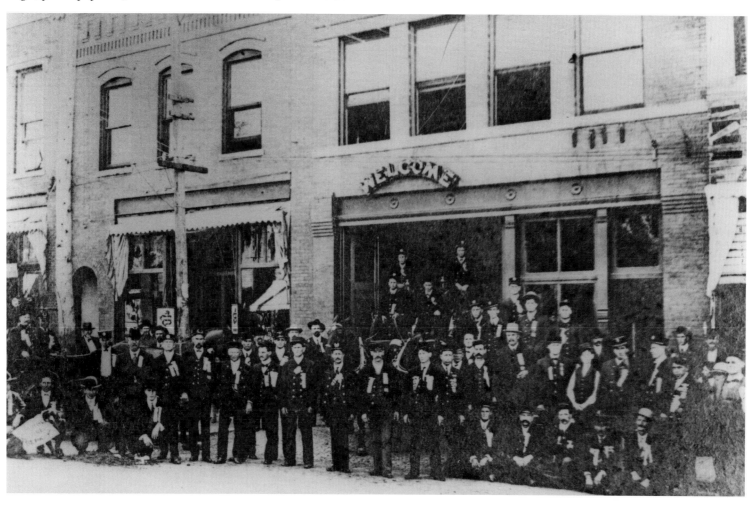

This bungalow in Mesta Park is typical of houses built throughout the northwest side as the city began to expand in the prosperous years after statehood.

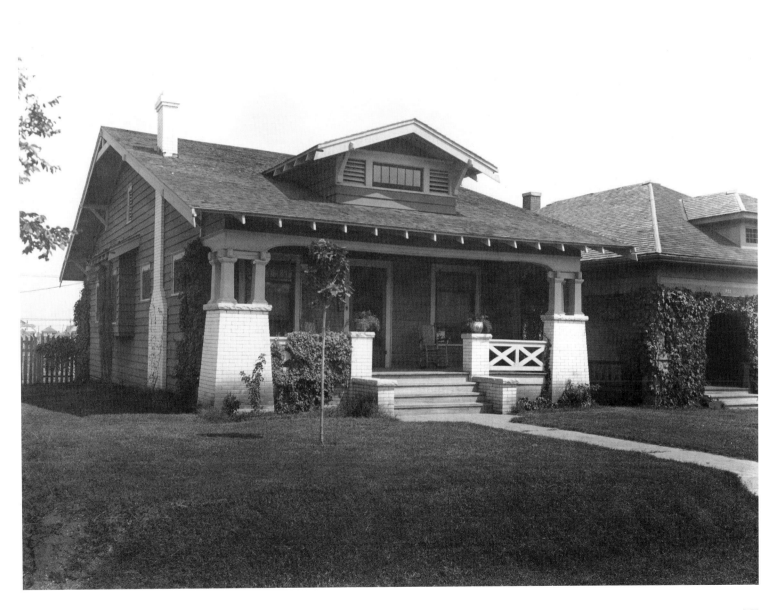

This is the view of the Morris & Company meatpacking plant, facing southeast from the cattle pens of the Oklahoma National Stockyards (ca. 1910s).

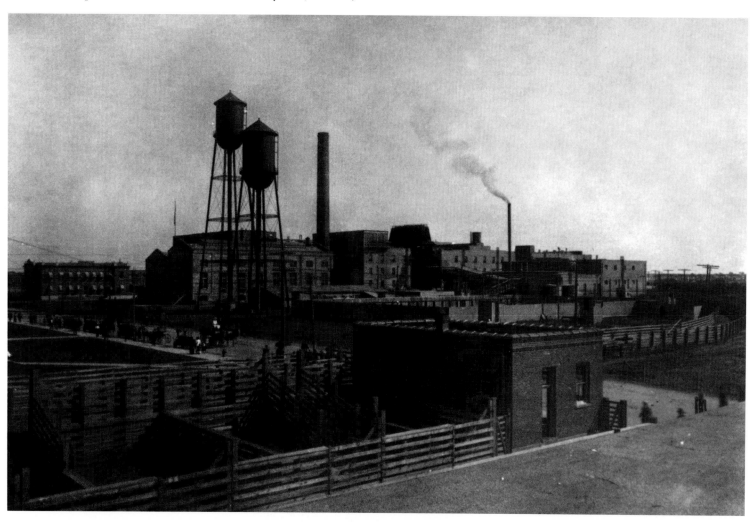

Teamsters for the Oklahoma Railway Company pose with their rigs in the 1910s. Freight provided an important revenue stream for the company, and perishable goods were frequent "passengers" on interurban cars.

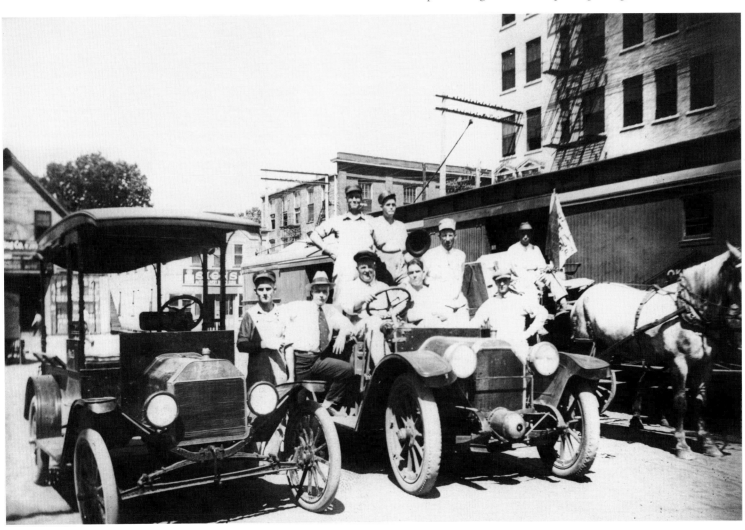

This recital hall was located on the third floor of the Fredrickson-Kroh music store at
221 West Main. Its decor was created by a French designer and featured the names of
composers along its walls. The room was gutted by fire in 1917.

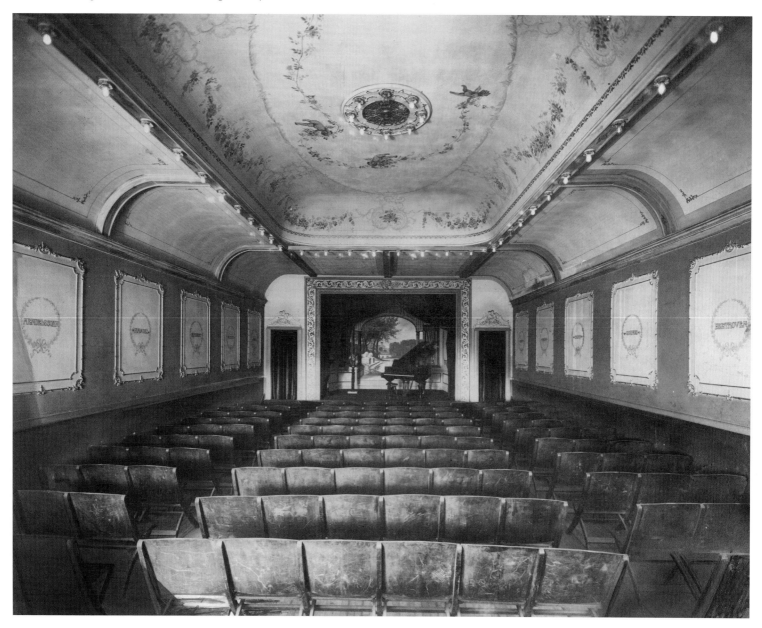

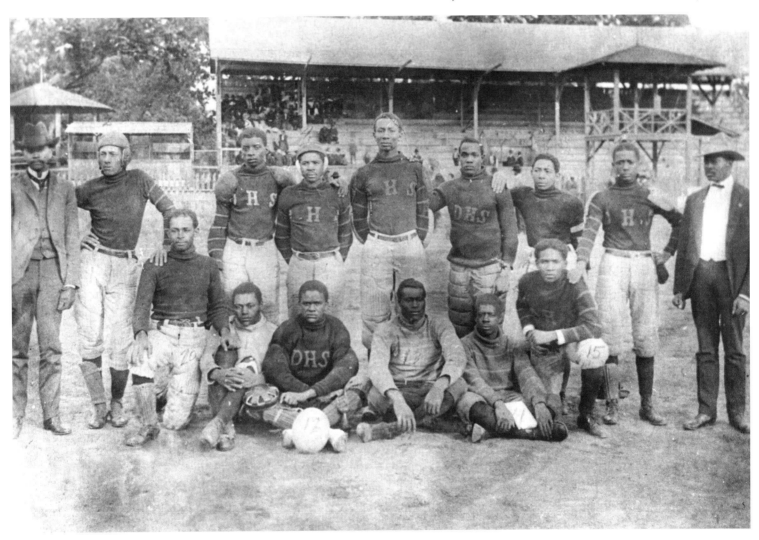

One of the earliest Douglass High School football teams poses for a group portrait (ca. 1910s). The Douglass "Red Machine," as it was known for a while, was a powerful team for several decades. Playing before thousands, they defeated teams as far afield as St. Louis and Gary, Indiana.

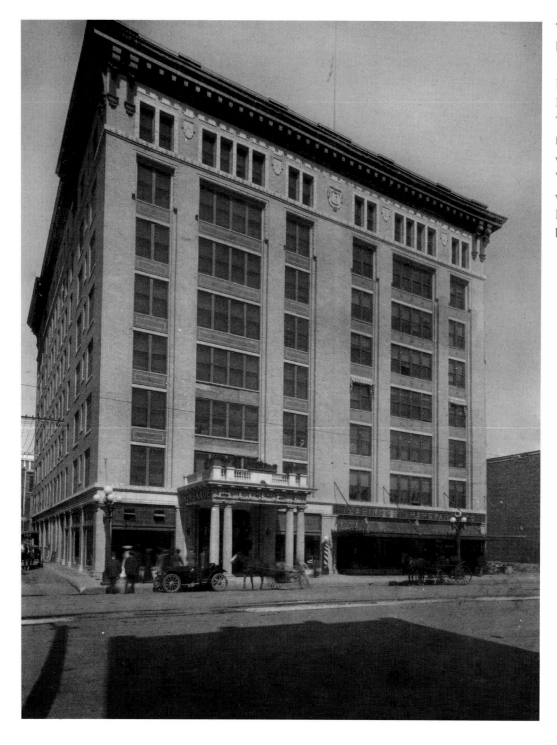

There are actually two buildings pictured here at 15-19 West Grand, the Kingkade (left) and the Lawrence Building (right). The Lawrence first had 5 floors, then the Kingkade was built with 8 in 1911. When this photograph was made, ca. 1915, the Lawrence Building had been expanded to 8 floors.

Charles Colcord came to Oklahoma City on the first day and became very wealthy through various successful endeavors. He built this home in 1903 as a replica of the one he left in Kentucky, at 421 West Thirteenth, seen here ca. 1915.

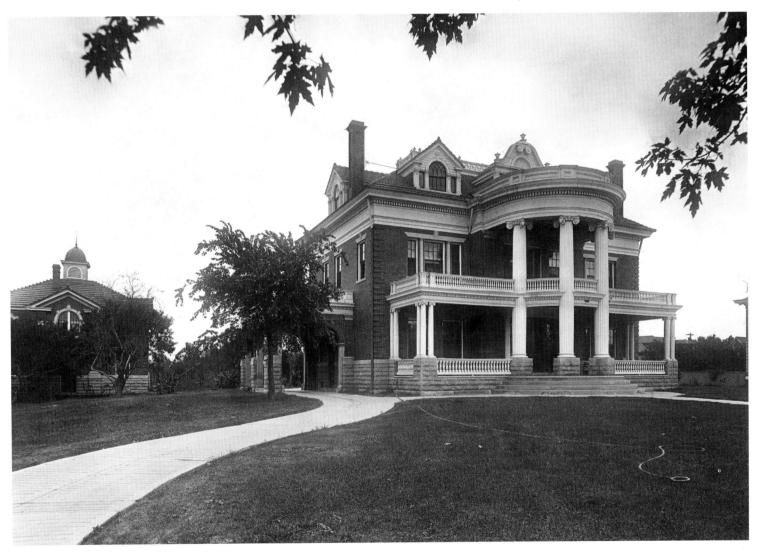

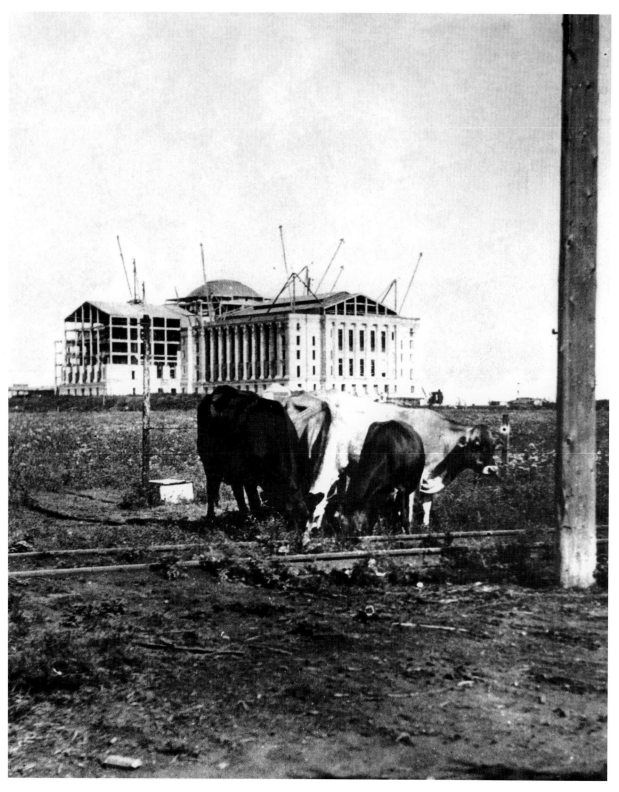

This photo of the state capitol under construction was taken by four-year-old Harry Schwartz in 1916. The cows are grazing along the streetcar tracks of William Harn's Yellow Mule Line. Named for the color of its only car, the line served northeastern parts of the city.

The congregation of the Second United Presbyterian Church gathers in their Sunday best in front of the church at 734 Northwest 25th in 1916.

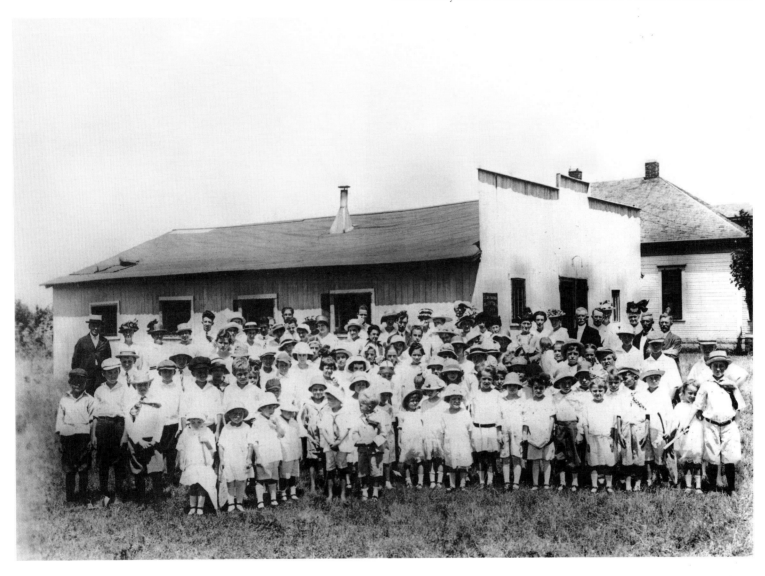

The Fall Flower Show was held on September 22, 1916, and featured a parade of cars and floats adorned with vibrant flower petals. The Rotary Club's float won third place and a prize of $15.

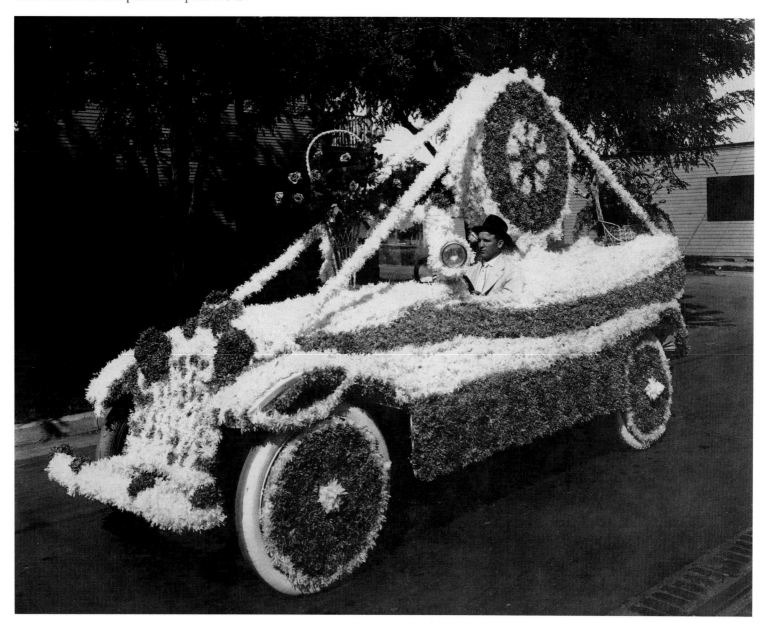

Five-year-old Hymie Miller hawks newspapers downtown. In 1917, the National Child Labor Committee investigated the conditions of child workers in Oklahoma. Noted photographer Lewis W. Hine documented the committee's work.

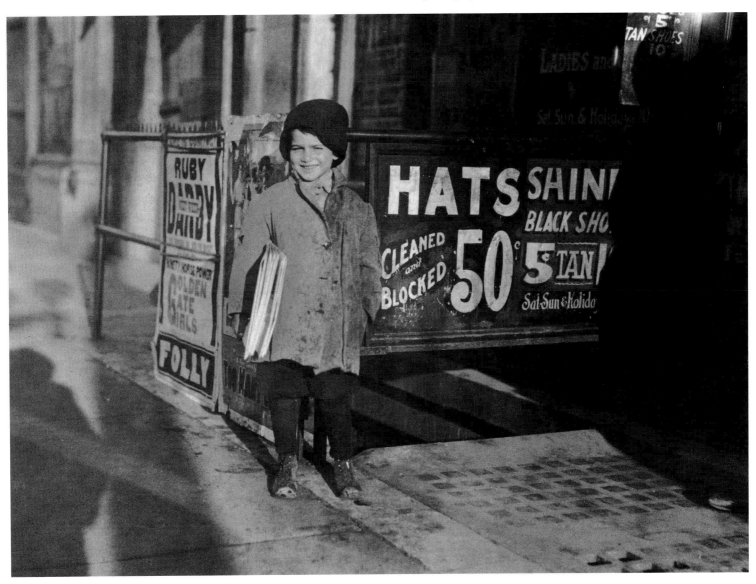

Newsie Ernest Chester was five years old when this photograph was made in 1917. The plight of newsies was brought to public awareness across the nation through the work of photographer Lewis Hine and others.

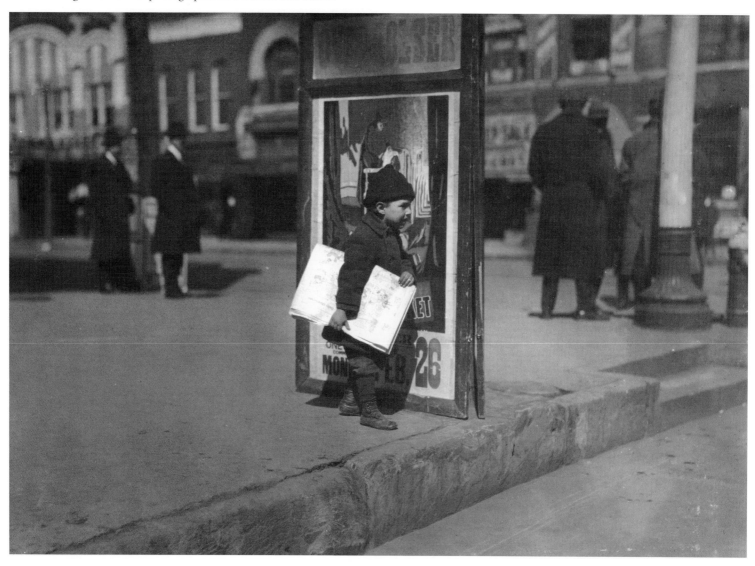

Charlie Scott was nine years old when photographed outside Kerr's Department Store in 1917. He admitted being truant, stating, "I dunno where the school is."

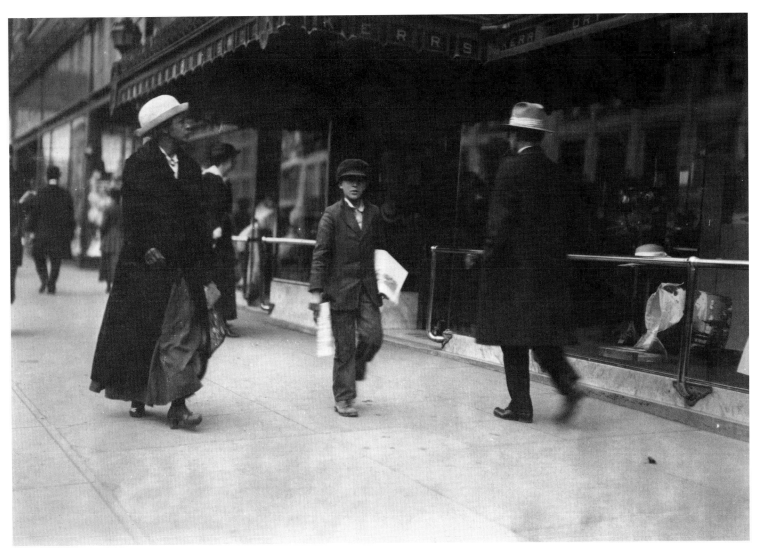

A young boy escorts a blind man across California Avenue along Robinson in 1917. The notorious jog in Robinson is noticeable by the position of the Baum building, between the subjects' heads, in the distance at Grand Avenue. The Baum appears to rise in the middle of the street.

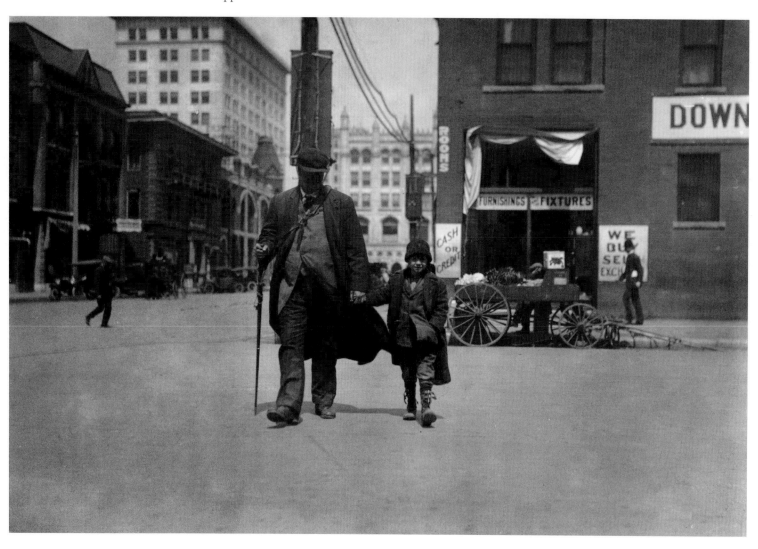

CAPITAL CITY OF THE GREAT SOUTHWEST

(1918–1929)

Following construction of the State Capitol in 1917 and other large civic projects, economic activity in Oklahoma City began to level out. The 1920 census revealed that there were 91,000 people, and for the first time Oklahoma City had not grown by triple-digit percentages between census years. But another boom was at hand.

The city seemed to catch its breath during this period as many affordable houses were built and more leisure opportunities became available. Lake Overholser and Northeast Park (new home of the zoo) offered outdoor activities, and luxurious new theaters began to show movies.

Throughout the 1920s oil fields were discovered all around Oklahoma, though oil had not been discovered in Oklahoma City. Because the city was at the geographic, economic, and political center of the state, however, the oil business began to gravitate in Oklahoma City's direction.

The office-tower building boom of the early 1920s paid big dividends when oil companies came to town looking for space. The immediate result was the building of even taller towers. The Perrine and Petroleum buildings, built in 1926 and 1927, were the first to truly scrape the sky by passing the 10-story and 12-story heights of their neighbors. This period also witnessed the maturing of the financial services industry in the city as bankers and insurers became adept at handling the special needs of oil producers.

By 1928, wildcatters began test drilling south of Oklahoma City, which was discovered to be at the center of the second largest pool of oil in the world. In December the first producing well came in on the south side of the city and the race was on. Over the next year, derricks began to march north toward the river and the city limits.

The discovery of oil could not have come at a better time for Oklahoma City. Things were so heady in those days that many people didn't seem to notice the stock market crash of 1929. The economic activity associated with the oil industry would help insulate the city from the effects of the depression—for a while.

When the Lakeside Country Club asked for boating privileges on the new city reservoir that would soon bear his name, Mayor Ed Overholser was horrified. City officials, however, soon relented, and boaters have enjoyed Lake Overholser since 1918.

Members of the Army Recruiting Service await the start of the first annual Armistice Day parade, November 11, 1919. All activity in the city stopped for one minute of silence at 11:00 A.M., to remember the fallen of World War I, which had ended one year earlier.

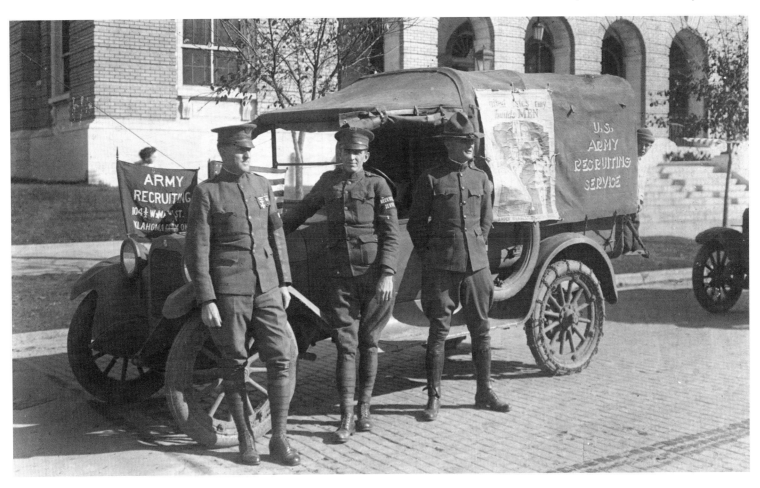

This view north on Broadway was taken about 1920 from the balcony of the Huckins Hotel. The Tradesmen's National Bank rises on the left, and the animated sign atop the Insurance Building on the right advertises its main tenant—the Oklahoma Gas and Electric Company.

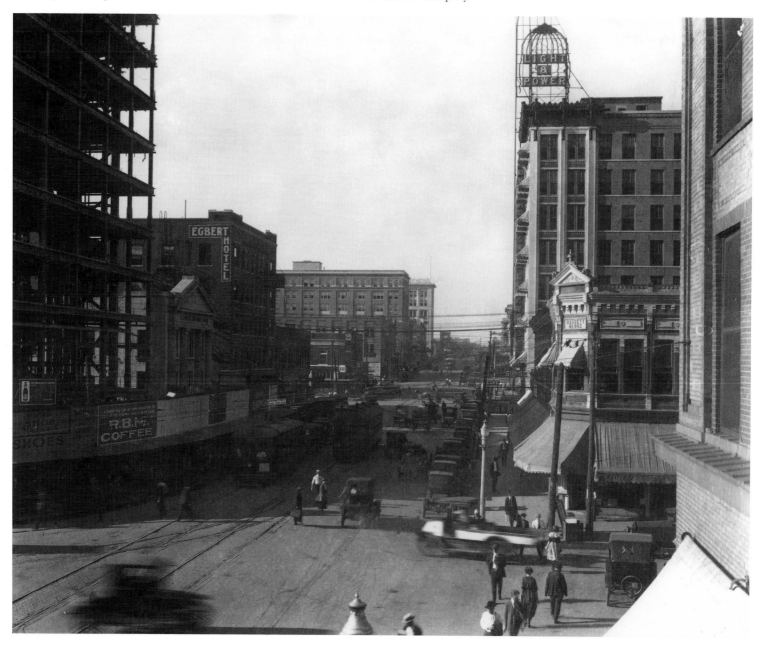

After dark, most of the action moved farther east to the entertainment district on Broadway, as seen in this view of Main, east from Harvey (ca. 1921).

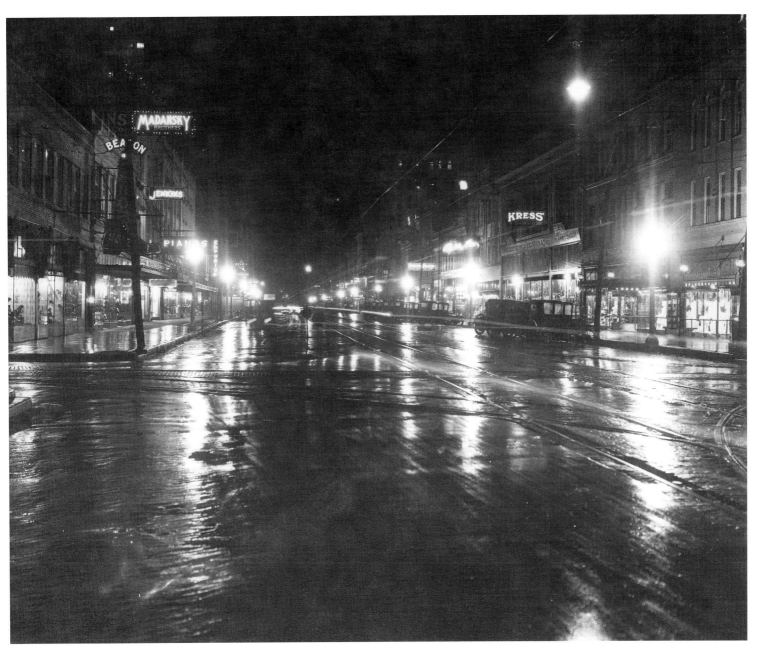

O. K. Transfer and Storage drays were a fixture around the city for decades. This
view of the 100 block of Main Street in 1921 shows the bustle of the era as horses,
bicycles, cars, and trolleys all shared the same crowded streets.

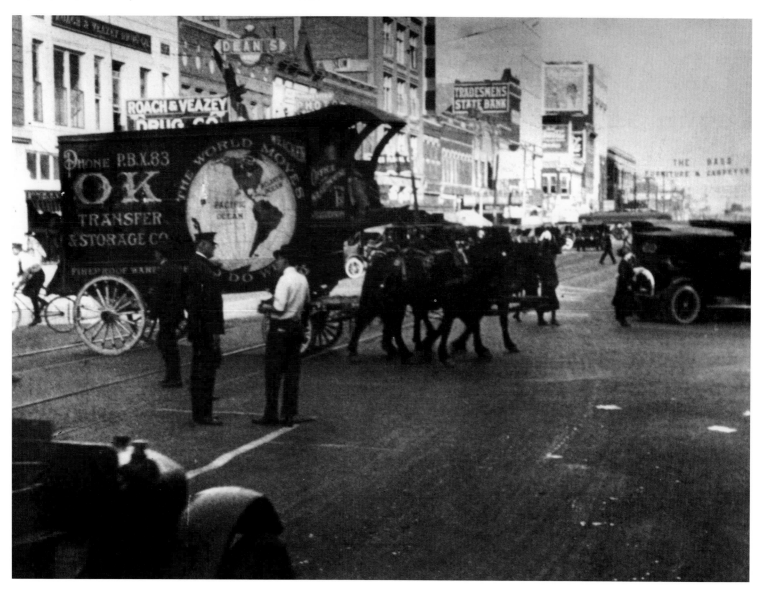

Heavy rains in late May and early June, 1923, swelled the North Canadian River, and the resulting floods brought the first test of the dam at Lake Overholser. The dam held, but several areas in the city were still damaged by floodwaters.

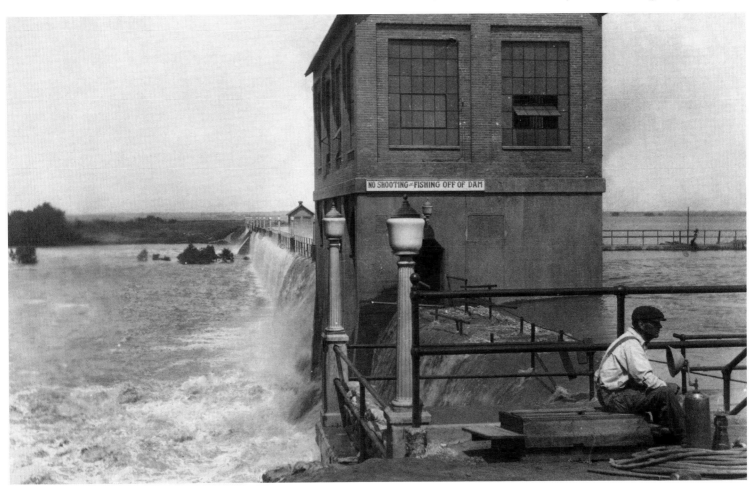

NO SHOOTING or FISHING OFF OF DAM

By 1924, traffic along Main Street had become very heavy. Traffic lights were installed at six key intersections in the city. This one hangs above Broadway and Main near the new Tradesmen's Bank at 101 West Main.

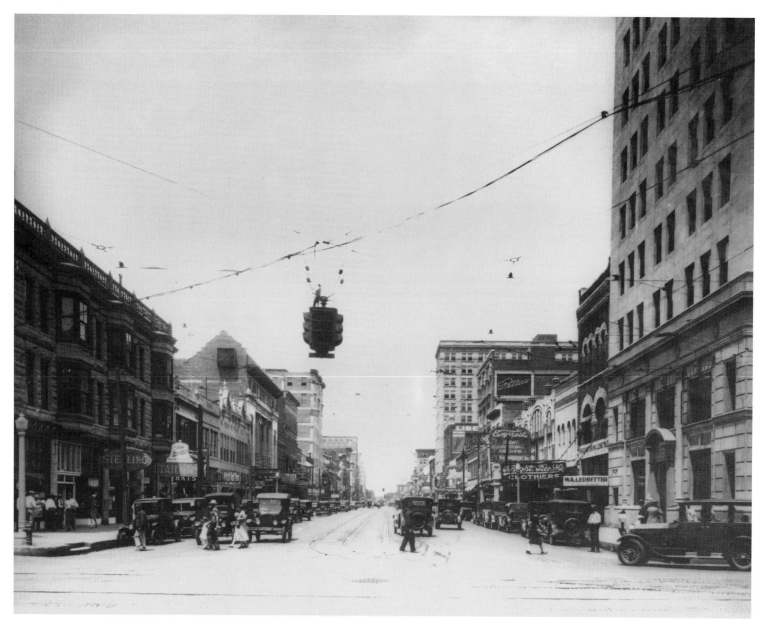

Halliburton's Department Store dominates the northeast corner of Main and Hudson in this elevated view looking east on Main (ca. 1925). Halliburton's remained at that location until 1960.

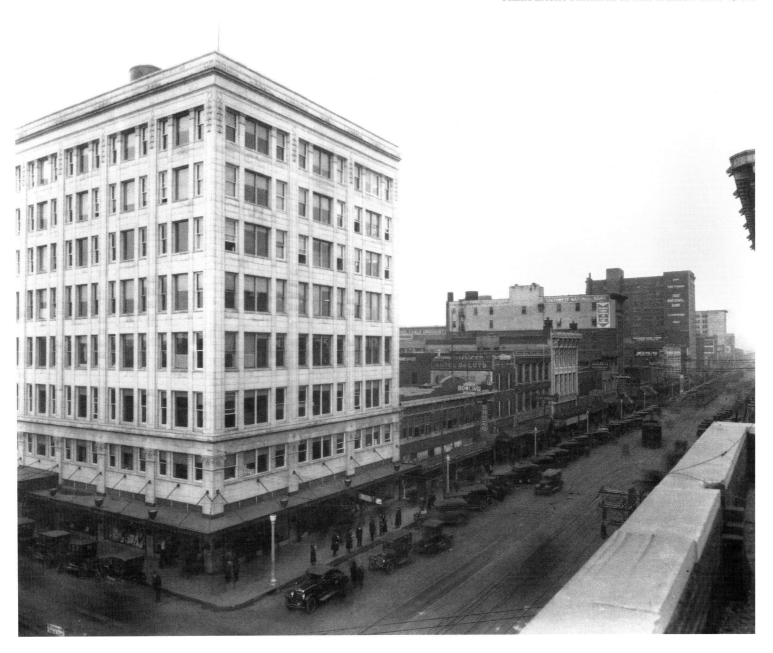

Cars line the streets along Main Street on this busy shopping day ca. 1925.
The Halliburton store (left) and Mercantile Building (right) anchor the
east side of the intersection with Hudson.

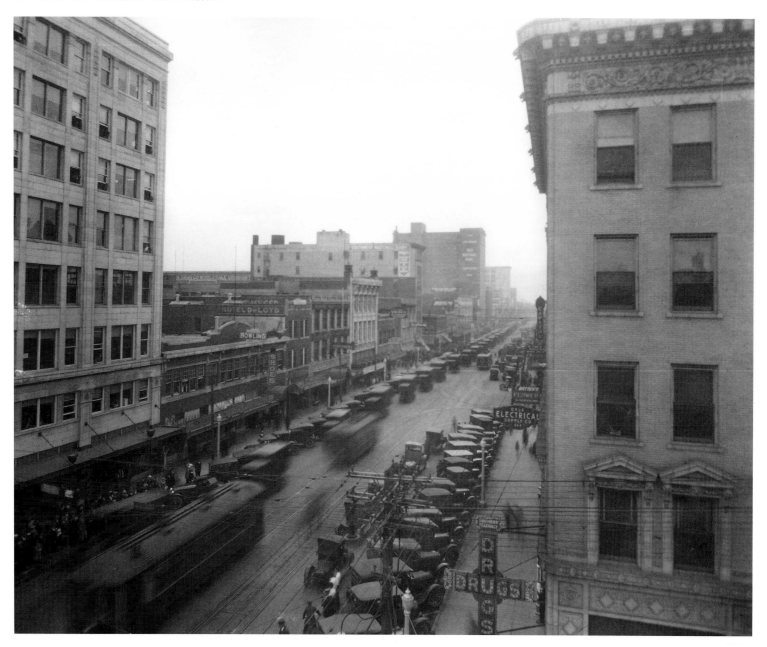

The Huckins Hotel, shown here ca. 1925, was a favorite of politicians and even served as the state capitol for a while.

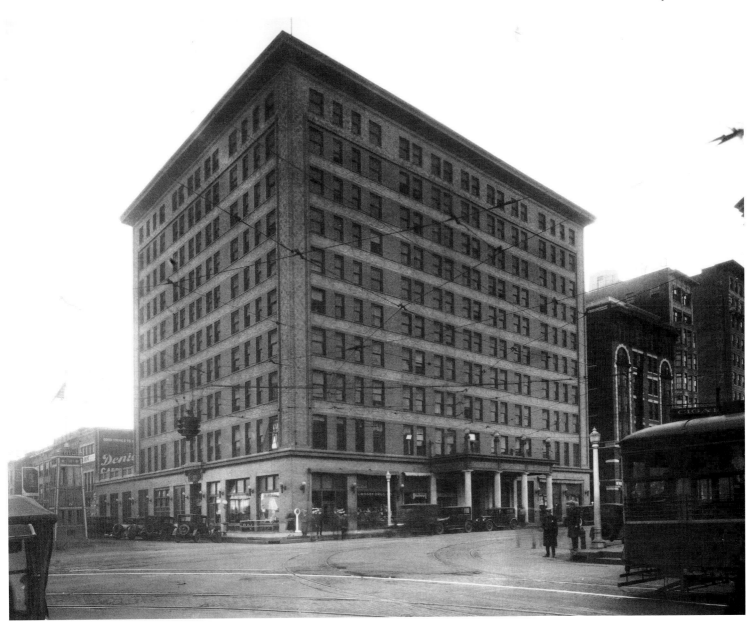

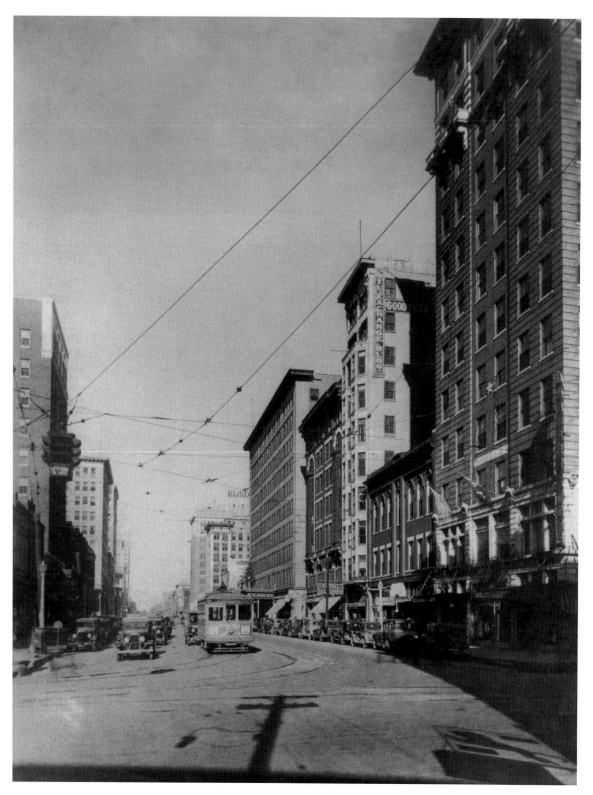

The commercial district along Broadway climbs ever higher as seen from the jog at Grand Avenue (ca. 1925). The Herskowitz building stands in the right foreground, the Huckins Hotel in the center, and the Skirvin Hotel in the background.

Streetcars rumble past the Orpheum Theatre at 213 West Grand (ca. 1925).
The Greek immigrant Sinopoulo family would entertain the city for decades,
first with Delmar Garden, then with the Overholser Theatre, revamped as the
first-class Orpheum, and later the Midwest Theatre.

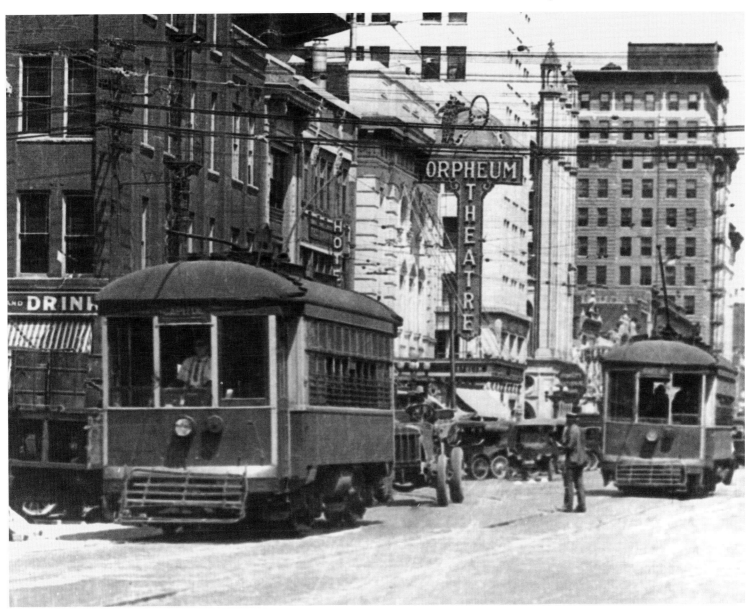

Patients in the girls' ward of University Hospital, 800 East 13th, welcome the opportunity to select reading materials on library day in the mid 1920s.

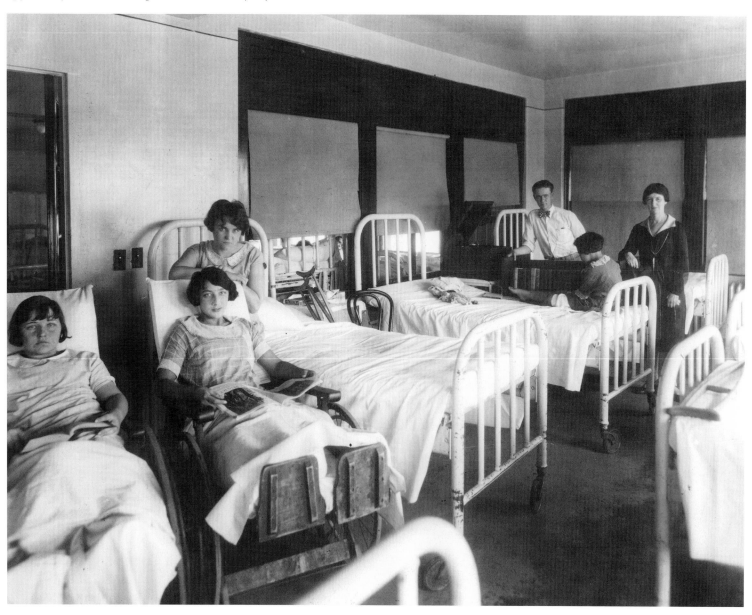

The entrance to the Skirvin Hotel is on the right in this view looking north on Broadway in the mid 1920s. Many cheap hotels and rooming houses were located here, in proximity to the Rock Island depot (on the right behind the Skirvin).

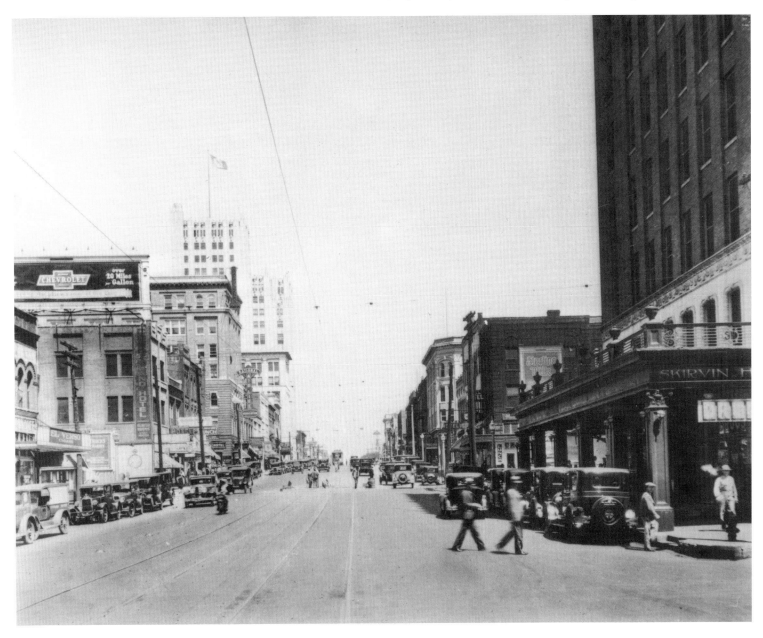

Oklahoma City was emerging as an aviation leader when this photograph was taken in the late 1920s. The Fokker Tri-motor plane is parked near Burrell Tibbs' flying school at the Municipal Airport near Woodson Park, Southwest 29th and May.

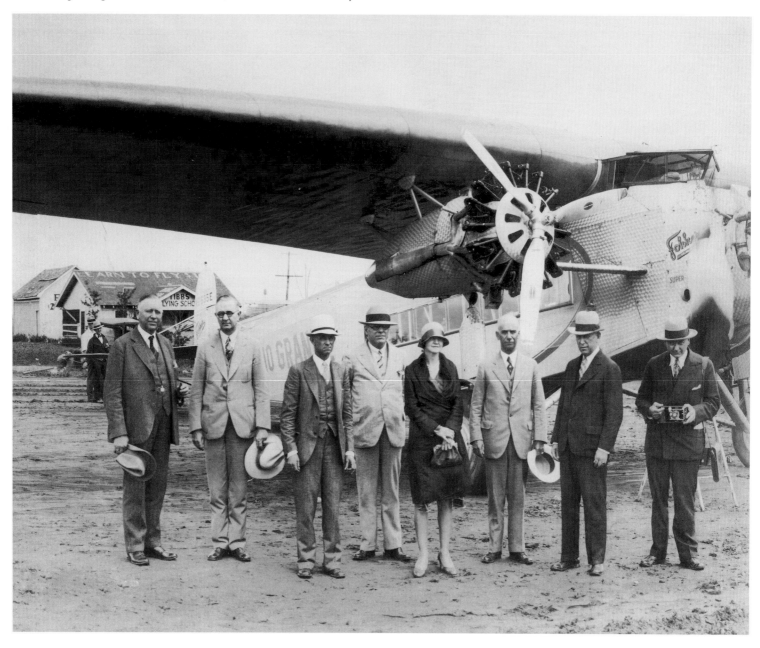

Main Street, shown here looking east from Lee Avenue ca. 1926, was considerably more sleepy the farther west one traveled. The large building on the left at 531 West Main is the OK Transfer and Storage Company, which originally housed the John Deere Plow Company.

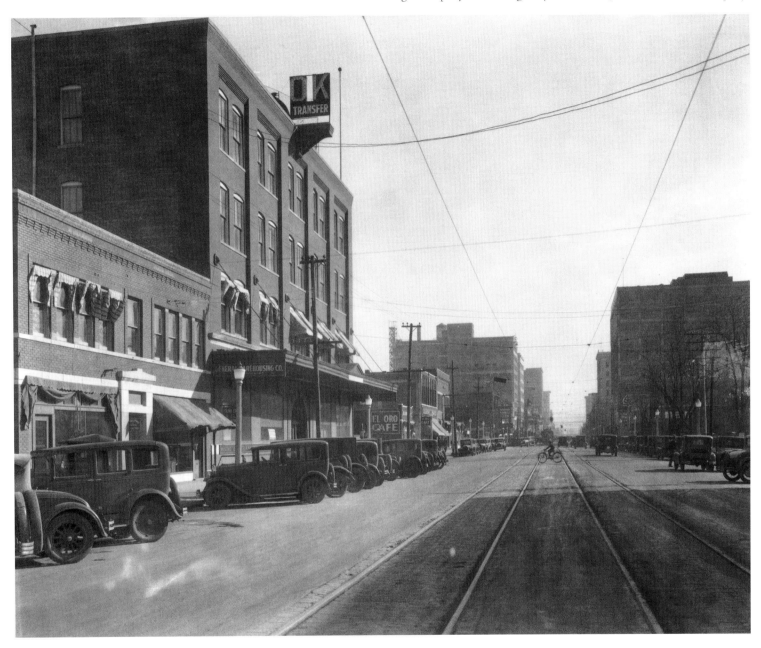

A rider prepares to board a streetcar on Broadway just before it turns onto
Grand Avenue headed for the terminal station (ca. 1925).

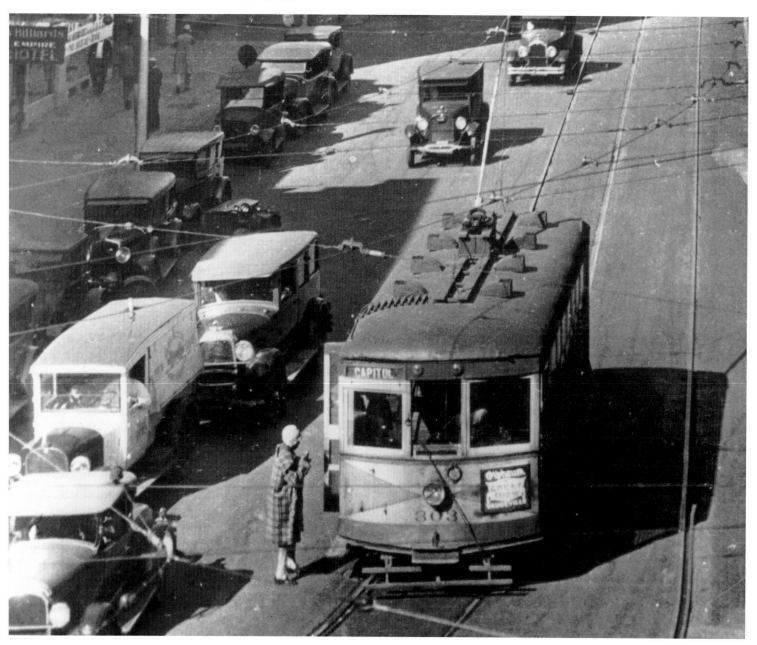

Since its construction in 1911 at 200 North Broadway, the luxurious Skirvin Hotel has shown remarkable adaptability. Shown here about 1925 is its second phase of development, after the third and tallest wing was added.

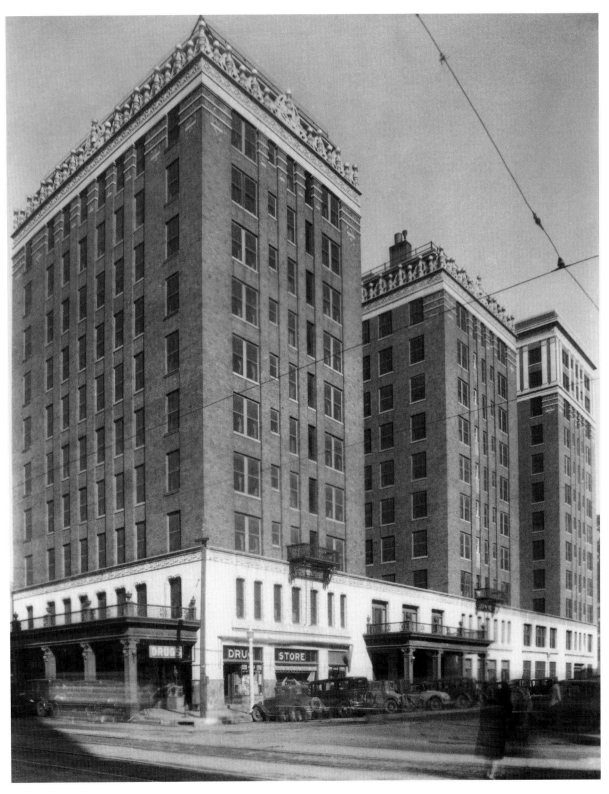

The north side of Main Street is congested, in this view west from Broadway in 1926. The Empress Theatre, 111 West Main, is featuring the silent western romance *Rustling for Cupid*.

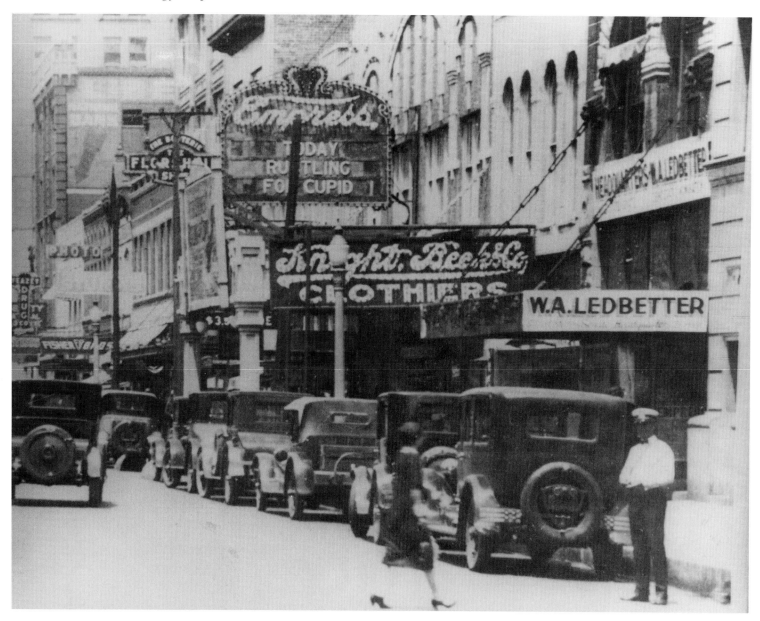

The White Motor Company was a leading producer of trucks after 1920. Here White Trucks are busy moving cattle at the barns in the Oklahoma National Stockyards (ca. 1920s).

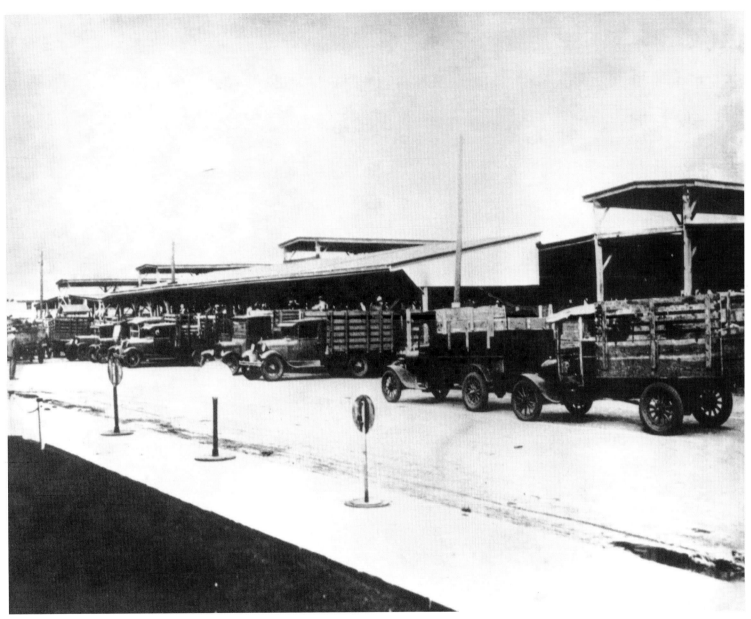

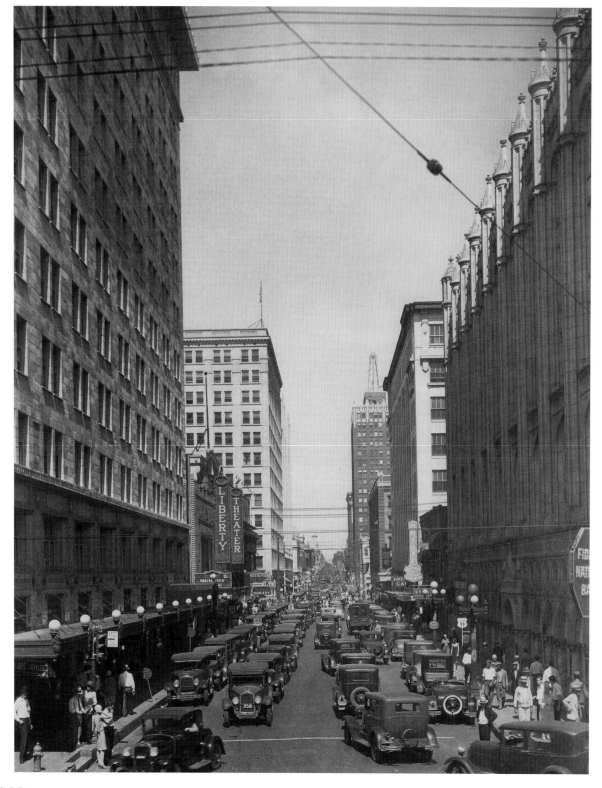

The late 1920s were prosperous times, as seen in this view of the crowded "canyon" looking north on Robinson from Grand (ca. 1928). The new Petroleum Building in the background with the derrick atop illustrated the rising importance of oil to the local economy.

The quaint Circle Theatre, 2510 South Robinson, opened in 1928 just as "talkies" began to hit screens in greater numbers. Seen here in 1929, the Circle was located in Capitol Hill and was part of the new trend in neighborhood theaters built outside the downtown core.

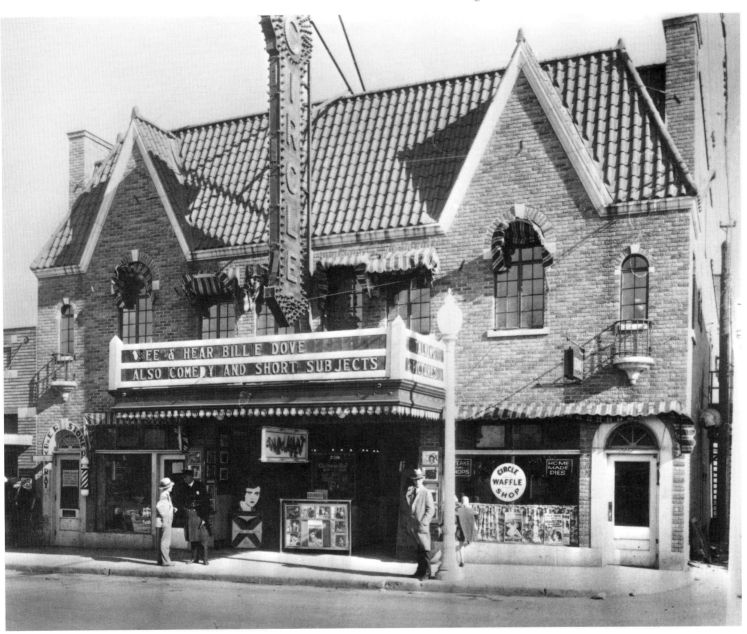

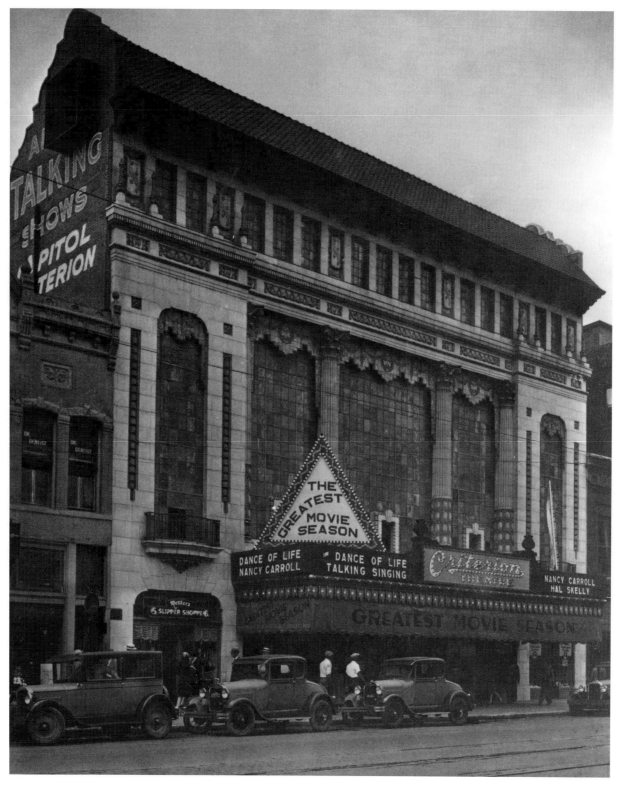

At the time of its construction in 1921, the Criterion Theatre, at 118 West Main, was considered to be among the finest in the nation. Shown here in 1929, the Criterion replaced the usual flashy signs with a glass panel facade, which projected a soft glow onto the street.

The Oklahoma Railway built its central terminal and transfer station on Grand between Harvey and Hudson in 1910. Passengers could board any line from here as well as transfer between lines.

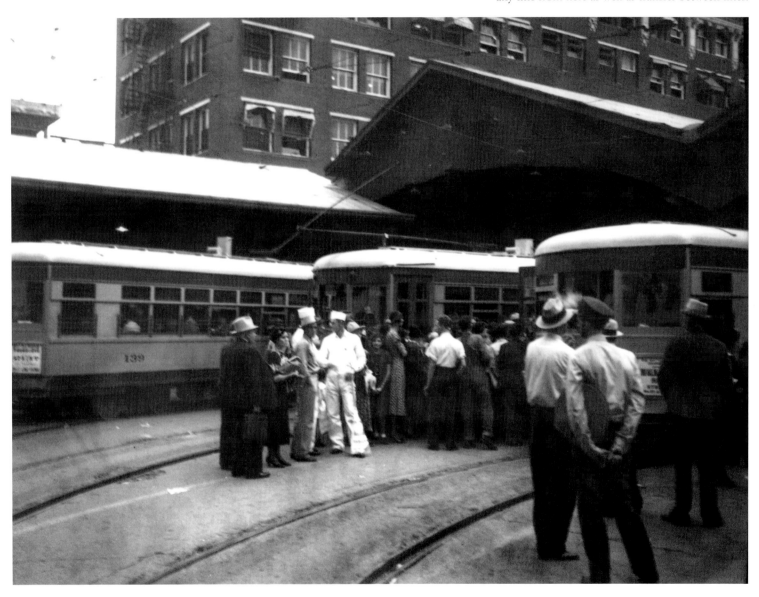

The Coliseum, often called the Stockyards Coliseum, was built on Exchange Avenue west of Agnew in Packingtown after the first one was destroyed by fire. The Coliseum hosted trade shows, exhibits, fairs, and even professional wrestling until 1970.

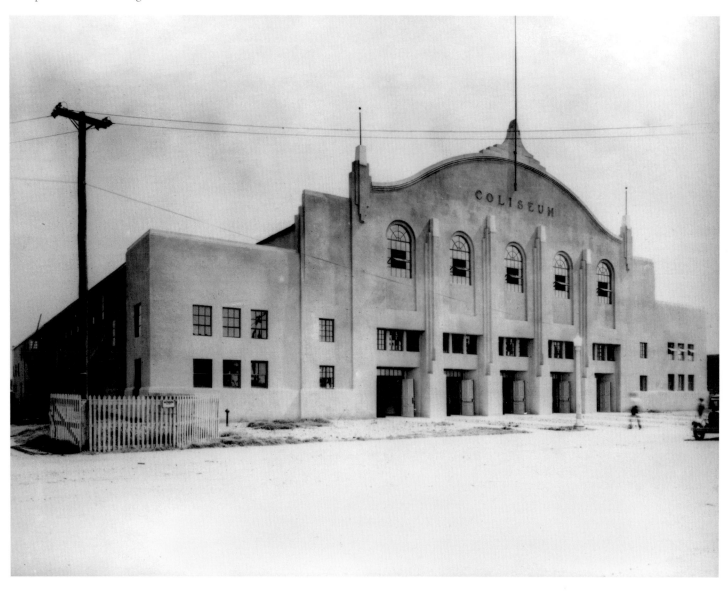

BUILDING BETTER TIMES

(1930–1945)

Despite the poor reputation accorded the state during the Great Depression, Oklahoma City was fortunate in that it suffered a delayed and milder impact when compared with many parts of the nation.

Behind this stroke of luck was the discovery of oil on the city's doorstep in late 1928. Any doubt of the import of the Oklahoma City field was blown away by the gusher Wild Mary Sudik in spring of 1930. The Sudik well became a national story—both the drama of the men fighting to control it and the staggering amount of oil it delivered. The colonization of the northeast side of the city—including the capitol grounds—by derricks became a serious concern to the city. City ordinances were routinely ignored by drillers, and the spray from gushers created both fire and ecological hazards.

Amazingly, the city led the nation with four years of economic gain during the depression, and four new buildings over 18 stories (including the two tallest) were built during this time. Civic leaders also realized their dream of removing the Rock Island and Frisco tracks, which ran through the center of town, replacing them with the Civic Center, City Hall, and the County Court House.

The depression did hit some harder than others, but residents exhibited a community spirit that has been a hallmark of the city since the first days in 1889 when the citizen's committee brought order out of chaos. When many refugees from other areas, including drought refugees, gathered in camps along the river, the municipal government, in partnership with the community, came together to provide basic services for them. The effort became a paradigm for Franklin Roosevelt's New Deal programs.

Oklahoma City's experience during World War II was not unlike that of many other cities. In 1940 the Army established a bomber base at the municipal airport, in 1942 Norman Naval Air Station was built, and in 1943 Tinker Field and the Douglas aircraft plant were established in Midwest City. The city proper was a rail transit center for troops and an attractive destination for servicemen on leave.

This crowd gathers in December 1930 to say farewell to the old Rock Island depot, located behind the Skirvin Hotel at 210 North Broadway. The sign on the depot says, "This historic building will be wrecked Monday—Leo Sanders—General Contractor—Oklahoma City." Charles Colcord's crusade to remove the tracks that divided downtown resulted in the development of the Civic Center complex.

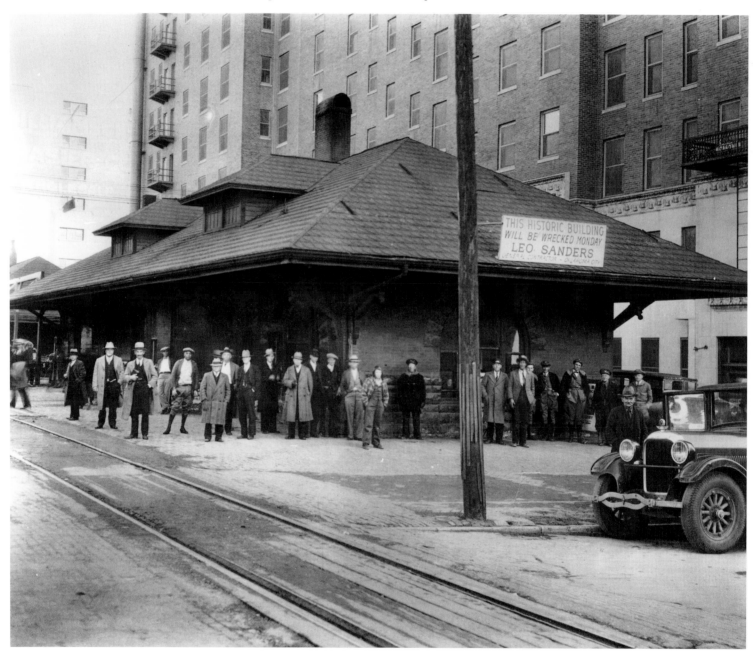

The Perrine Building, 119 North Robinson, was built on the southwest corner of First and Robinson in 1927. Shown here about 1930, it was called the "headquarters of the Mid-Continent Field," but it would soon be dwarfed by two new skyscrapers on opposite corners.

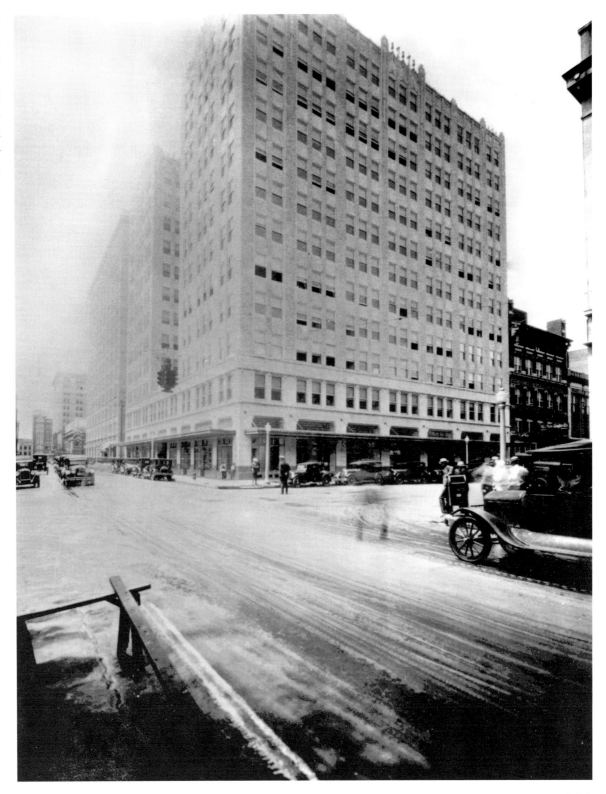

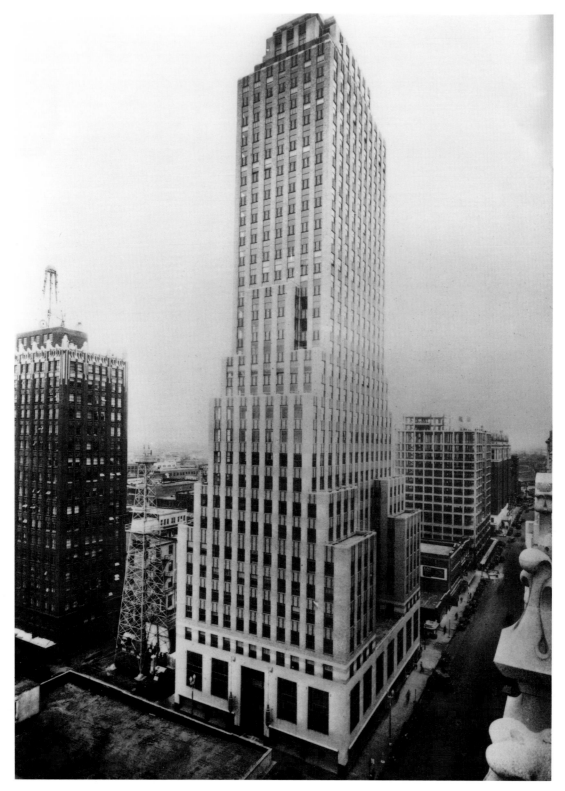

The Ramsey Tower (center) was the city's tallest building for just a few weeks until the completion of First National Bank in 1931. In this view from atop the Perrine Building in 1932, one can see the steel skeleton of the Skirvin Tower to the right on Broadway.

Horse races, like this one at the state fairgrounds, remained popular throughout the first fifty years of the city's history.

Despite being one of Hollywood's biggest stars in the silent film era, Tom Mix was no stranger to Oklahoma—he got his start in show business at the famous 101 Ranch in Ponca City. He made this appearance in a downtown shop with his trademark oversized hat.

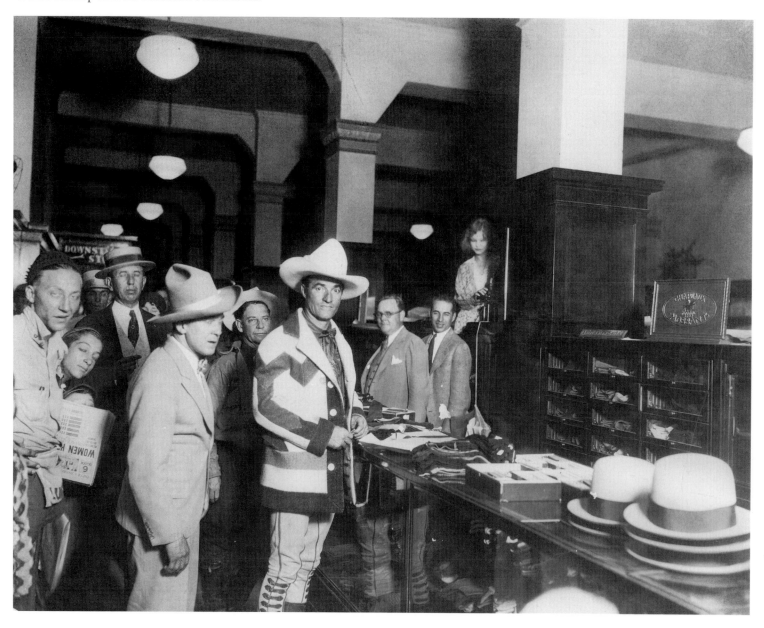

Students study in the Roosevelt Junior High School reading room in 1935.

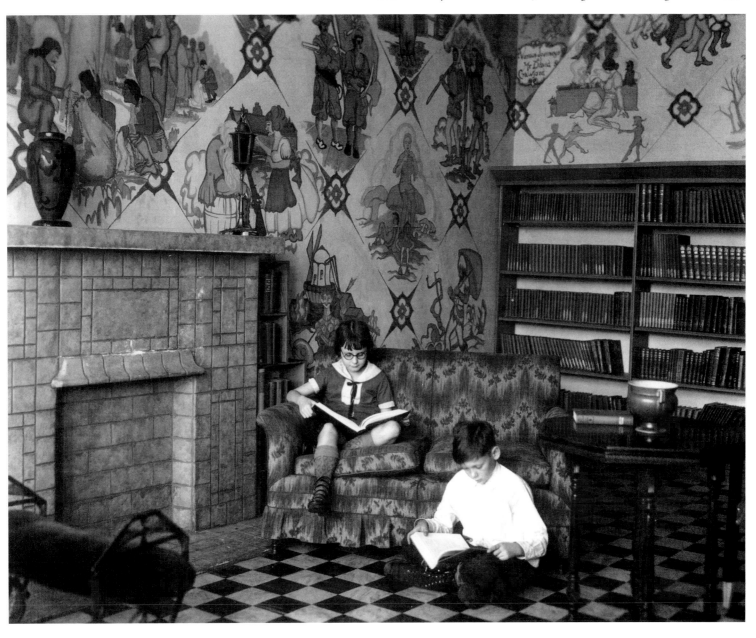

This fleet of Cord limousines is on display at the Auburn-Bennett Motor Company at 308-10 West Tenth. The float on the right is promoting the film *Mamba,* directed by city native Albert Rogell in 1930.

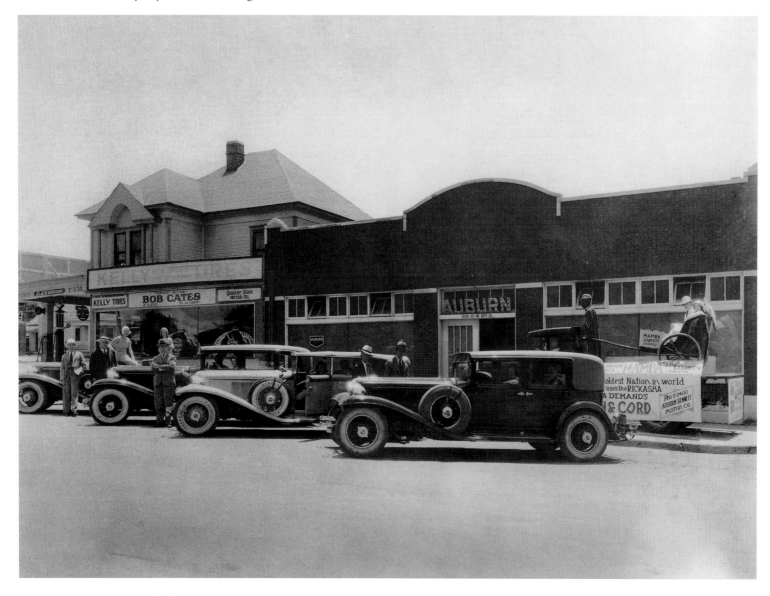

The massive Biltmore Hotel was the largest hotel in the state when it opened on the southeast corner of Grand and Hudson in 1932. It was said to be a "city unto itself" and rivaled the Skirvin for the city's upscale trade.

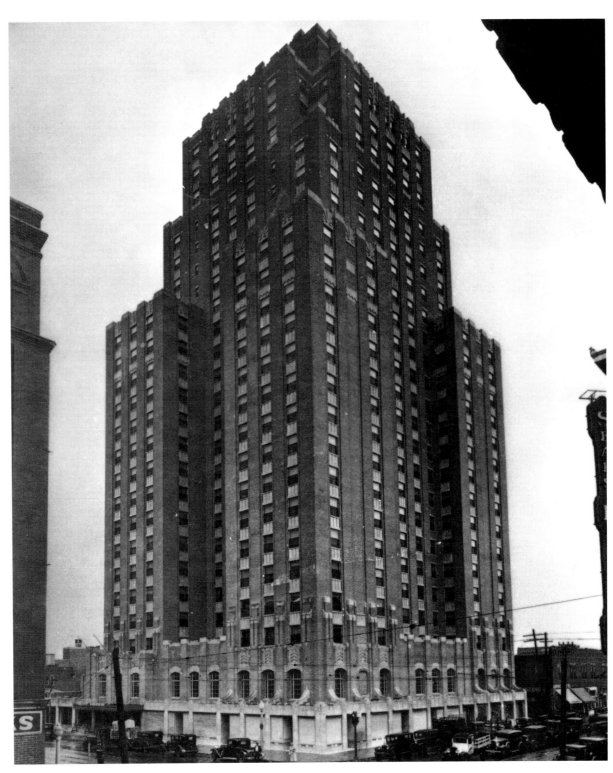

145

John J. Harden built the Public Market on top of the old Delmar Garden site at Klein and Exchange in 1928. Here farmers in 1933 are selling their goods outside the market.

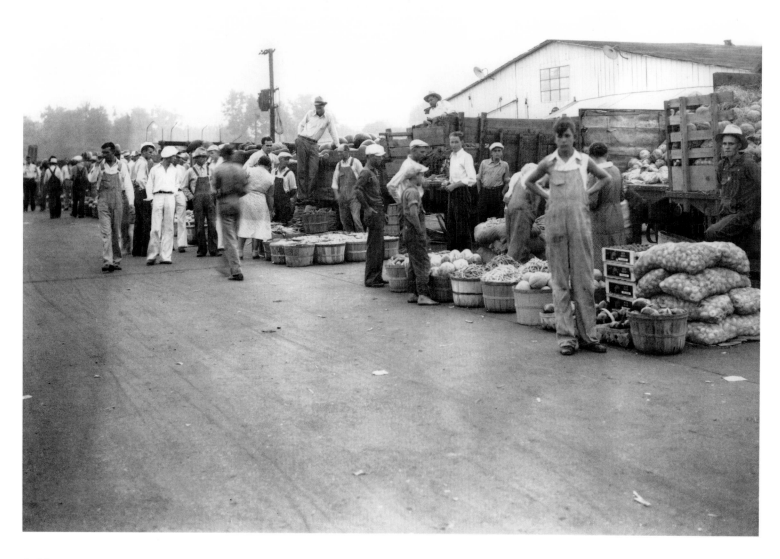

The new facilities at the Public Market led most wholesalers to abandon "Market Row" on California Avenue. Here the trucking area is already busy at 6:30 A.M.

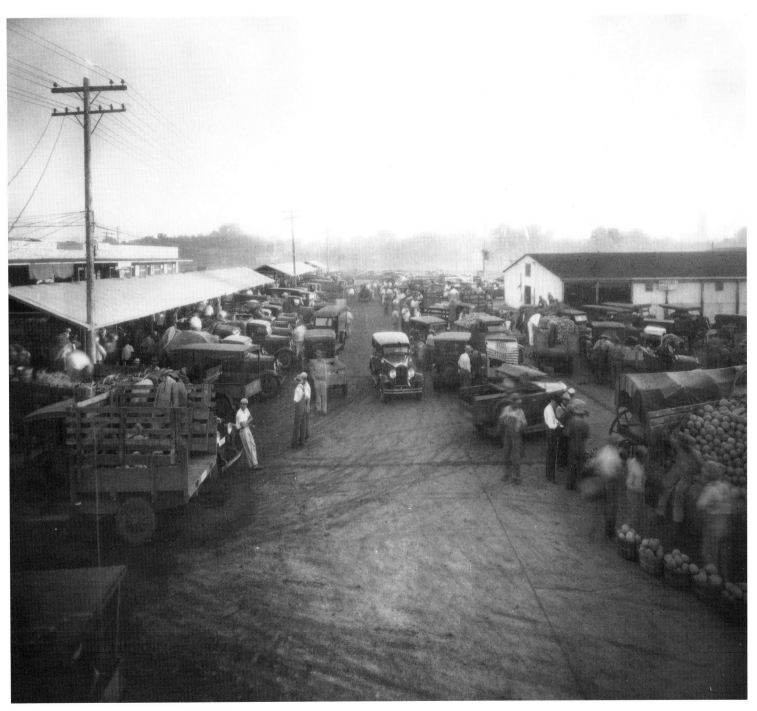

The Public Market (in background) held more than 100 permanent produce stalls and retail stores inside. The outdoor stalls were located in a horseshoe around the market and allowed farmers to sell directly to local shoppers.

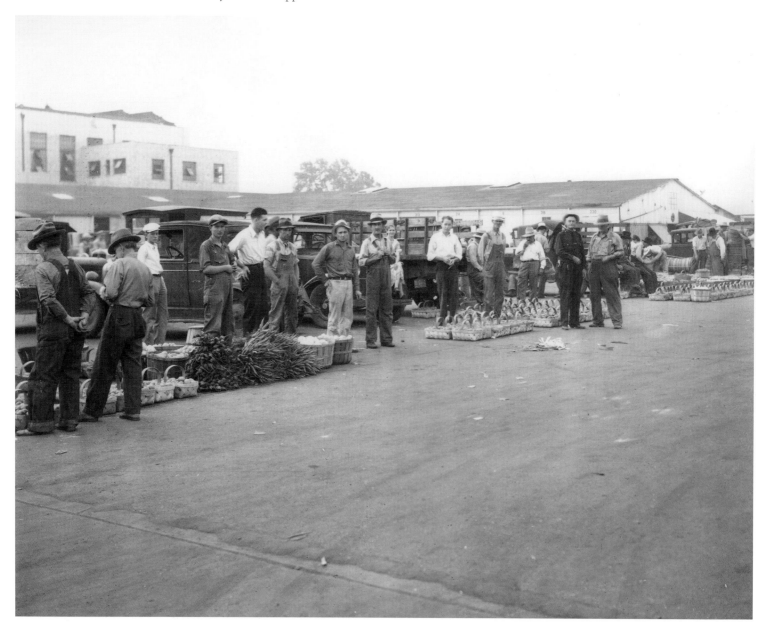

The classic design of the Tradesmen's National Bank Building, shown here ca. 1932, has ensured its place in the downtown skyline since 1921.

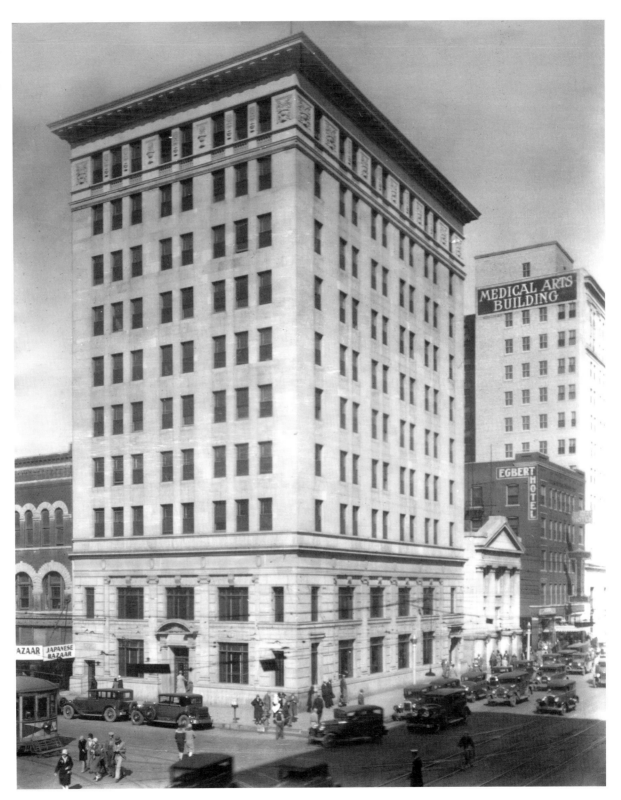

Ever larger stores dominate the south side of Main Street, seen here
looking west from Harvey. The giants located along this row are (left
to right) Kerr's, the Mercantile Building, Harbour-Longmire (across
Hudson), and Montgomery Ward in the distance.

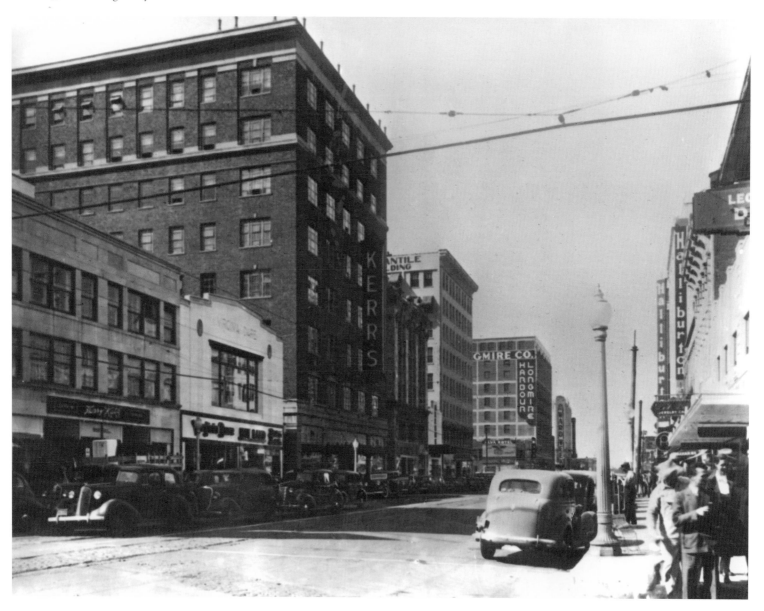

The retail district is dressed for the holiday season in this view of the north side of Main Street between Harvey and Hudson (ca. 1935).

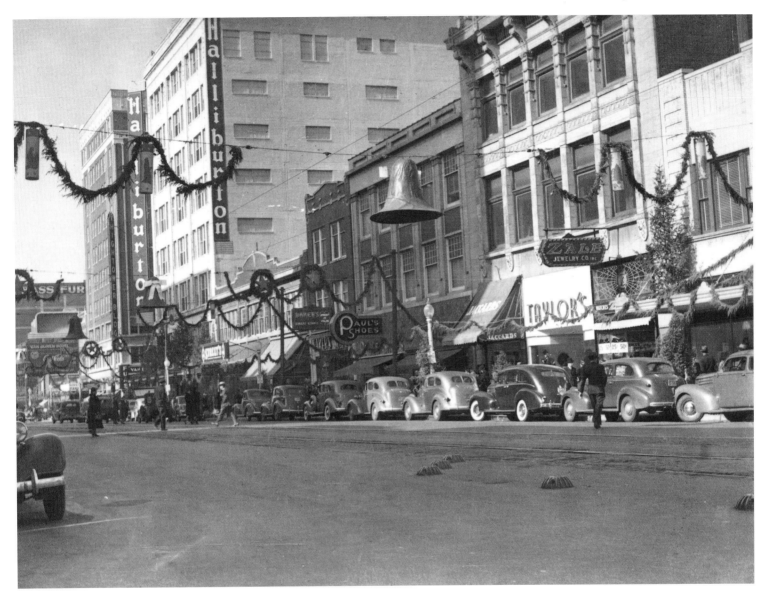

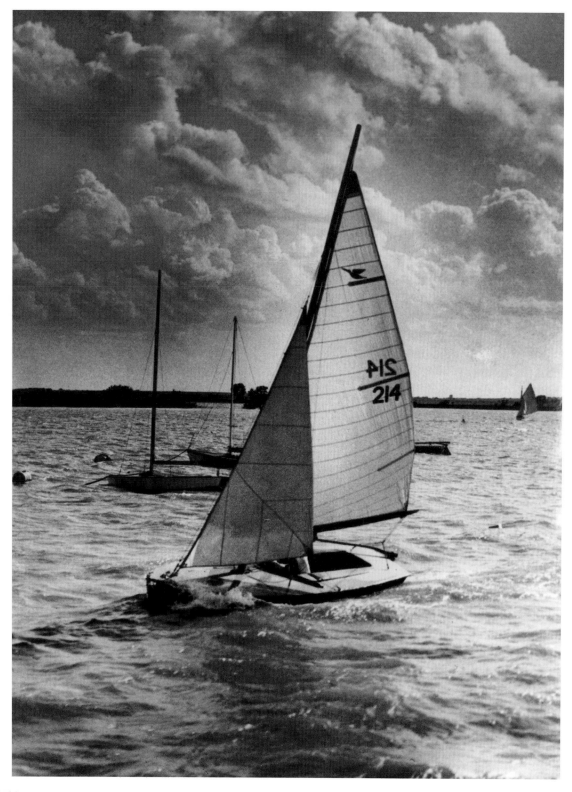

The region's strong winds made sailing popular at Lake Overholser. The Oklahoma City Yacht Club, chartered in 1932, held annual regattas and cup races on the city reservoir.

Oil derricks sprout up in northeast Oklahoma City in this aerial view ca. 1935. Oil was discovered on the south side of the city in 1929, and reached city limits in 1930. Drilling was largely forbidden in the city until 1935.

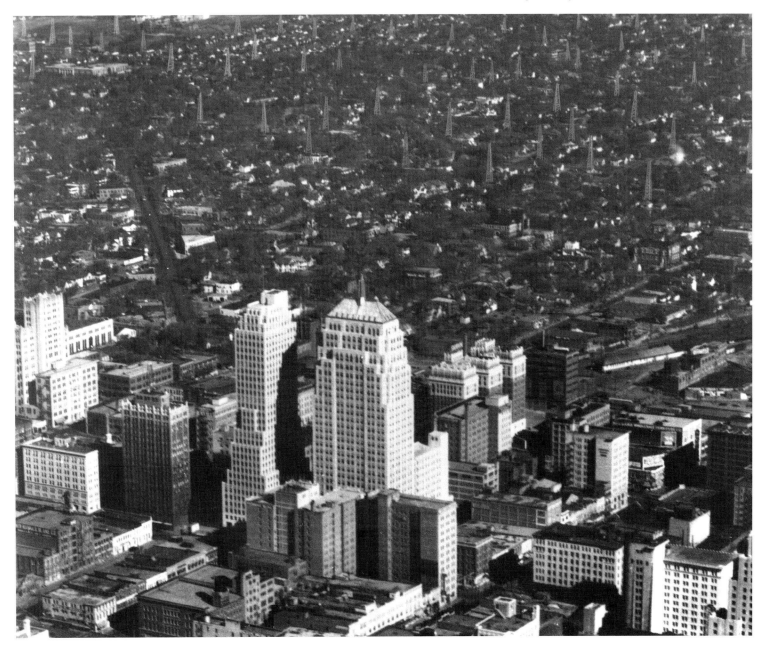

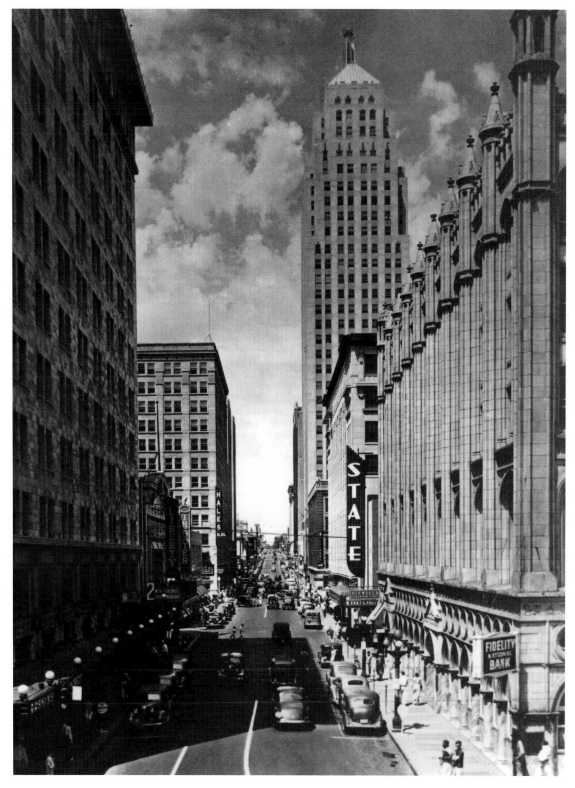

The ornate Baum Building contrasts with the sleek and modern First National Bank Building in this view north up the "Robinson canyon" from Grand Avenue (ca. 1937).

This is the view looking north from Broadway and Grand—one of the busiest intersections in the city. The Wells-Roberts, on the left, was a modest hotel near the Santa Fe depot. It was so well built it took a full ten minutes to fall when it was dynamited in 1973.

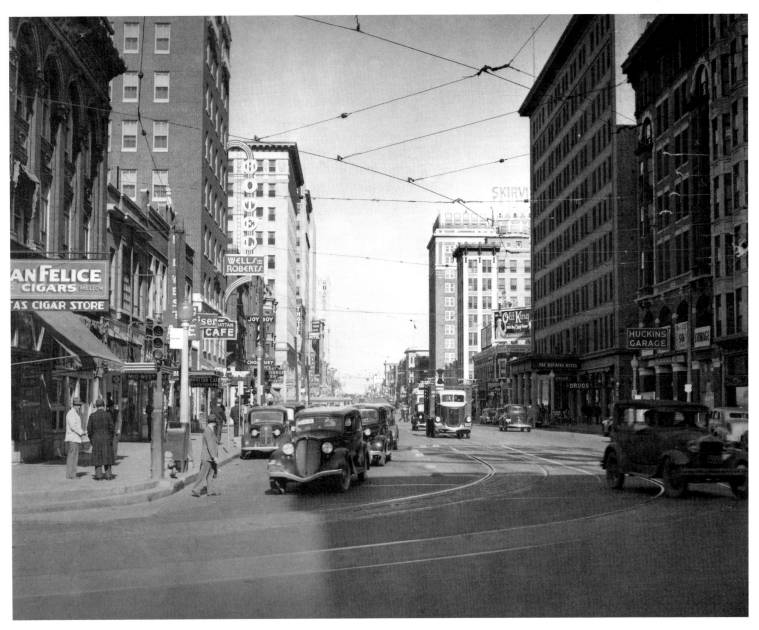

Reenactments of the Land Run, like this one sponsored by the Capitol
Hill Commerce Club, were a popular feature of 89er Day celebrations
throughout the 1930s.

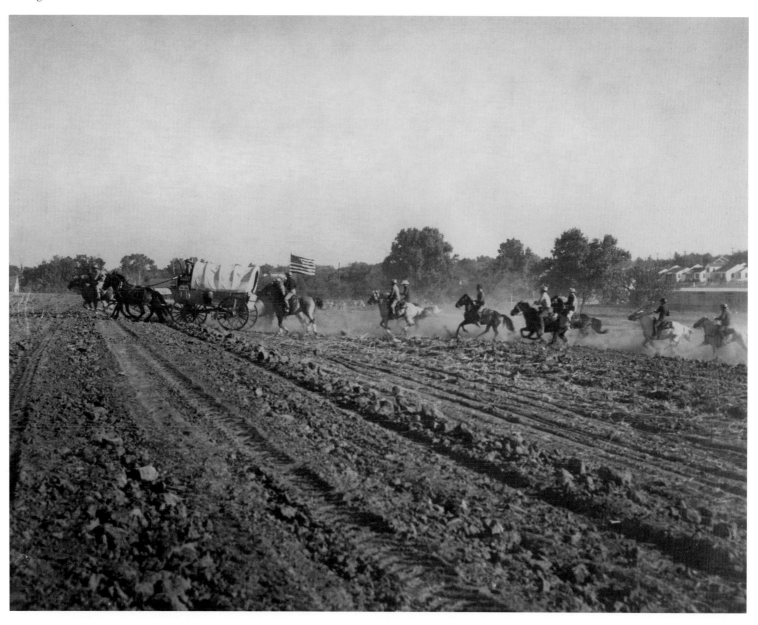

Sears Roebuck was a latecomer to the Oklahoma City retail district. Shown here in the late 1930s, Sears took over the Grain Exchange Building on the southwest corner of Grand and Harvey in 1929.

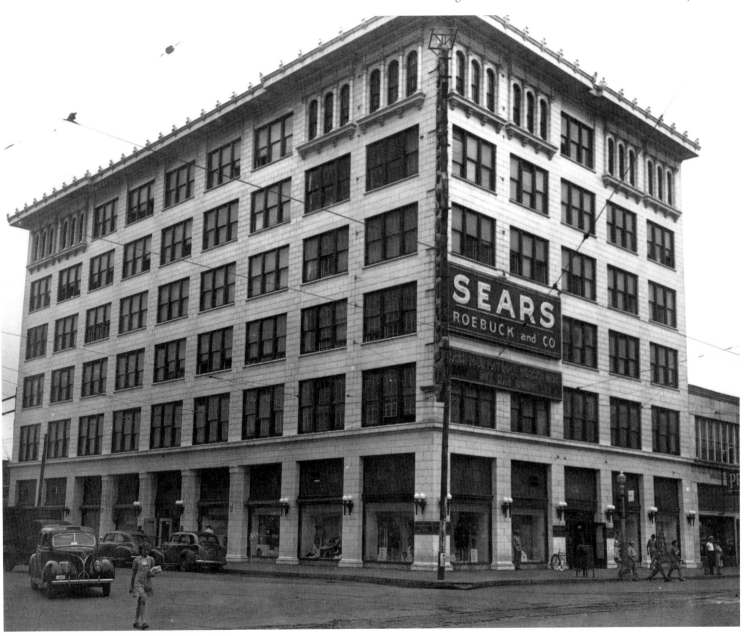

Although not a true grindhouse, the Rialto Theatre, at 131 West Grand, was not averse to showing exploitation films such as *The Pace That Kills* (ca. 1935). The ornate facade belongs to the Baum Building on the corner of Grand and Robinson.

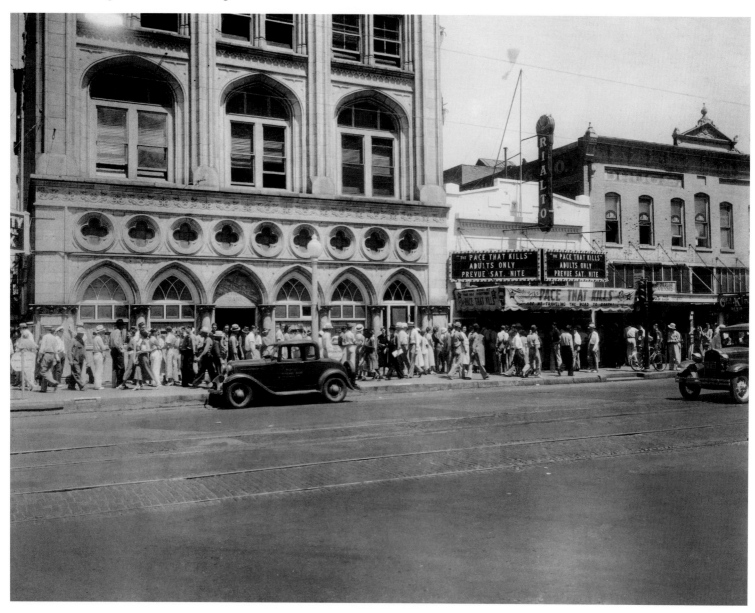

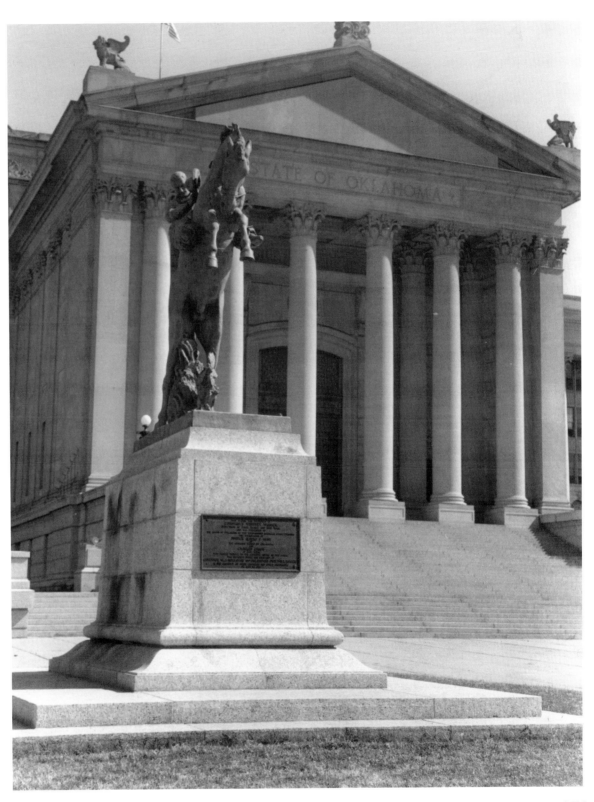

Tribute to Range Riders, the statue at the south entrance to the state capitol, was erected in 1930. Governor "Alfalfa Bill" Murray's grudge against Will Rogers held up the dedication of the statue (shown here in 1938), which inexplicably did not take place until 1957.

Oklahoma was the only state with a producing oil well on its capitol grounds when this photograph was taken in 1939. Governor Marland approved drilling on state property in 1936, despite staunch opposition from Oklahoma City that its zoning laws were being violated.

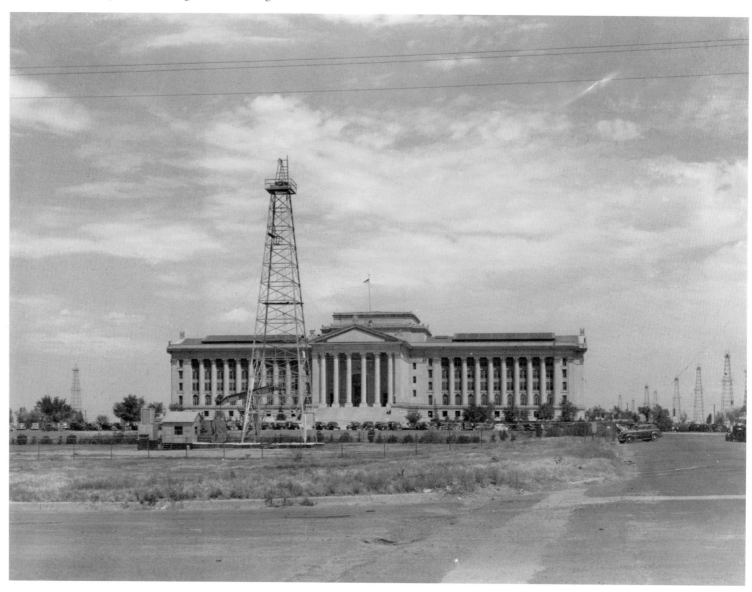

This view of the downtown skyline, facing southeast about 1937, would change very little until the glass-and-steel towers of the urban renewal era began to rise in the late 1960s.

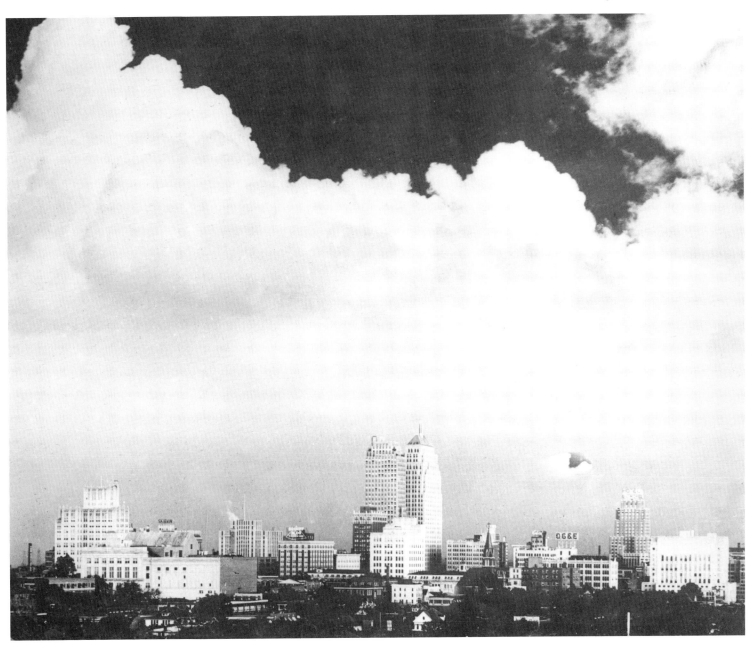

A Braniff Airways DC-2 on the runway in front of the Oklahoma City Air Terminal.
Braniff purchased a fleet of DC-2s in 1937 for their Great Lakes to the Gulf route.
This plane was requisitioned by the Army in 1942, but didn't survive the war.

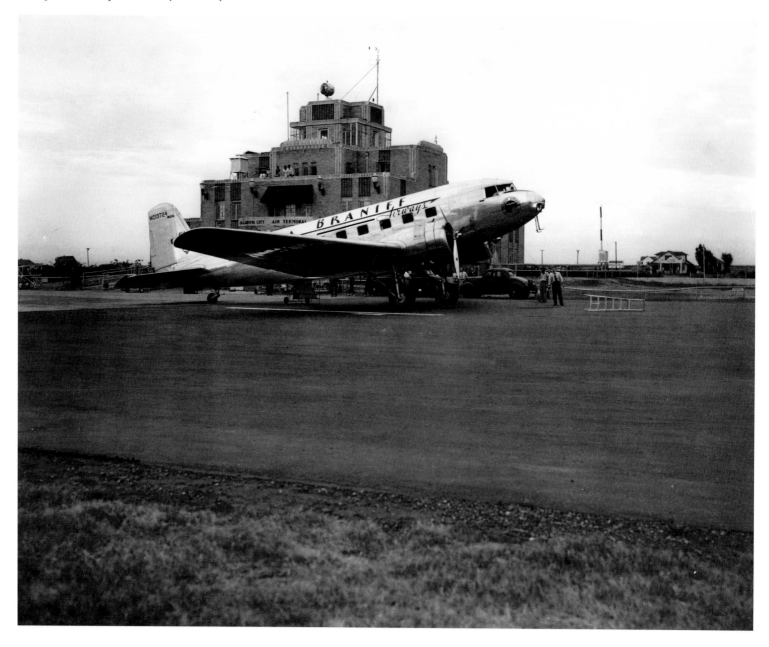

Three Ferris wheels create a dazzling nighttime display in this view of the 1938 State Fair. Depression-weary citizens were hungry for diversion that year—the weeklong fair broke both single-day and total attendance records.

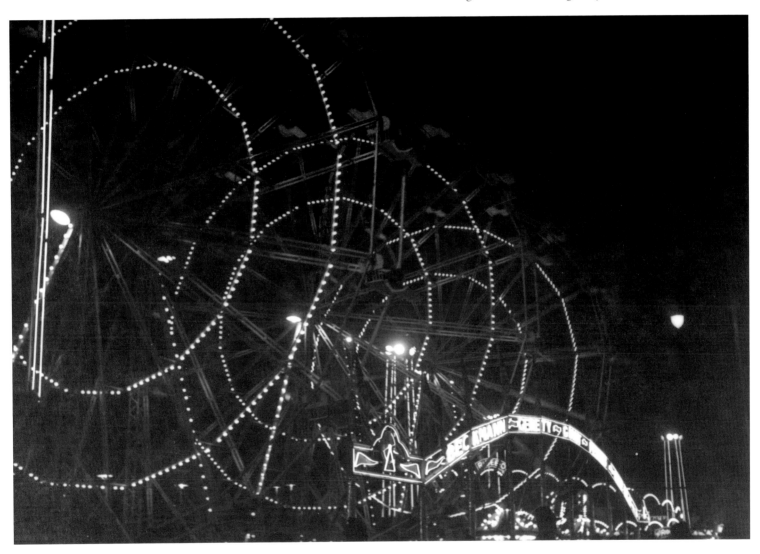

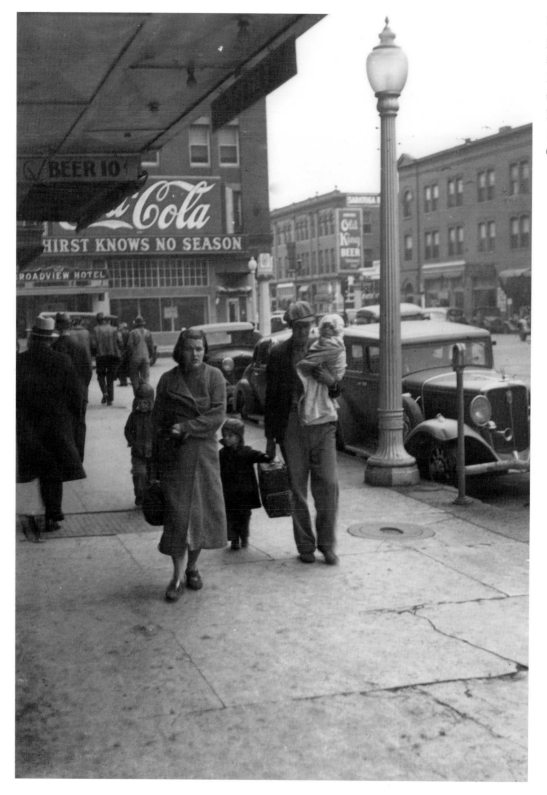

Not all of Oklahoma's poverty-stricken families left for California in the 1930s. Hundreds of families, like this one at the corner of Broadway and Grand in 1937, came to Oklahoma City for work or relief.

Riders embark and debark at the streetcar terminal in 1939. The terminal was located between Main and Grand near Hudson.

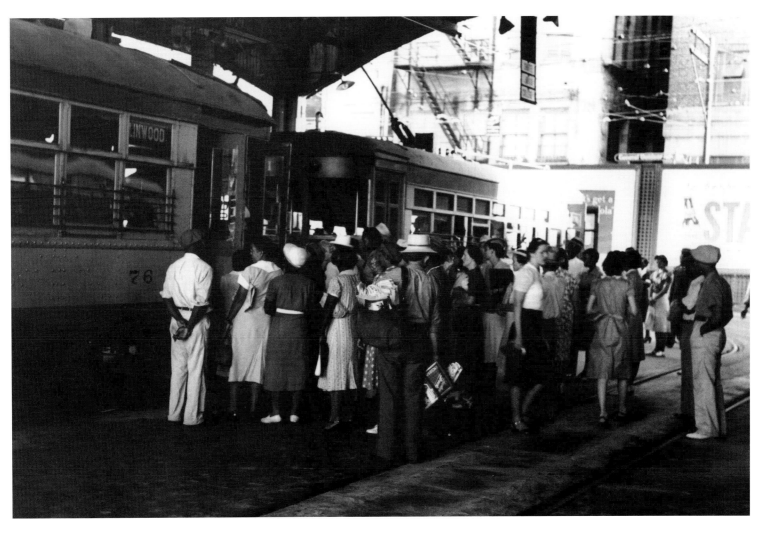

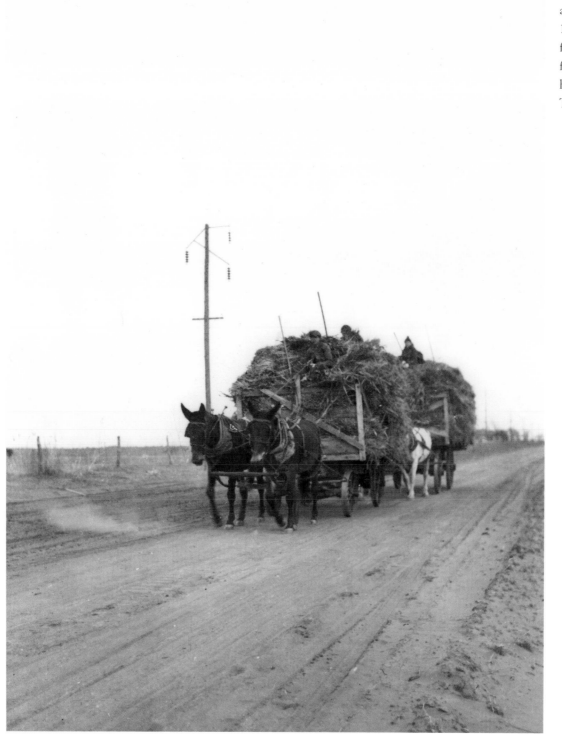

Despite the city's building boom, Oklahoma was still an agricultural state in the 1930s, and one needn't travel far from the city limits to find a farm. Here loads of hay are hauled on Northeast Tenth Street in 1939.

Collisions with trolleys were not uncommon as automobiles crowded into city streets. At around 20 tons, the trolleys usually fared better when metal met metal, as this one did in November 1939.

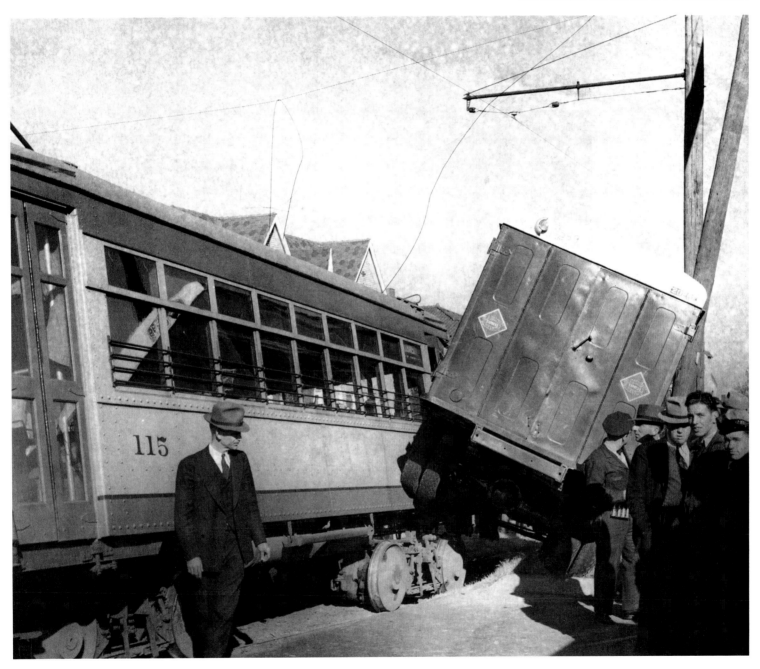

The First National Bank Building greets members of the Independent Petroleum
Association of America, who are visiting the city for their eighth annual convention in
November 1936. Oil wells dot the northeast part of the city to the right.

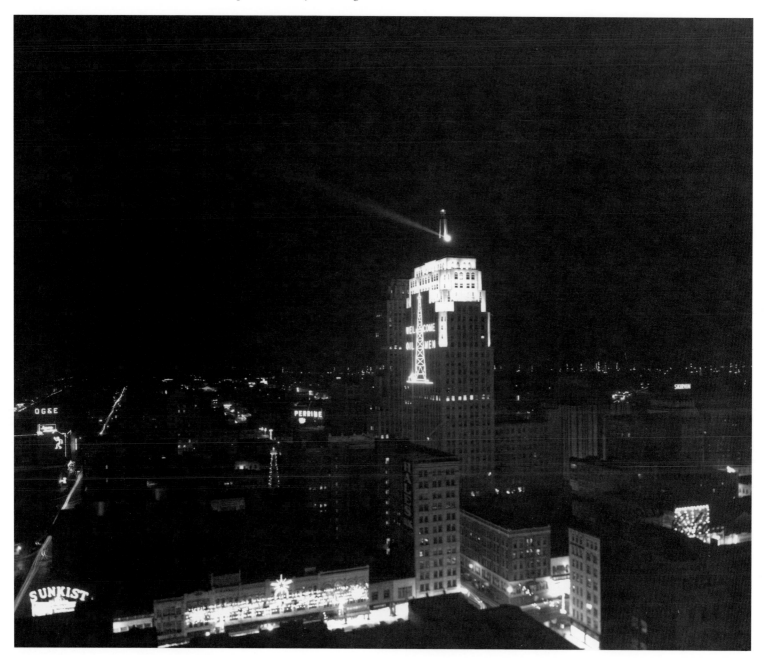

In July 1941, a national campaign collected scrap aluminum for the building of warplanes needed in case of war. Oklahoma City collected 16 tons. Here the Hales building anchors a banner promoting the drive.

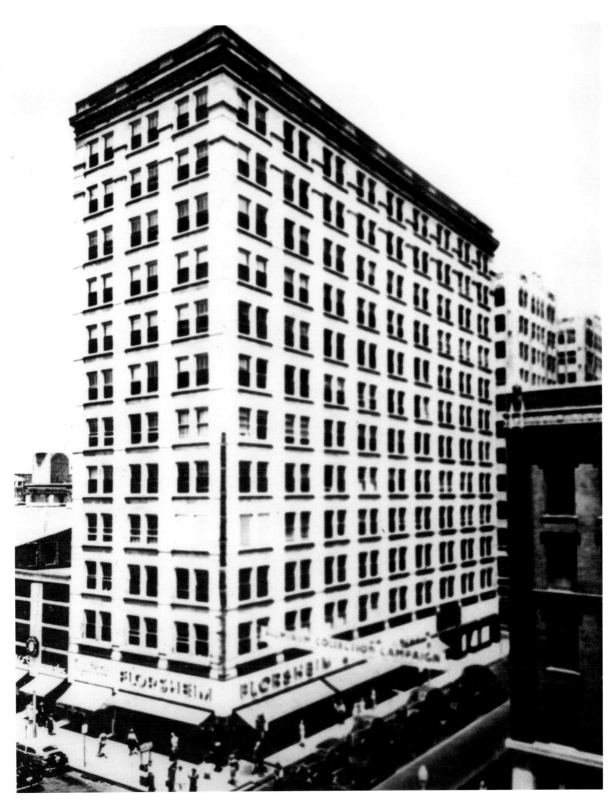

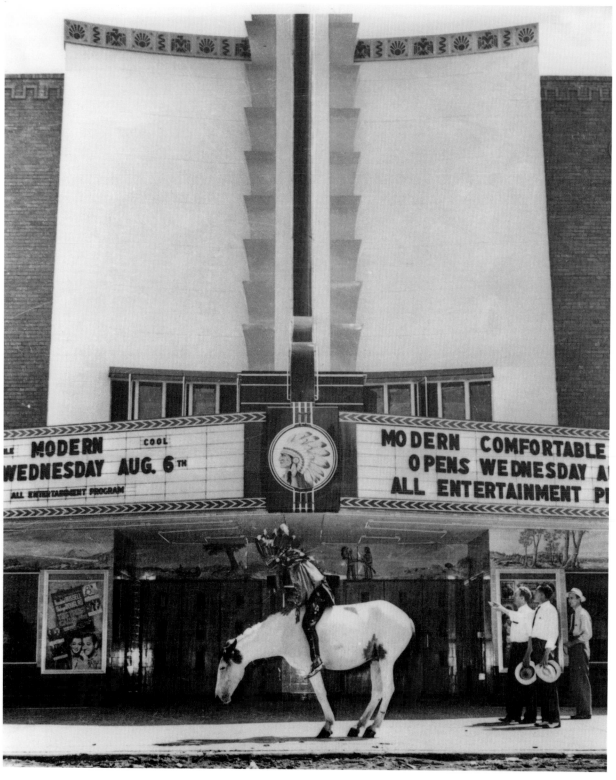

The Redskin Theatre, at 822 Southwest 29th, was a very popular neighborhood theater in Capitol Hill. The Barton family, who owned several south side theaters, built it in 1941 and named it for the Capitol Hill High School mascot.

Crowds gather for the grand opening of the Redskin Theatre on August 6, 1941. The Redskin became an integral part of social life in Capitol Hill for decades.

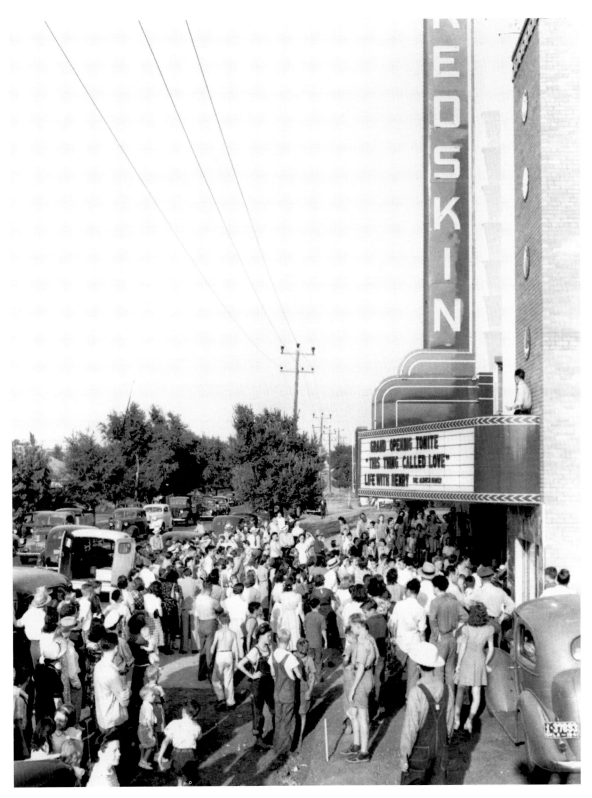

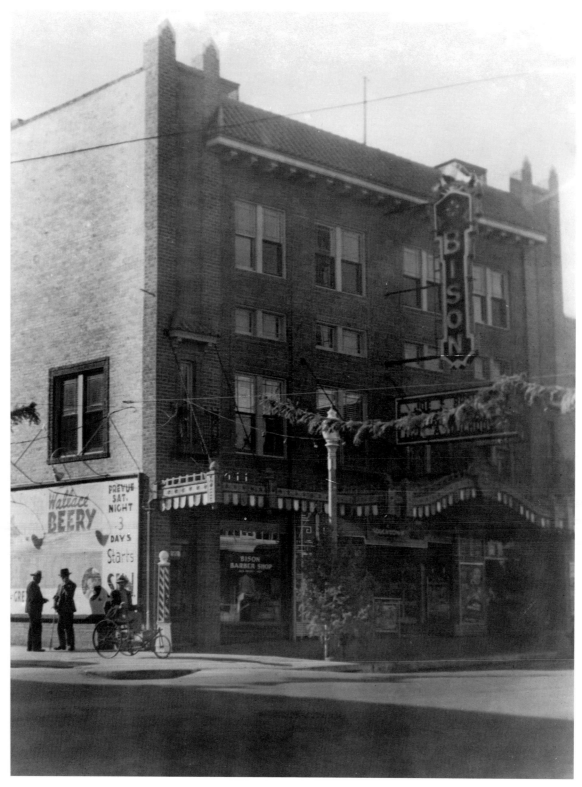

The Bison Theatre, at 1341 Northeast 23rd, was a neighborhood theater serving neighborhoods near the capitol like Lincoln Terrace and Culbertson Heights. It was built in 1941 by local theater-chain owner Peter Caporal.

Janet's Millinery opened in the Mercantile Building at Main and Hudson in 1941. The large gap between the Mercantile and the Hudson Hotel was the entrance to the streetcar terminal, which closed in 1941.

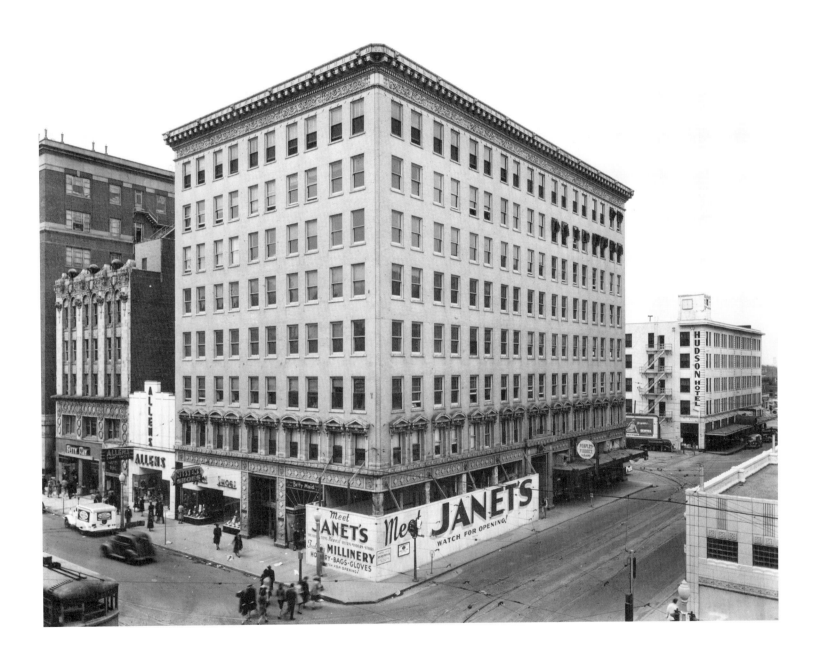

The congregation of the Avery Chapel A.M.E. Church, at 429 East First, assembles on Easter Sunday, 1942. Author Ralph Ellison moved into the parsonage of the church with his mother after his father's death in 1917.

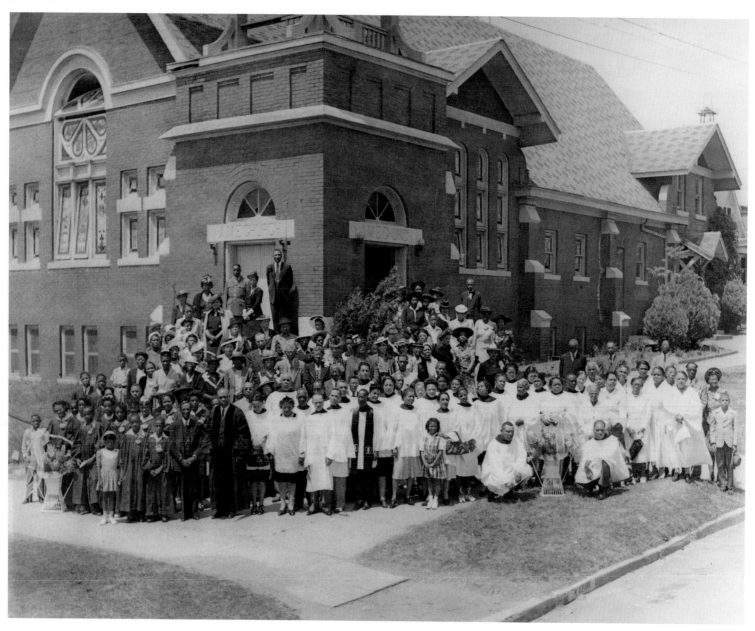

The Baltimore Building opened on the northeast corner of Grand and Harvey in 1904 and housed the YMCA on two floors for several years. This view was recorded in April 1941, when it began a new career as low-income housing. It would close in 1947.

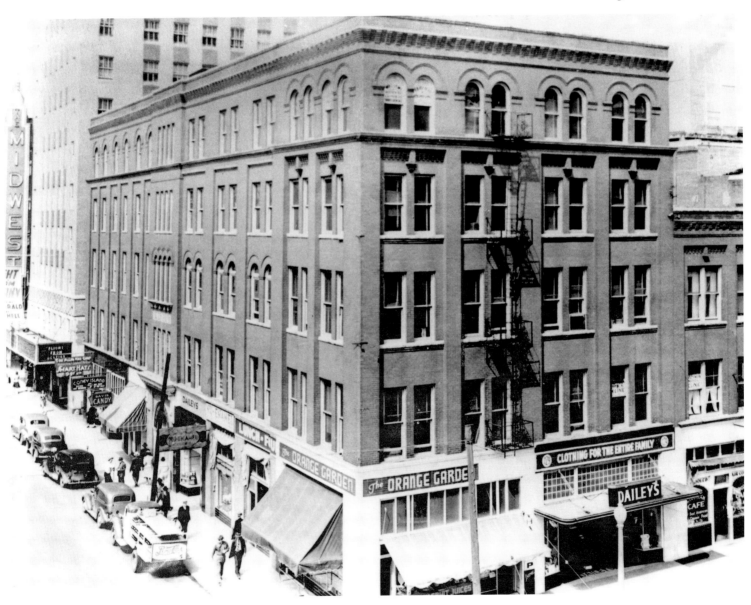

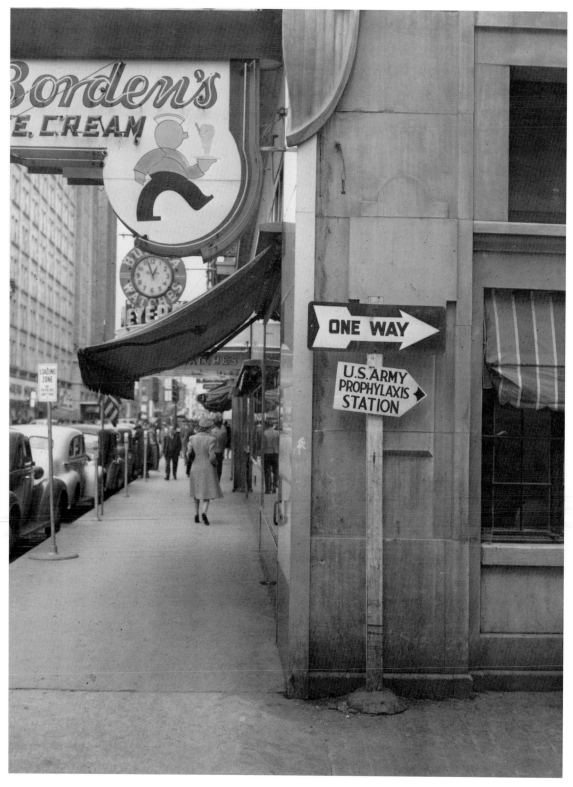

This sign points the way to a U.S. Army prophylaxis station in 1942. Vice was such a problem in Oklahoma City, a seven-block area extending from the Santa Fe depot between Grand to Reno was off-limits to soldiers for some time.

During World War II, a "deuce and a half" truck from Will Rogers Army Air Field cruises down Broadway in the 1942 Independence Day parade.

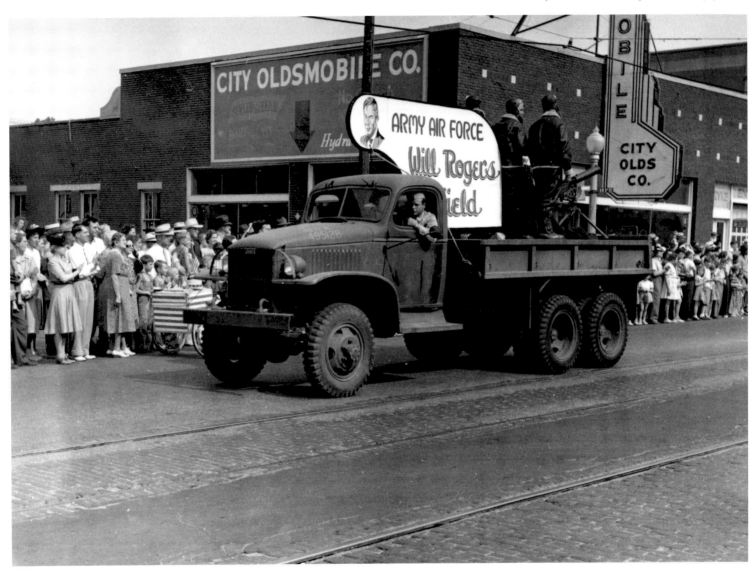

A battery of 75mm artillery from Fort Sill parades down Broadway in the
1942 Independence Day parade.

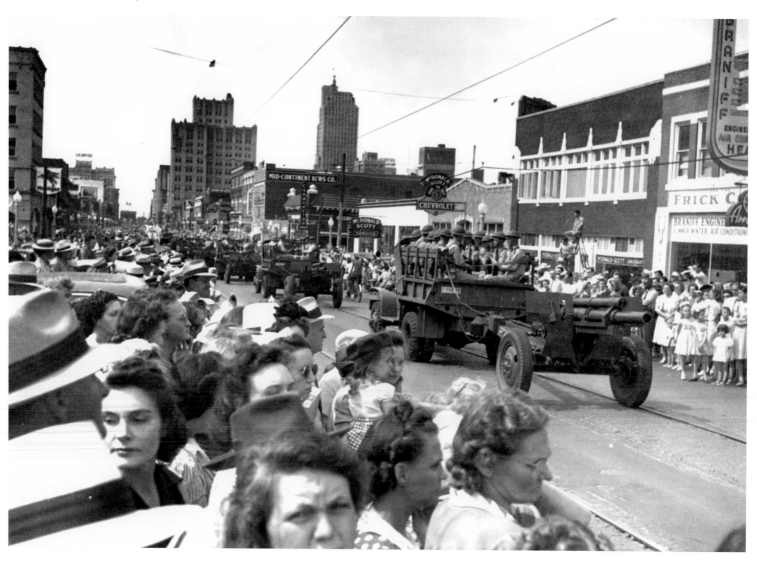

Employees of the Oklahoma City Air Depot march on Broadway in the 1942 Independence Day parade. More than 100,000 people crowded city streets to watch the parade.

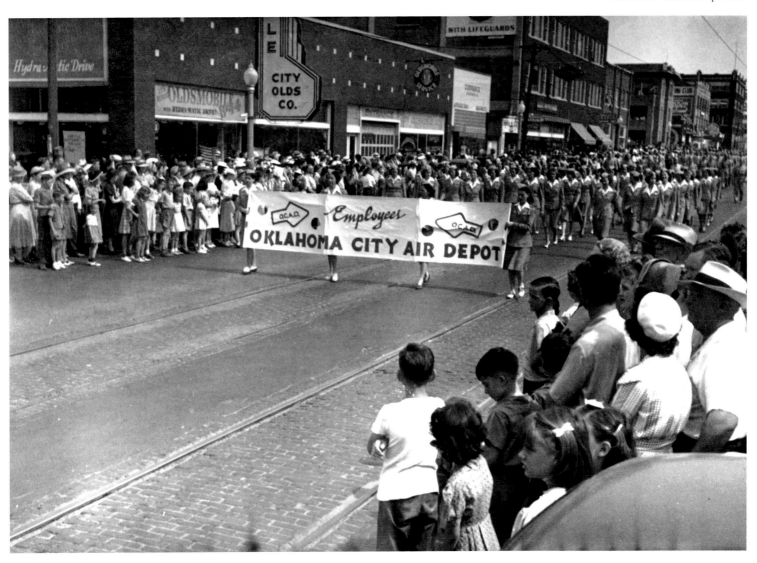

With World War II in progress, three C-47 Skytrains from the Douglas Aircraft plant make a test-flight over downtown (ca. 1943). Oklahoma City produced more than 5,000 planes for Douglas, including more than 700 lend-lease planes for the Soviet Union.

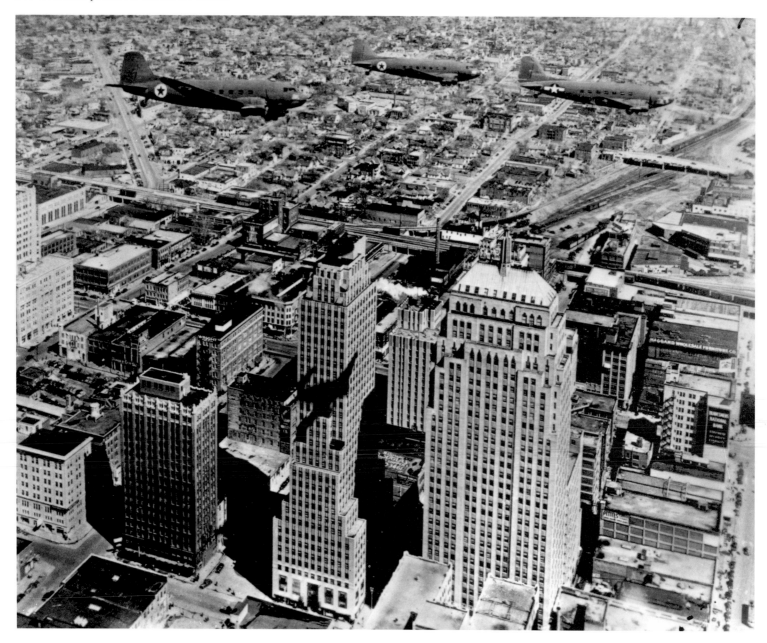

In addition to the three large military facilities in the metro area, Oklahoma City was a regular stopover for troops traversing the country. Here servicemen mix with locals in front of the Majestic Building at Main and Harvey in 1944.

Moviegoers line up to see Darryl Zanuck's *Wilson* at the Midwest Theater, 16 North Harvey, in the fall of 1944. The movie, albeit a box-office flop, won five Oscars and was nominated for five more.

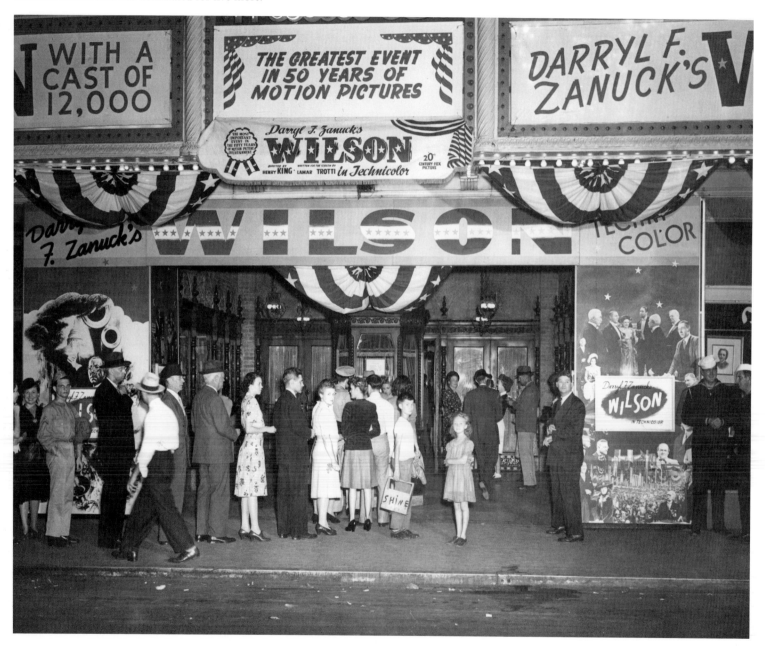

The enduring Colcord
Building, shown here in 1944,
was built of reinforced concrete
in 1910 after Charles Colcord
witnessed the aftermath of the
San Francisco earthquake.

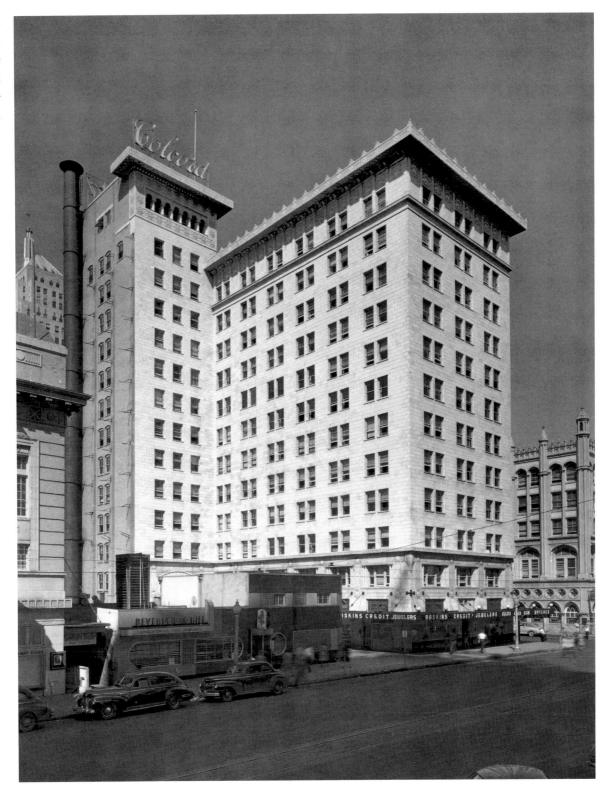

Lots of diversions were available along this stretch of Main Street in June 1945, not the least of which was the beautiful Criterion Theatre at 113 West Main.

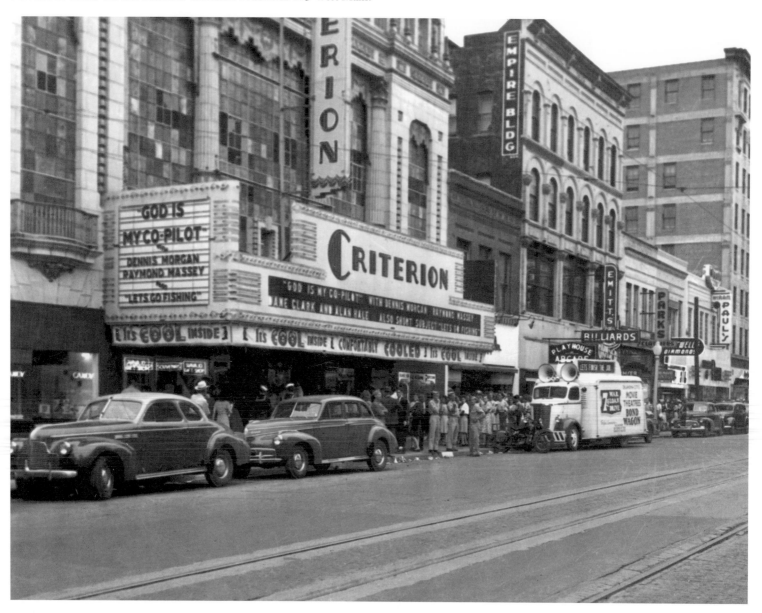

Arrows to Atoms

(1946–1961)

Oklahoma City followed a trajectory similar to that of the rest of the nation in the years after World War II. The slow, controlled departure from the Depression and wartime economies in the late 1940s began to give way to the baby boom population explosion and expansion into suburban areas.

Expansion was the operative word for the postwar era. Suburban housing developments filled as soon as they were built, and they were being built at an astounding rate. On the northwest side, houses continued to push out to the north and west, but for the first time the city began to see large areas of development to the south.

This expansion was made possible, of course, by the rising importance of the automobile in American life. Streetcars left city streets after the war, and by the early 1950s the automobile was making life downtown increasingly difficult. Traffic jams were a daily nuisance and parking was a headache. By the end of the postwar era, many older buildings downtown had been demolished and the lots simply paved over for parking.

In the mid 1950s, downtown retailers began to cast their eyes to the suburbs and the opportunities to build larger stores with free and plentiful parking. Several began to leave downtown, and some, like Halliburton's, closed for good.

Oklahoma City was fortunate to have strong leadership during the postwar era, in particular, Stanley Draper at the Chamber of Commerce. Seeing the difficulties older cities were having adjusting to expansion, Draper led the way in annexing large swathes of land into the city limits. These areas made possible the future growth of modern highways, the airport, the air depot, and several new reservoirs in addition to more housing and larger industrial plants.

Optimism was high in Oklahoma City during the 1950s, and nowhere was this more evident than during the year-long Semi-Centennial celebration in 1957. A huge tract of land west of May Avenue was designated the new State Fairgrounds and many futuristic exposition buildings were built. Throughout the year, slogans like "Arrows to Atoms" kept spirits high by reminding residents just how far they had come in such a short time.

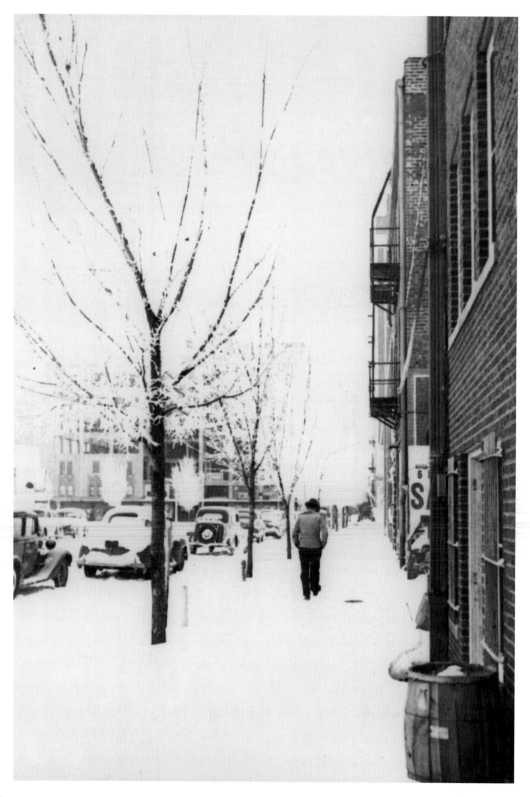

This unusual view was recorded from the alley created when a railroad siding was removed between Main and Park east of Broadway. Looking east through the snow, one can see the First National Bank Building rising in the distance.

Americans went on a spending spree after the war as industry retooled to manufacture domestic goods. Economists grew anxious that shoppers, like these ladies crossing Harvey on Main Street in the retail district ca. 1946, would wreak havoc on the postwar economy.

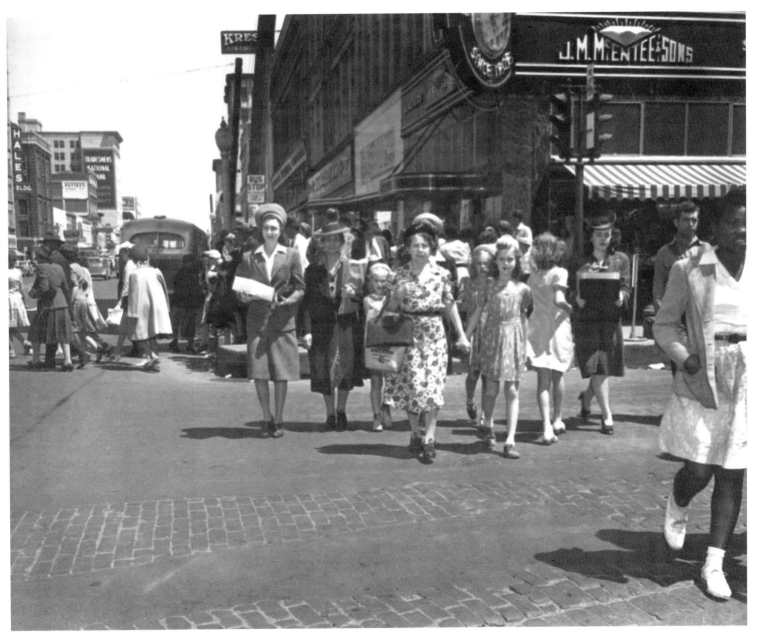

The American Airlines DC-3 *Flagship Missouri* waits on the tarmac at Will Rogers Field. The Army commandeered the municipal airport during the war, but passenger service quickly resumed after the war ended.

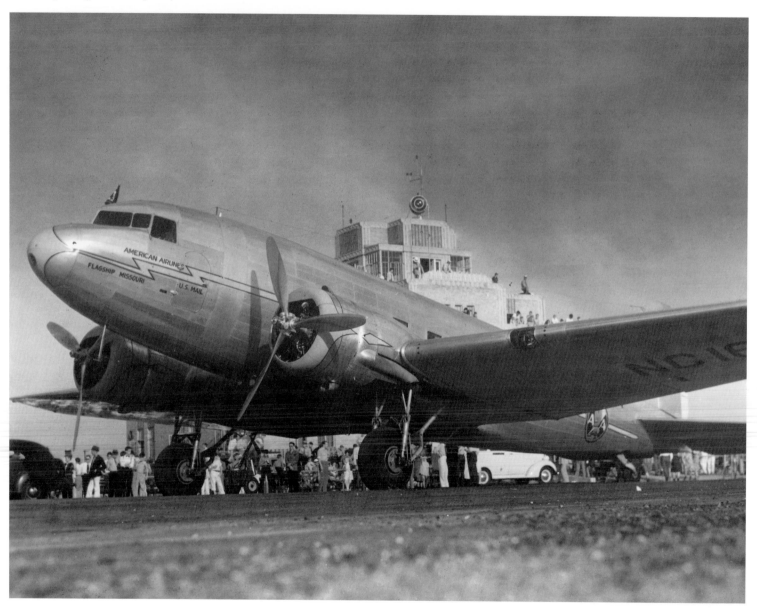

Hollywood came to town in July 1947 for the premiere of *Black Gold*, a film about Oklahoma's 1924 Kentucky Derby–winning horse. Here crowds throng star Anthony Quinn as he speaks from a podium at the Midwest Theatre, at 16 North Harvey.

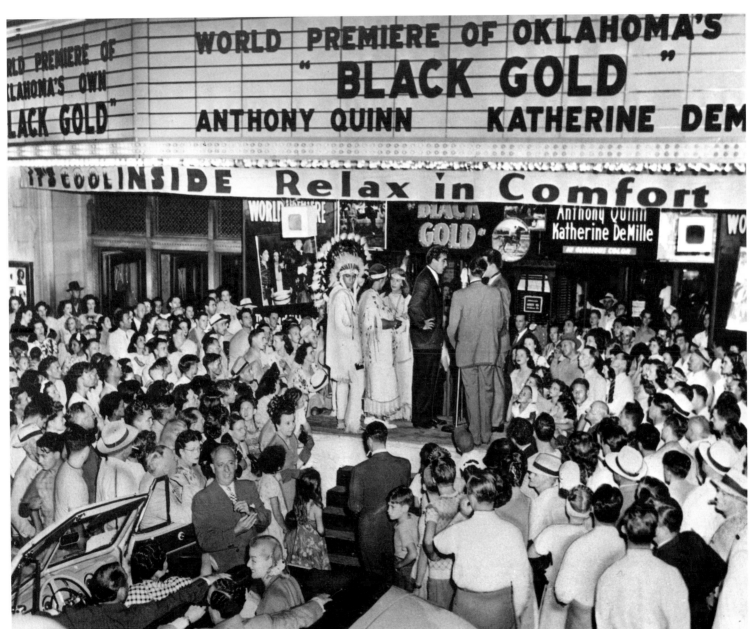

Cattle are ready for market in holding pens at the Oklahoma National Stock Yards (1947).

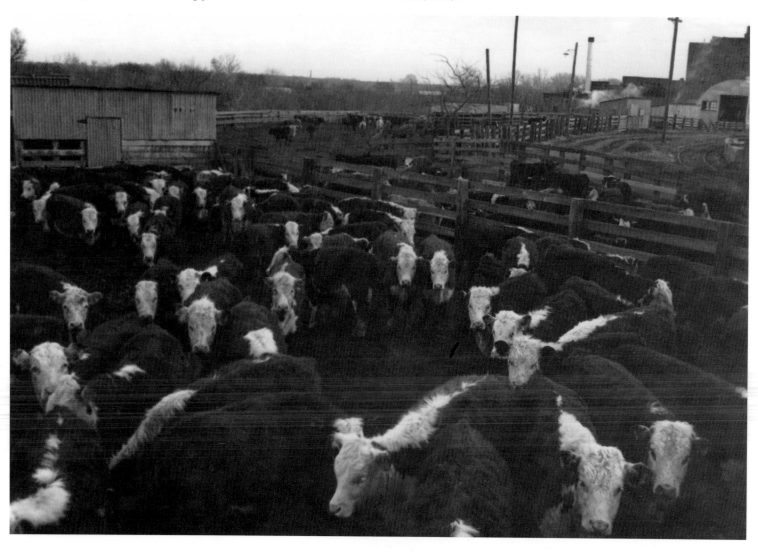

Traffic fills North Broadway on a busy Saturday afternoon in October 1947. The streetcar tracks down the center and lack of lane striping were sources of consternation for drivers.

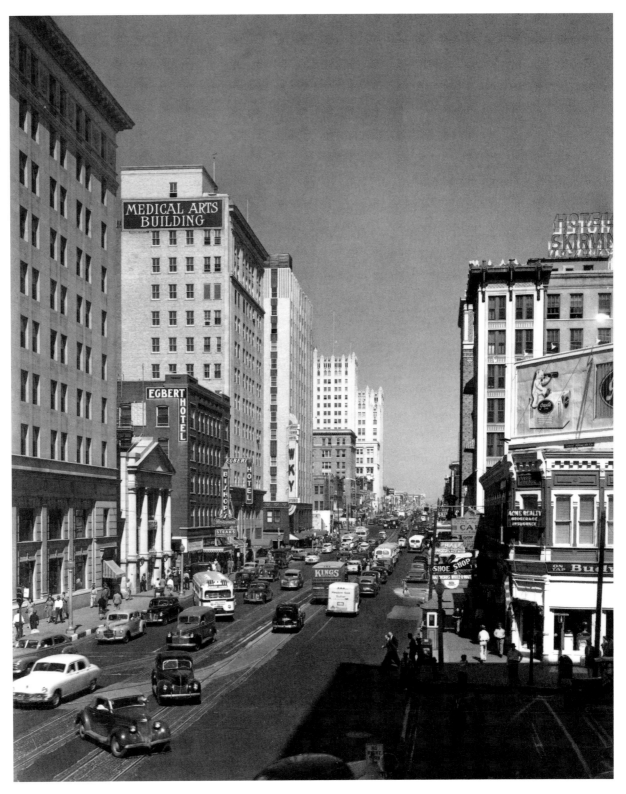

The Baum Building, at 14 North Robinson, was known as the Fidelity Building for much of its life because of its main tenant, Fidelity National Bank. Shown here in 1949, it was designed by Solomon Layton in 1910 in the style of the Venetian palazzos. It was leveled in 1973 to make way for a small shopping center.

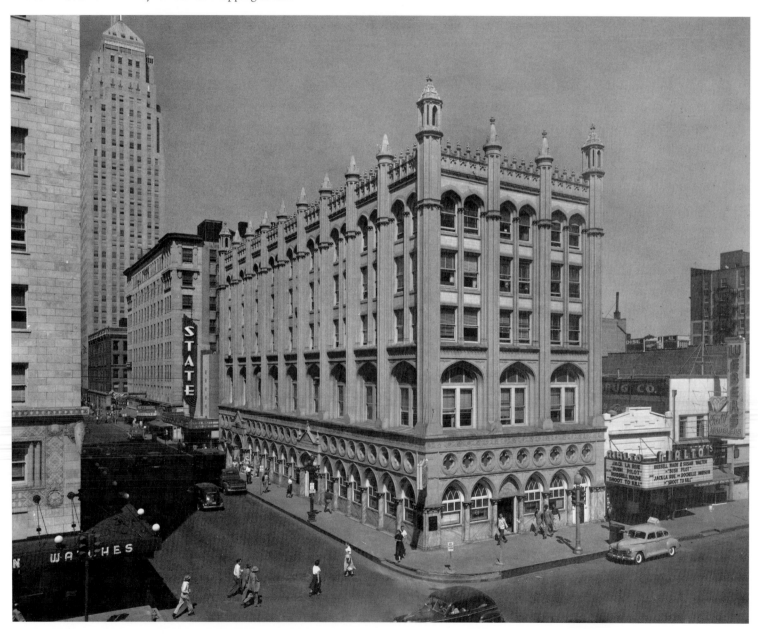

In March 1949, the Oklahoma Safety Council teamed with several groups for a highway safety promotional blitz around the state. The road show truck, parked in front of the Mid-Continent Life building at 1400 Classen Drive, featured loudspeakers and a searchlight.

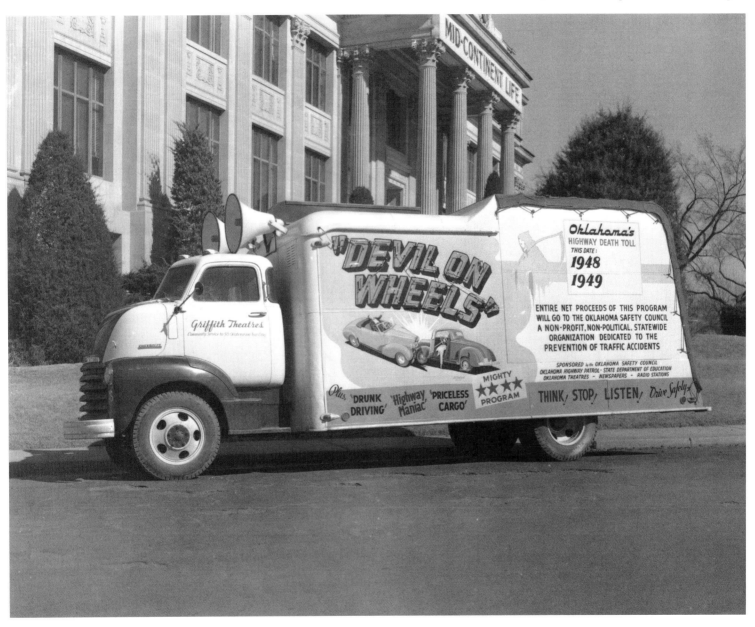

Main Street, in this view facing east from Walker, was aglow with new
Christmas decorations in 1949.

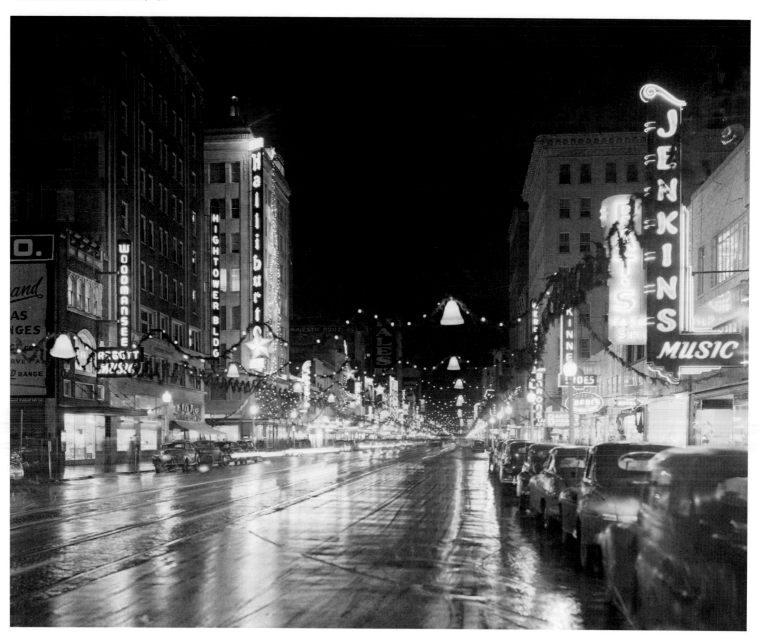

A Santa Fe passenger locomotive with the distinctive "warbonnet" paint scheme waits at the platform at the Santa Fe depot in January 1952. The new depot and raised platform, or viaduct, was built in 1934 at the east end of California Avenue.

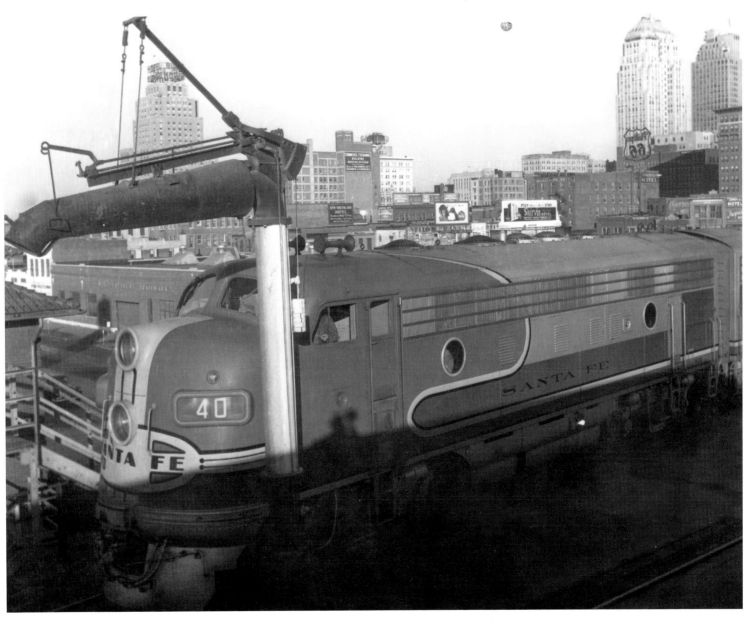

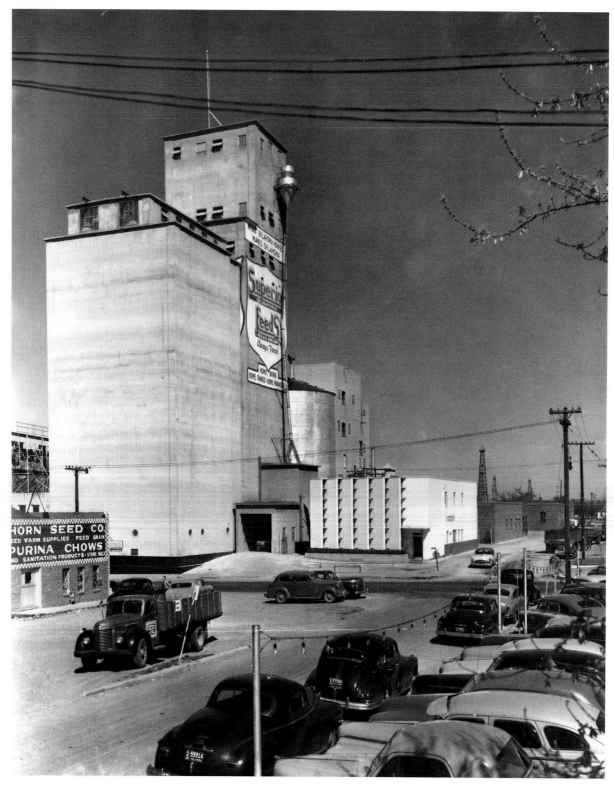

The Superior Feed Mills elevator, at 2100 South Robinson, was built in 1939 by the family of Lebanese immigrant and longtime civic leader B. D. Eddie. This view faces east across the intersection of Southwest 21st and Robinson.

By the time this photograph of Broadway was taken, ca. 1952, trolley tracks had been paved over and green- and yellow-striped poles (at center) marked pedestrian safety islands for crossing the street.

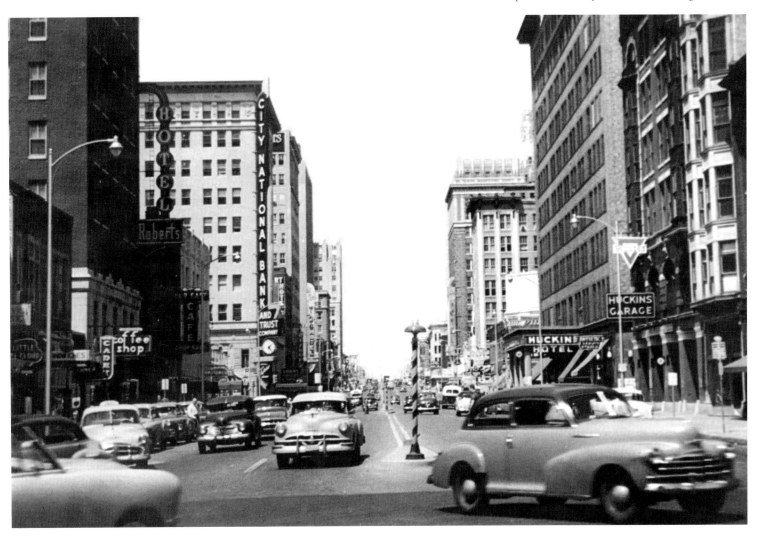

The art deco Petroleum Building's 18 stories made it the city's tallest when it was built at Robinson and Second in 1927. Still a prominent building when photographed here in 1953, it would soon be crowded out by modern glass-and-steel structures.

Oklahoma Air National Guard Captain Doyle Hastie of the 185th Fighter Squadron wings over Oklahoma City. The 185th received 10 F-80 Shooting Stars from the Air Force in the summer of 1953.

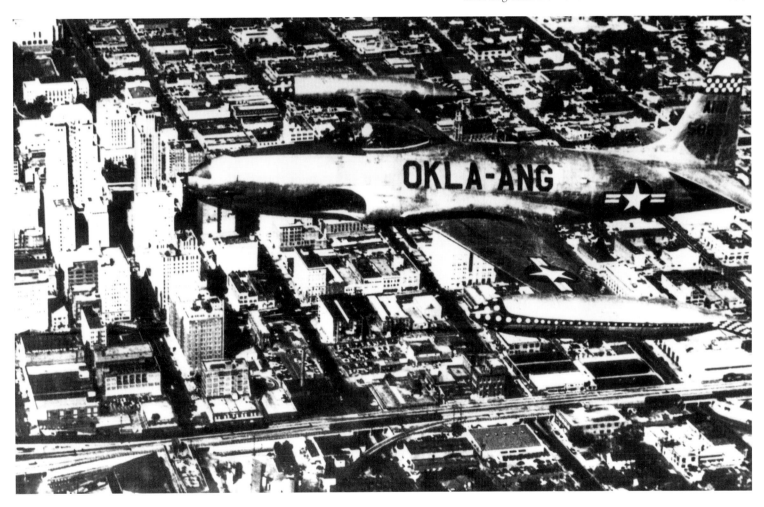

Notes on the Photographs

These notes, listed by page number, attempt to include all aspects known of the photographs. Each of the photographs is identified by the page number, photograph's title or description, photographer and collection, archive, and call or box number when applicable. Although every attempt was made to collect all available data, in some cases complete data was unavailable due to the age and condition of some of the photographs and records.

II **Early Tents**
Oklahoma Historical Society
18012

VI **Civil Rights Protest**
Oklahoma Historical Society
20246.38

X **Postmaster**
Oklahoma Historical Society
19445

2 **Street Confusion**
Oklahoma Historical Society
9616

4 **Tent City**
Oklahoma Historical Society
5172

5 **Brickyard**
Oklahoma Historical Society
19558

6 **Framed Structures**
Oklahoma Historical Society
19568

7 **Native Americans**
Oklahoma Historical Society
9617

8 **Post Office**
Oklahoma Historical Society
19412

9 **City Court**
Oklahoma Historical Society
20738

10 **C. A. McNabb**
Oklahoma Historical Society
9248

11 **Main Street**
Oklahoma Historical Society
19445

12 **Independence Day**
Oklahoma Historical Society
6505

14 **First Disaster**
Oklahoma Historical Society
12390

15 **McNabb Store**
Oklahoma Historical Society
9290

16 **Storefronts**
Oklahoma Historical Society
4574

17 **Ox-Drawn Wagons**
Oklahoma Historical Society
21802

18 **Building Materials**
Oklahoma Historical Society
10115

19 **Baseball**
Oklahoma Historical Society
11035

20 **Striking a Deal**
Oklahoma Historical Society
18008

21 **The Weaver**
Oklahoma Historical Society
10057

22 **Bassett Block**
Oklahoma Historical Society
5714

23 **Main Street**
Oklahoma Historical Society
16948

24 **First National Bank**
Oklahoma Historical Society
19539

25 **Masonic Temple**
Oklahoma Historical Society
9249

26 **Aurora Bargain Store**
Oklahoma Historical Society
18692

27 **Stage Line**
Oklahoma Historical Society
14259

28 **Grand Avenue**
Oklahoma Historical Society
10076

29 **Tornado**
Oklahoma Historical Society
MLSOK0004

30 **Street Fair**
Oklahoma Historical Society
5800

31 **First Methodist**
Oklahoma Historical Society
19589

32 **Ragon & Atwood**
Oklahoma Historical Society
16949.2

33 **FREE STREET FAIR**
Oklahoma Historical Society
16949..4

34 **WESTERN NATIONAL**
Oklahoma Historical Society
18731

36 **THEODORE ROOSEVELT**
Oklahoma Historical Society
2094.4

37 **ROUGH RIDERS**
Oklahoma Historical Society
19554.6

38 **NATIVE AMERICANS**
Oklahoma Historical Society
22602.1

39 **HORSELESS CARRIAGE**
Oklahoma Historical Society
18482

40 **CARNEGIE LIBRARY**
Oklahoma Historical Society
MLSPL0003

42 **WHEELER PARK**
Oklahoma Historical Society
5725

43 **DOC AND BOB**
Oklahoma Historical Society
19644

44 **EPWORTH UNIVERSITY**
Oklahoma Historical Society
MLSOK0005

45 **THREADGILL**
Oklahoma Historical Society
20538.24

46 **HERSKOWITZ STORE**
Oklahoma Historical Society
19206

47 **DELIVERY WAGON**
Oklahoma Historical Society
19578

48 **BROADWAY**
Oklahoma Historical Society
5678

49 **FAIRGROUNDS**
Oklahoma Historical Society
21412.BH2372

50 **CALIFORNIA AVENUE**
Oklahoma Historical Society
5689

51 **JENKINS MUSIC STORE**
Oklahoma Historical Society
20377.11

52 **DAILY POINTER**
Oklahoma Historical Society
5672 OKC

53 **HOTEL FIRE**
Oklahoma Historical Society
20947.6

54 **HUCKINS HOTEL**
Oklahoma Historical Society
21412.BH399.A

55 **MAIN STREET**
Oklahoma Historical Society
21412.BH2108

56 **ANTON CLASSEN**
Oklahoma Historical Society
MLSOK0349

57 **LABOR DAY PARADE**
Oklahoma Historical Society
2097

58 **COTTON CROP**
Oklahoma Historical Society
MLSOK0021

60 **DOUBLE STOREFRONT**
Oklahoma Historical Society
17030

61 **URBAN HOME**
Oklahoma Historical Society
MLSOK0440

62 **HORSE RACING**
Oklahoma Historical Society
19439.5.60

64 **STREETCAR**
Oklahoma Historical Society
21409.N.30

65 **RAILWAY COMPANY**
Oklahoma Historical Society
21409.N.28

66 **BROADWAY BOOM**
Oklahoma Historical Society
18827.67

67 **BROADWAY**
Oklahoma Historical Society
5730

68 **FIRST CHRISTIAN**
Oklahoma Historical Society
20538.18

69 **DAILY OKLAHOMAN**
Oklahoma Historical Society
19279.1

70 **PARADE**
Oklahoma Historical Society
21460.37.A

71 **DELMAR GARDEN**
Oklahoma Historical Society
18827.51

72 **DELMAR GARDEN**
Oklahoma Historical Society
MLSOK0023

74 **PROHIBITION**
Oklahoma Historical Society
22194.3899.2

75 **COURTHOUSE**
Oklahoma Historical Society
18827.72

76 **COURT ENTRANCE**
Oklahoma Historical Society
21714.4

77 **STATE FAIR GROUNDS**
Oklahoma Historical Society
21409.N.35

78 **RENO WOOD YARD**
Oklahoma Historical Society
5527

79 **CAPITOL HILL LINE**
Oklahoma Historical Society
22201.4

80 **FIREMEN'S CONVENTION**
Oklahoma Historical Society
5690.B

81 **BELLE ISLE PARK**
Oklahoma Historical Society
11405

82 **CANOEING**
Oklahoma Historical Society
MLSOK0034

83 **LAYING TRACKS**
Oklahoma Historical Society
MLSOK0604

84 **STATE NATIONAL BANK**
Oklahoma Historical Society
20905.5

85 **ST. LUKE'S METHODIST**
Oklahoma Historical Society
MLSOK0043

86 **CHARLES WILLARD**
Oklahoma Historical Society
21412.BH2228

87 **LIVESTOCK EXCHANGE**
Oklahoma Historical Society
18827.6.1

88 **YUKON EXPRESS**
Oklahoma Historical Society
20538.55 No 48

89 **COUNTRY CLUB**
Oklahoma Historical Society
MLSOK0455

90 **GOVERNOR HASKELL**
Oklahoma Historical Society
MLSOK0341

92 **STATE NATIONAL BANK**
Oklahoma Historical Society
21412.BH.108

93 **DREAMLAND THEATRE**
Oklahoma Historical Society
21412.HH.108.1

94 **MAYWOOD PHARMACY**
Oklahoma Historical Society
MLSOK0343

95 **DOC AND BILL**
Oklahoma Historical Society
21412.BH1438.1

96 **FIREMEN PROTEST**
Oklahoma Historical Society
21412.BH2355.1

97 **BUNGALOW**
Oklahoma Historical Society
MLSOK0030

98 **MORRIS & COMPANY**
Oklahoma Historical Society
18827.46

99 **TEAMSTERS**
Oklahoma Historical Society
MLSOK0061

100 **RECITAL HALL**
Oklahoma Historical Society
MLSOK0024

101 **FOOTBALL TEAM**
Oklahoma Historical Society
MLSOK0115

102 **KINGKADE**
Oklahoma Historical Society
18827.38

103 **COLCORD HOME**
Oklahoma Historical Society
MLSOK0031

104 **STATE CAPITOL**
Oklahoma Historical Society
19442

105 **CONGREGATION**
Oklahoma Historical Society
MLSOK0426

106 **FALL FLOWER SHOW**
Oklahoma Historical Society
21210

107 **HYMIE MILLER**
Library Of Congress
nclc 04035

108 **ERNEST CHESTER**
Library Of Congress
nclc 04018

109 **CHARLIE SCOTT**
Library Of Congress
nclc 04027

110 **ESCORTING THE BLIND**
Library Of Congress
nclc 05262

112 **BOATING**
Oklahoma Historical Society
20533.293

113 **RECRUITING SERVICE**
Oklahoma Historical Society
20595.19

114 **BROADWAY**
Oklahoma Historical Society
21412.M221.6

115 **AFTER DARK**
Oklahoma Historical Society
21412.BH1532

116 **O.K. TRANSFER**
Oklahoma Historical Society
MLSOK0473

117 **DAM FLOOD**
Oklahoma Historical Society
18469.11

118 **MAIN STREET**
Oklahoma Historical Society
21412.BH2173

119 **HALLIBURTON'S**
Oklahoma Historical Society
21412.BH2132.2

120 **MAIN STREET**
Oklahoma Historical Society
21412.BH1560 300

121 **HUCKINS HOTEL**
Oklahoma Historical Society
21412.M30.5

122 **COMMERCIAL DISTRICT**
Oklahoma Historical Society
19270.8

123 **STREETCARS**
Oklahoma Historical Society
21412.BH1788

124 **UNIVERSITY HOSPITAL**
Oklahoma Historical Society
MLSPL0007

125 **SKIRVIN HOTEL**
Oklahoma Historical Society
21412.BH2667

126 **THE FOKKER**
Oklahoma Historical Society
19270.89

127 **MAIN STREET**
Oklahoma Historical Society
21412.BH2160

128 **BOARDING PASSENGER**
Oklahoma Historical Society
21412.BH.121.2

129 **SKIRVIN HOTEL**
Oklahoma Historical Society
21412.B113.11

130 **EMPRESS THEATRE**
Oklahoma Historical Society
21412.BH2173.1

131 **WHITE MOTOR COMPANY**
Oklahoma Historical Society
21282.8

132 **ROBINSON AVENUE**
Oklahoma Historical Society
19270.12

133 **CIRCLE THEATRE**
Oklahoma Historical Society
21412.BH.107

134 **CRITERION THEATRE**
Oklahoma Historical Society
21412.BH137

135 **OKLAHOMA RAILWAY**
Oklahoma Historical Society
20218.6332

136 COLESIUM
Oklahoma Historical Society
21412.BH2364

138 ROCK ISLAND DEPOT
Oklahoma Historical Society
21412.BH2130

139 PERRINE BUILDING
Oklahoma Historical Society
21412.BH1963

140 RAMSEY TOWER
Oklahoma Historical Society
21412.BH2179

141 HORSE RACE
Oklahoma Historical Society
21412.BH768

142 TOM MIX
Oklahoma Historical Society
20772.6.3

143 STUDENTS STUDY
Oklahoma Historical Society
MLSOK0001

144 AUBURN-BENNETT
Oklahoma Historical Society
19270.22

145 BILTMORE HOTEL
Oklahoma Historical Society
21412.BH237

146 PUBLIC MARKET
Oklahoma Historical Society
21412.M167.7

147 MARKET ROW
Oklahoma Historical Society
21412.M167.5

148 PUBLIC MARKET
Oklahoma Historical Society
21412.M167.6

149 TRADESMEN'S BANK
Oklahoma Historical Society
21412.M209.1

150 MAIN STREET
Oklahoma Historical Society
21412.BH1529

151 HOLIDAY DECORATIONS
Oklahoma Historical Society
21412.BH.106

152 LAKE OVERHOLSER
Oklahoma Historical Society
20533.297

153 OIL DERRICKS
Oklahoma Historical Society
21412.BH2192.B

154 BAUM BUILDING
Oklahoma Historical Society
20533.15

155 BROADWAY AND GRAND
Oklahoma Historical Society
20533-143

156 LAND RUN
Oklahoma Historical Society
19695

157 SEARS
Oklahoma Historical Society
20533.42

158 RIALTO THEATRE
Oklahoma Historical Society
20546.19.1

159 STATE CAPITOL STATUE
Oklahoma Historical Society
fsa8b38728

160 DRILLING AT CAPITOL
Oklahoma Historical Society
fsa8b22697

161 SKYLINE
Oklahoma Historical Society
20533.1

162 DC-2
Oklahoma Historical Society
21412.BH676

163 FERRIS WHEELS
Oklahoma Historical Society
20218.156

164 RELOCATING
Oklahoma Historical Society
20218.1283

165 BOARDING STREETCAR
Oklahoma Historical Society
ok016

166 HAY LOADS
Oklahoma Historical Society
20218.463

167 TROLLEY COLLISION
Oklahoma Historical Society
20622.19.1

168 FIRST NATIONAL BANK
Oklahoma Historical Society
21412.B5.57

169 METAL DRIVE
Oklahoma Historical Society
21412.BH1364

170 REDSKIN THEATRE
Oklahoma Historical Society
21412.BH2595

171 GRAND OPENING
Oklahoma Historical Society
822 SW 29

172 BISON THEATRE
Oklahoma Historical Society
21412.M1083.2

173 MERCANTILE BUILDING
Oklahoma Historical Society

174 AVERY CHAPEL
Oklahoma Historical Society
MLSOK0047

175 BALTIMORE BUILDING
Oklahoma Historical Society
21412.BH1867

176 PROPHYLAXIS STATION
Oklahoma Historical Society
ok019

177 DUECE AND A HALF
Oklahoma Historical Society
20218.1992

178 75MM ARTILLERY
Oklahoma Historical Society
20218.1998

179 AIR DEPOT
Oklahoma Historical Society
20128.1997

180 C-47s
Oklahoma Historical Society
21412.BH1247

181 MAJESTIC BUILDING
Oklahoma Historical Society
21412.M203.1

182 MIDWEST THEATER
Oklahoma Historical Society
MLSOK0340

183 COLCORD BUILDING
Oklahoma Historical Society
21412.M9.4

184 CRITERION THEATRE
Oklahoma Historical Society
21412.bh239

Heston, Pierce, and West met little opposition in their one hour march around Downtown.

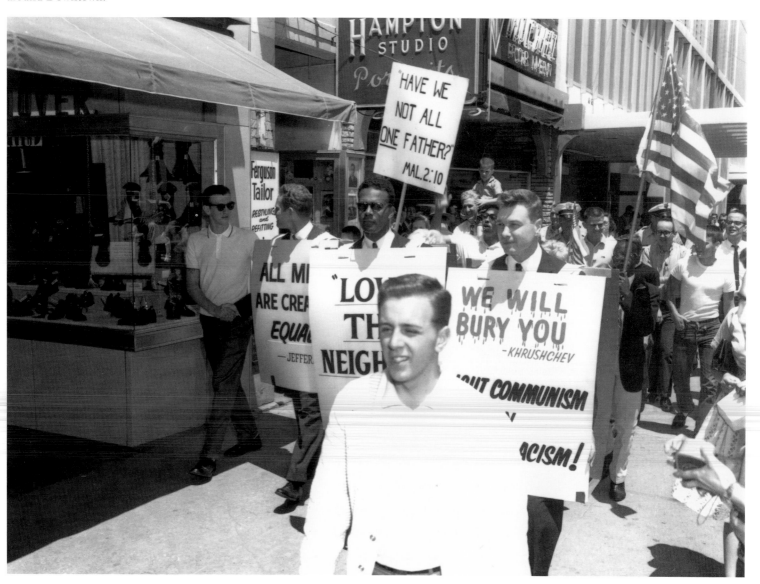